OUR MOVIE YEAR

AMERICAN SPLENDOR

STORIES BY HARVEY PEKAR

Art by
R. Crumb, Gary Dumm, Mark Zingarelli, Josh Neufeld,
Gerry Shamray, G. Budgett, Frank Stack, Ed Piskor,
Joe Zabel, and Dean Haspiel

Ballantine Books New York

A Ballantine Books Trade Paperback Original

Copyright © 2004 by Harvey Pekar LLC

Published in the United States by Ballantine Books, an imprint of
The Random House Publishing Group, a division of Random House, Inc., New York.

Ballantine and colophon are registered trademarks of Random House, Inc.

Library of Congress Cataloging-in-Publication Data: 2004097833

ISBN 0-345-47937-8

Printed in the United States of America

Ballantine Books website address: www.ballantinebooks.com

First Edition: December 2004

2 4 6 8 9 7 5 3 1

OUR MOVIE YEAR

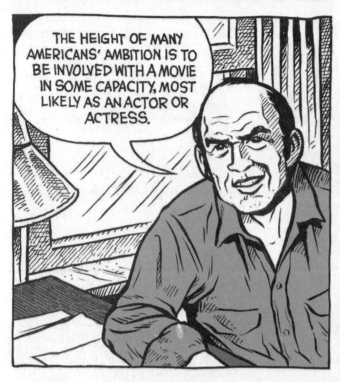

THE HEIGHT OF MANY AMERICANS' AMBITION IS TO BE INVOLVED WITH A MOVIE IN SOME CAPACITY, MOST LIKELY AS AN ACTOR OR ACTRESS.

GENERALLY, THE HIGH POINT OF THEIR WEEKENDS IS TO SEE A MOVIE. TO THEM IT'S THE HIGHEST FORM OF ART AND ENTERTAINMENT.

STAR CINEMAS

HARRY POTTER
SHALLOW HAL
MONSTERS INC
DOMESTIC DISTURBANCE

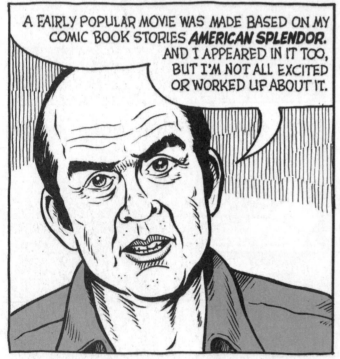

A FAIRLY POPULAR MOVIE WAS MADE BASED ON MY COMIC BOOK STORIES *AMERICAN SPLENDOR.* AND I APPEARED IN IT TOO, BUT I'M NOT ALL EXCITED OR WORKED UP ABOUT IT.

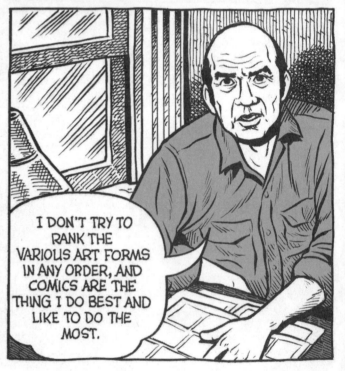

I DON'T TRY TO RANK THE VARIOUS ART FORMS IN ANY ORDER, AND COMICS ARE THE THING I DO BEST AND LIKE TO DO THE MOST.

BUT I'LL TELL YOU WHAT, YOU CAN MAKE A LOT MORE MONEY IN MOVIES THAN YOU CAN IN COMICS AND I RESPECT THEM FOR THAT. I'VE ALWAYS KNOWN THAT THE MONEY I MADE ON MY FEDERAL GOVERNMENT RETIREMENT PENSION, AFTER 37 YEARS AS A FILE CLERK, WOULD NOT BE ENOUGH TO SUPPORT MY FAMILY ADEQUATELY.

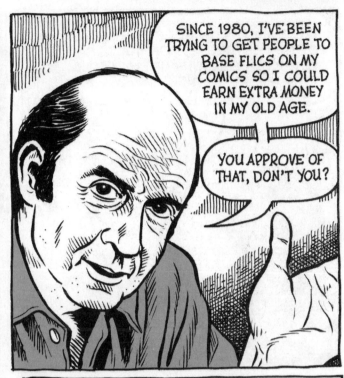

SINCE 1980, I'VE BEEN TRYING TO GET PEOPLE TO BASE FLICS ON MY COMICS SO I COULD EARN EXTRA MONEY IN MY OLD AGE.

YOU APPROVE OF THAT, DON'T YOU?

YEAH, IN 1980 A BIG COMPLIMENTARY ARTICLE CAME OUT ABOUT MY COMICS IN THE *VILLAGE VOICE*, IT MUST'VE HAD SOME IMPACT, BECAUSE A SHORT TIME LATER **JONATHAN DEMME** CALLED ME TO SEE IF HE COULD BASE A MOVIE ON MY COMICS. HOWEVER, HE HADN'T MADE A NAME YET AND COULDN'T GET THE DOUGH TOGETHER TO MAKE THE FILM.

FROM OPP THE ST OF CLEVELAND

AMERIC #0 $1 SPLEN

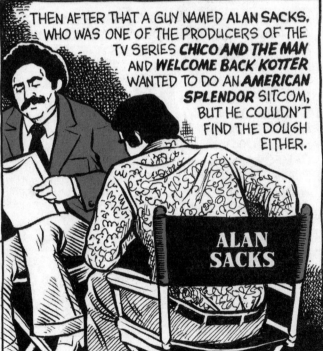

THEN AFTER THAT A GUY NAMED ALAN SACKS, WHO WAS ONE OF THE PRODUCERS OF THE TV SERIES *CHICO AND THE MAN* AND *WELCOME BACK KOTTER* WANTED TO DO AN *AMERICAN SPLENDOR* SITCOM, BUT HE COULDN'T FIND THE DOUGH EITHER.

ALAN SACKS

SEE, EVEN A "LOW BUDGET" FILM COSTS A COUPLE MILLION BUCKS TO PRODUCE, A SUM WHICH FEW PEOPLE CAN AFFORD TO THROW AWAY.

THEN A GUY WHO MADE VIDEOS WANTED TO PRODUCE VIDEO VERSIONS OF MY STORIES FOR CABLE, HE WAS GOOD, BUT AT THAT TIME CABLE WASN'T PAYING VERY MUCH SO I SAT TIGHT.

SO I KEPT WRITING AND PUBLISHING MY AUTOBIOGRAPHICAL COMICS THROUGH THE EIGHTIES, AND SOME INTERESTING THINGS HAPPENED. THREE THEATER GROUPS, LANCASTER, PA., WASHINGTON DC, AND ONE IN HOLLYWOOD, CALIFORNIA DID PLAYS BASED ON *AMERICAN SPLENDOR*. THEY GOT A GOOD CRITICAL REACTION TOO.

NOW MY COMICS ARE AUTOBIOGRAPHICAL. THEY DEALT WITH MY EVERY DAY LIFE AS A FILE CLERK. I THINK THAT I AND JUST ABOUT EVERYBODY ELSE LEAD LIVES INTERESTING ENOUGH TO DO MOVIES OR NOVELS ABOUT.

MANY ARE UNSUNG HEROES, THEY STRUGGLE MIGHTILY, SOMETIMES WORK AT JOBS THEY HATE, JUST SO THEIR FAMILY CAN SURVIVE.

THERE'S A LOT OF HUMOR THAT CROPS UP IN THEIR LIVES TOO WHICH IS FRESHER AND FUNNIER THAN THE STUFF YOU SEE ON TELEVISION.

HARVEY PEKAR? MY NAME IS BERNT CAPRA...

IN THE 1990'S, THIS L.A. BASED MOVIE ART DIRECTOR, BERNT CAPRA, ACTUALLY SIGNED A COUPLE OF OPTION AGREEMENTS WITH ME TO DO AN *AMERICAN SPLENDOR* FILM. WE TRIED EVERYTHING WE COULD TO SELL IT.

WE BOTH HAD CONNECTIONS TO LEONARDO DiCAPRIO, ME THROUGH MY ACQUAINTANCE WITH HIS FATHER GEORGE WHO WAS AN EXCELLENT UNDERGROUND COMICS WRITER, AND BERNT HAD ACTUALLY WORKED WITH LEONARDO ON THE *GILBERT GRAPE* MOVIE.

The American Splendor

So I WENT OUT TO L.A. AND GEORGE TRIED TO SELL AN *AMERICAN SPLENDOR* MOVIE TO SOME HOLLYWOOD PRODUCERS HE KNEW IMPLYING THAT LEONARDO, WHO WAS REALLY HOT THEN, MIGHT APPEAR IN THE FLIC.

BUT THAT WASN'T ENOUGH TO GET ANYBODY TO COME UP WITH THE JACK. MAN, THIS WAS GETTING DISCOURAGING.

THE GUY WHO'D PLAYED THE LEAD IN THE A.S. PLAY IN HOLLYWOOD WAS *DAN CASTELLENETA*, THE VOICE OF HOMER SIMPSON, AND SIOBAHN FALLON, A TALENTED **TV** AND MOVIE COMEDIENNE WAS IN IT. THE L.A. PAPERS REALLY DUG THE PLAY TOO, BUT MOVIE PEOPLE STILL DON'T WANNA RISK INVESTING IN IT.

LATER ON IN THE 1990's, BERNT GOT SOME KINDA CONNECTION WITH ROB SCHNEIDER, A GOOD TV AND MOVIE COMEDIAN, AND THEY STARTED TALKING UP *AMERICAN SPLENDOR* AS A SHOWCASE FOR SCHNEIDER'S TALENT. BUT THAT WAS A SLOW DEVELOPING PROJECT.

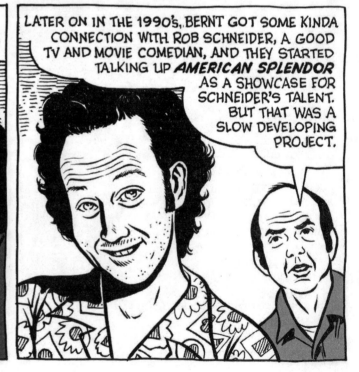

THEN, IN 1999, SOMETHING POSITIVE HAPPENED. *DEAN HASPIEL*, THIS GUY WHO'D DONE SOME ILLUSTRATION WORK FOR ME CALLED. DEAN TOLD ME A PRODUCER HE WAS DOING SOME FREELANCE WORK FOR WAS REALLY INTERESTED IN DOING AN *AMERICAN SPLENDOR* MOVIE.

THIS PRODUCER, A GUY NAMED *TED HOPE*, WAS CONNECTED WITH A HIGHLY REGARDED INDEPENDENT FILM COMPANY, *GOOD MACHINE* WHICH HAD PRODUCED SOME OF ANG LEE'S BEST PICTURES.

FOR SOME CRAZY REASON I DIDN'T FOLLOW UP ON IT IMMEDIATELY, BUT DEAN CALLED AGAIN AND TOLD MY WIFE, JOYCE, ABOUT IT. SHE GOT RIGHT ON IT AND...

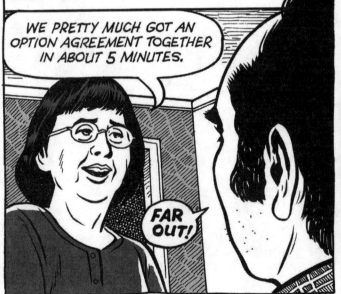

WE PRETTY MUCH GOT AN OPTION AGREEMENT TOGETHER IN ABOUT 5 MINUTES.

FAR OUT!

ORIGINALLY, TED HOPE WANTED ME TO WRITE A SCRIPT FOR AN A.S. MOVIE, SO I GOT INTO DOING THAT. THE SCRIPT WRITING WAS MORE EPISODIC THAN THE USUAL COMMERCIAL MOTION PICTURE STORY, SO I DIDN'T KNOW HOW TED WOULD FEEL ABOUT THAT.

MEANWHILE...TED HOPE HAD GOTTEN THE IDEA, WHICH HE HADN'T TOLD ME ABOUT, THAT HE WANTED ME IN THE FLIC AS WELL AS AN ACTOR THAT PLAYED ME.

HE TOLD THIS TO BOB PULCINI AND SHARI SPRINGER BERMAN, A MARRIED COUPLE WHO WOULD DIRECT THE PICTURE. BOB AND SHARI NOT ONLY AGREED WITH TED, BUT HAD SOME MORE FAR OUT IDEAS ABOUT DOUBLE CASTING.

ANYWAY, I GOT PAID FOR THE WORK I'D DONE ON THE SCRIPT. THEN BOB AND SHARI TOOK IT OVER AND WROTE A NEW SCRIPT.

IT TURNED OUT TO BE *GREAT* THAT THEY DID.

MEANWHILE...THINGS WEREN'T GOING TOO WELL FOR ME THEN ON MY DAY GIG. I WAS HAVING PANIC ATTACKS EVERY MORNING, BEGINNING ON ABOUT JUNE 2001. SOMETIMES THEY HAD TO TAKE ME TO THE DOCTOR ON THE JOB.

BY THAT TIME I'D PUT IN ALMOST 37 YEARS WORKING FOR THE FEDERAL GOVERNMENT, MOSTLY FOR THE VA HOSPITAL AND I WAS STARTING TO THINK MAYBE IT WOULD BE A GOOD IDEA IF I RETIRED.

IF I HUNG AROUND ANY LONGER I WOULDN'T GET MUCH MORE ON MY PENSION AND MAYBE WORK WAS DRIVING ME NUTS.

MEANWHILE... TED HOPE HAD BEEN BUSY TRYING TO GET THE BREAD TO DO AMERICAN SPLENDOR. HE WENT TO MAUD NADLER, THE VICE PRESIDENT OF MOVIES AT HBO AND MAUD LIKED THE SCRIPT.

SOMEHOW, WE'LL GET THIS THING DONE.

WELL, I WASN'T GETTING ANY BETTER AT WORK. THE PANIC ATTACKS STILL CAME. SO I DECIDED TO RETIRE IN OCTOBER 2001. THE NEXT MONTH THEY WERE SHOOTING THE MOVIE IN CLEVELAND.

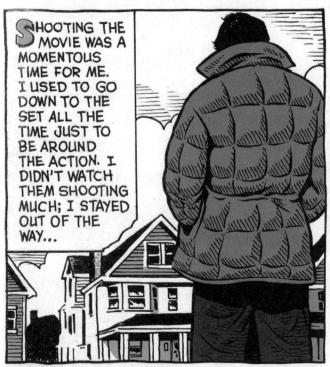

SHOOTING THE MOVIE WAS A MOMENTOUS TIME FOR ME. I USED TO GO DOWN TO THE SET ALL THE TIME JUST TO BE AROUND THE ACTION. I DIDN'T WATCH THEM SHOOTING MUCH; I STAYED OUT OF THE WAY...

...BUT I WOULD KIBITZ WITH THE CAST AND CREW MEMBERS WHO WEREN'T BUSY. SOMETIMES I'D EAT LUNCH WITH THEM.

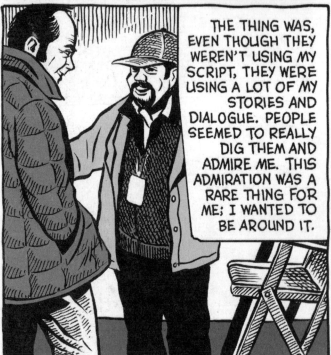

THE THING WAS, EVEN THOUGH THEY WEREN'T USING MY SCRIPT, THEY WERE USING A LOT OF MY STORIES AND DIALOGUE. PEOPLE SEEMED TO REALLY DIG THEM AND ADMIRE ME. THIS ADMIRATION WAS A RARE THING FOR ME; I WANTED TO BE AROUND IT.

FINALLY IN DECEMBER 2001, THE SHOOTING FOR THE *AMERICAN SPLENDOR* MOVIE WAS COMPLETED. THEN I *REALLY* HIT ROCK BOTTOM. I HAD NOWHERE TO GO IN THE MORNING, MY LIFE HAD NO SHAPE OR DIRECTION. I GOT WAY MORE DEPRESSED...I HAD TO BE HOSPITALIZED FOR "MAJOR DEPRESSION."

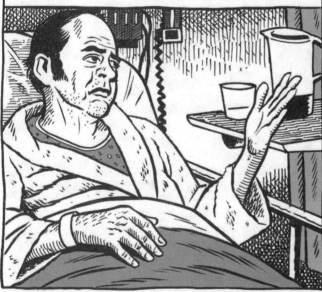

WHILE I WAS IN THE HOSPITAL I NOTICED I HAD A LUMP IN MY RIGHT GROIN, SIMILAR TO THE ONE IN MY LEFT GROIN IN 1990, WHICH TURNED OUT TO BE LYMPHOMA.

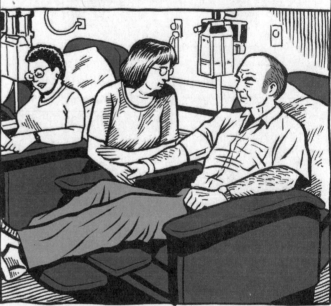

SO WHEN I GOT OUT OF THE HOSPITAL FOR DEPRESSION I STARTED CHEMO-THERAPY TREATMENTS FOR LYMPHOMA.

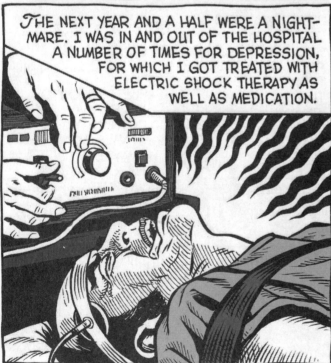

THE NEXT YEAR AND A HALF WERE A NIGHTMARE. I WAS IN AND OUT OF THE HOSPITAL A NUMBER OF TIMES FOR DEPRESSION, FOR WHICH I GOT TREATED WITH ELECTRIC SHOCK THERAPY AS WELL AS MEDICATION.

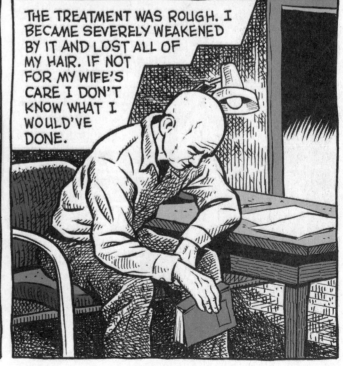

THE TREATMENT WAS ROUGH. I BECAME SEVERELY WEAKENED BY IT AND LOST ALL OF MY HAIR. IF NOT FOR MY WIFE'S CARE I DON'T KNOW WHAT I WOULD'VE DONE.

THINGS WERE MOVING RIGHT ALONG WITH THE POST PRODUCTION OF *AMERICAN SPLENDOR*, THOUGH. IN THE SUMMER OF 2002 MY FAMILY AND I WERE FLOWN TO NEW YORK TO SEE IT.

I DUG IT, BUT THE COMBINATION OF THE TREATMENT FOR CANCER AND DEPRESSION HAD REALLY DISORIENTED ME AND SOME OF THE FILM WAS CONFUSING TO ME.

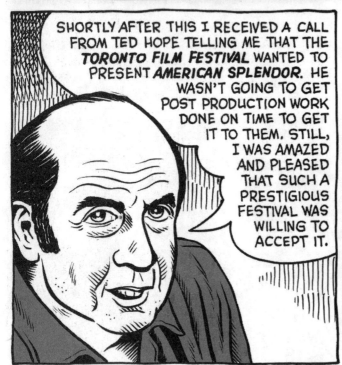

SHORTLY AFTER THIS I RECEIVED A *CALL* FROM TED HOPE TELLING ME THAT THE *TORONTO FILM FESTIVAL* WANTED TO PRESENT *AMERICAN SPLENDOR*. HE WASN'T GOING TO GET POST PRODUCTION WORK DONE ON TIME TO GET IT TO THEM. STILL, I WAS AMAZED AND PLEASED THAT SUCH A PRESTIGIOUS FESTIVAL WAS WILLING TO ACCEPT IT.

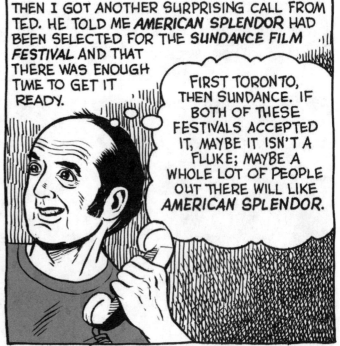

THEN I GOT ANOTHER SURPRISING CALL FROM TED. HE TOLD ME *AMERICAN SPLENDOR* HAD BEEN SELECTED FOR THE *SUNDANCE FILM FESTIVAL* AND THAT THERE WAS ENOUGH TIME TO GET IT READY.

FIRST TORONTO, THEN SUNDANCE. IF BOTH OF THESE FESTIVALS ACCEPTED IT, MAYBE IT ISN'T A FLUKE; MAYBE A WHOLE LOT OF PEOPLE OUT THERE WILL LIKE *AMERICAN SPLENDOR*.

WHAT BLEW MY MIND WAS THAT MY COMIC BOOKS HAD BEEN SELLING SO POORLY FOR SO LONG THAT, ASIDE FROM EXCELLENT REVIEWS, WHICH I STILL GOT, I EXPECTED NO RETURN FROM THEM. AND HERE THIS MOVIE, WHICH WAS BASED ON MY COMICS STORIES, HAD BEEN ACCEPTED BY TWO OF THE MOST PRESTIGIOUS FILM FESTIVALS IN THE WORLD.

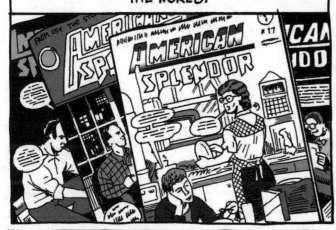

AH WELL, MAYBE IT DIDN'T MEAN SO MUCH AFTER ALL. THE PEOPLE WHO DID THE SELECTING FOR THE MOVIES WERE PROBABLY ALSO CRITICS. MY STUFF HAD ALWAYS BEEN WELL-RECEIVED BY THE CRITICS. IT WAS THE BROAD MASSES I HAD TO WORRY ABOUT.

MY WIFE, MY KID AND I GOT A FREE TRIP TO PARK CITY, UTAH HOME OF THE *SUNDANCE FILM FESTIVAL*, COURTESY OF HBO. THAT MIGHT BE THERAPUTIC. I WAS STILL VERY DEPRESSED AND AT SUNDANCE MAYBE I'D GET SOME *R-E-S-P-E-C-T.*

WE TOOK A JANUARY FLIGHT OUT TO UTAH. THE FELLOW NEXT TO ME POINTED OUT THAT IN THE AISLE NEXT TO OURS WAS *AL GORE.* I LOOKED AND SURE ENOUGH, IT *WAS* AL.

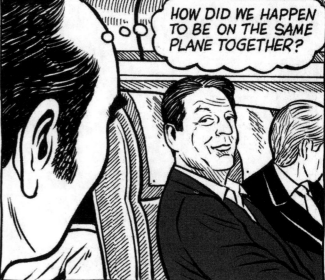

HOW DID WE HAPPEN TO BE ON THE SAME PLANE TOGETHER?

THE PLANE LANDED IN SALT LAKE CITY AND FROM THERE WE GOT A LIMO RIDE TO PARK CITY. PRETTY POSH. I WAS ENTERING A NEW WORLD TEMPORARILY.

WE WERE ASSIGNED A CONDO WITH A JACUZZI AND IT WAS STOCKED WITH SEVERAL DAYS WORTH OF FOOD. PLUS WE HAD OUR OWN WASHING MACHINE, IN CASE AN EMERGENCY AROSE.

THE NEXT NIGHT THEY SHOWED *AMERICAN SPLENDOR* FOR THE FIRST TIME. THERE WAS A FULL HOUSE, SOMETHING THAT GLADDENED MY HEART.

MASS SUPPORT— IT'S WONDERFUL.

GYPTIAN

SUNDANCE FILM FESTIVAL

I SAW AMERICAN SPLENDOR WITH A CLEAR HEAD THIS TIME AROUND, AND WAS VERY IMPRESSED WITH THE JOB TED AND BOB AND SHARI—THE WHOLE CAST AND CREW IN FACT—HAD DONE.

14

MEANWHILE...

THE MOVIE WAS NOT ONLY DONE VERY WELL ON A TECHNICAL LEVEL, I REALIZED THAT IT WAS INNOVATIVE. BOB AND SHARI MIXED DIFFERENT FORMS—DOCUMENTARY, NARRATIVE FICTION, ANNIMATION AND STILL PHOTOS OF CARTOONS.

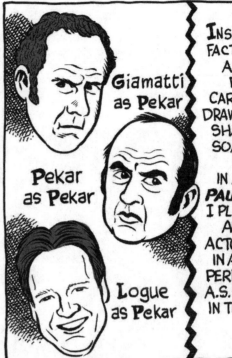

Giamatti as Pekar

Pekar as Pekar

Logue as Pekar

INSPIRED BY THE FACT THAT I USED A BUNCH OF DIFFERENT CARTOONISTS TO DRAW ME, BOB AND SHARI ALSO DID SOME MULTIPLE CASTING. IN ADDITION TO **PAUL GIAMATTI** I PLAYED MYSELF AND A THIRD ACTOR PLAYED ME IN A THEATRICAL PERFORMANCE OF A.S. WITH GIAMATTI IN THE AUDIENCE.

JOYCE WAS PLAYED BY HOPE DAVIS AND HERSELF...

...AND THERE WERE OTHER EXAMPLES OF MULTIPLE CASTING, WHICH ALLOWED VIEWERS THE OPPORTUNITY TO ASSESS THE CHARACTERS FROM MORE THAN ONE STANDPOINT.

PEOPLE WERE STOPPING ME IN THE STREET TO TELL ME HOW MUCH THEY LIKED IT, INCLUDING SOME CRITICS AND MOVIE PROFESSIONALS.

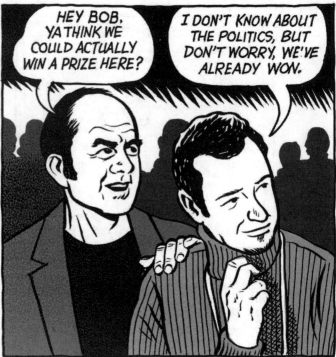

HEY BOB, YA THINK WE COULD ACTUALLY WIN A PRIZE HERE?

I DON'T KNOW ABOUT THE POLITICS, BUT DON'T WORRY, WE'VE ALREADY WON.

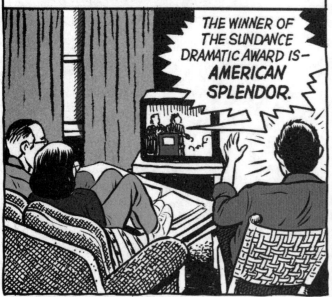

WE LEFT BEFORE THE PRIZES WERE GIVEN OUT, BUT I DID WATCH THEM ON TV WHEN WE GOT BACK TO CLEVELAND AND...

THE WINNER OF THE SUNDANCE DRAMATIC AWARD IS— AMERICAN SPLENDOR.

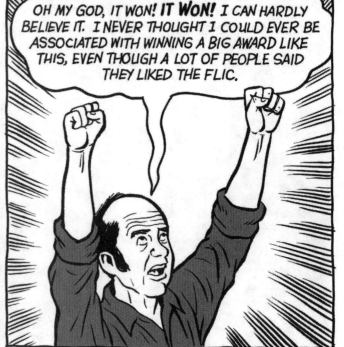

OH MY GOD, IT WON! **IT WON!** I CAN HARDLY BELIEVE IT. I NEVER THOUGHT I COULD EVER BE ASSOCIATED WITH WINNING A BIG AWARD LIKE THIS, EVEN THOUGH A LOT OF PEOPLE SAID THEY LIKED THE FLIC.

MAN, THAT SUNDANCE AWARD WAS ONE OF THE NICEST THINGS THAT EVER HAPPENED TO ME. I HAD LOST FAITH IN PEOPLE'S WILLINGNESS TO GIVE SUBSTANTIAL SUPPORT TO ANYTHING I DID.

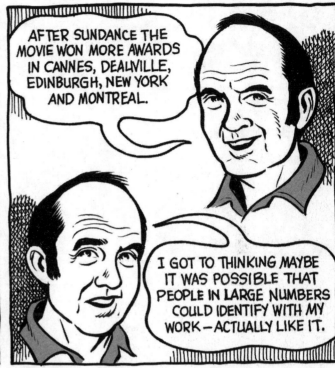

AFTER SUNDANCE THE MOVIE WON MORE AWARDS IN CANNES, DEAUVILLE, EDINBURGH, NEW YORK AND MONTREAL.

I GOT TO THINKING MAYBE IT WAS POSSIBLE THAT PEOPLE IN LARGE NUMBERS COULD IDENTIFY WITH MY WORK—ACTUALLY LIKE IT.

SO NOW IT'S DECEMBER, 2003 AND THE SEASON OF THE BIG PUBLICIZED MOVIE PRIZES IS ON US. CONSIDERING THAT NO ONE CONNECTED WITH *AMERICAN SPLENDOR* IS A **BIG** NAME, IT'S GOT A SHOT AT SOME AND HAS ACTUALLY BEEN NOMINATED FOR A FEW SO FAR, MADE SOME TOP TEN LISTS.

SO PEOPLE ASK ME, WHAT ADVICE DO I HAVE TO GIVE TO MOVIE MAKERS SO THEY TOO CAN GET AWARDS, AND HOW HAS THIS EXPERIENCE CHANGED MY LIFE.

The American Splendor Movie

Story by
Harvey Pekar

Art by
Mark Zingarelli

PART 9

MAN, MY LIFE IS ON HOLD RIGHT NOW. I'VE PICKED UP SOME EXTRA GIGS BECAUSE OF THE MOVIE'S SUCCESS, BUT WHAT HAPPENS WHEN THAT'S OVER?

LIKE I SAID, I'M NOT A MOVIE MAKER, I'M A COMICS MAKER. UNLESS SOMEONE ELSE CONTACTS ME TO DO MORE MOVIES BASED ON MY WORK, THAT STUFF IS OVER.

I GUESS THE MOVIE HAD A POSITIVE EFFECT ON SALES OF MY COMICS BECAUSE NOW MY PUBLISHER IS OFFERING ME A LOT MORE BREAD TO DO COMICS FOR HIM. I'M ALSO GETTING GIGS WRITING PROSE ARTICLES— BOOK REVIEWS, RECORD REVIEWS, POLITICAL PIECES.

BUT I'M SO TENSE—HOW LONG WILL THIS LAST? WILL I FINALLY BE ABLE TO MAKE SOME DECENT MONEY ON COMICS TO SUPPLEMENT MY PENSION INCOME?

The American Splendor Movie

Story by
Harvey Pekar
Art by
Mark Zingarelli

PART 10

I GOTTA TAKE CARE OF MY WIFE AND KID, I CAN'T REALLY RETIRE. I'VE GOT TO DO FREELANCE WRITING FROM HERE ON IN.

THE QUESTION IS, WILL THE JOBS KEEP COMING AND, IF SO, WILL I BE ABLE TO GET THEM FAIRLY EASILY OR HAVE TO BEG FOR THEM?

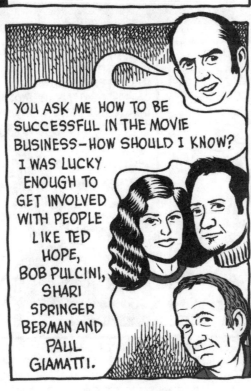

YOU ASK ME HOW TO BE SUCCESSFUL IN THE MOVIE BUSINESS—HOW SHOULD I KNOW? I WAS LUCKY ENOUGH TO GET INVOLVED WITH PEOPLE LIKE TED HOPE, BOB PULCINI, SHARI SPRINGER BERMAN AND PAUL GIAMATTI.

I ONLY HOPE YOU'RE SO LUCKY.

HOLLYWOOD REPORTER

STORY BY HARVEY PEKAR · ART BY JOSH'2K · Copyright ©2000 by Harvey Pekar

HI! YOUR HOLLYWOOD REPORTER HERE. TODAY--AN INTERVIEW WITH INDEPENDENT FILM LEADING MAN **TOBY RADLOFF,** WHO'S JUST WRAPPED UP ANOTHER **SOCKO** FLICK, **TOWNIES.**

BUT FIRST, A BRIEF REVIEW OF RADLOFF'S **METEORIC** RISE: IT ALL STARTED IN 1987 WHEN TOBE WAS WORKING WITH BIG **HARV PEKAR** AT CLEVELAND'S V.A. HOSPITAL, WHERE BOTH WERE (AND STILL ARE) FILE CLERKS.

BIG HARV WANTED EVERYBODY IN ON THE ACT, SO HE ASKED PRODUCER/DIRECTOR **STUART COHN** TO INTERVIEW HIS FELLOW EMPLOYEES. NOT SURPRISINGLY, COHN WAS IMMEDIATELY TAKEN WITH TOBY.

WHERE'D YOU GET THAT **HAIRCUT?**

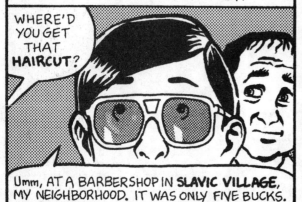

Umm, AT A BARBERSHOP IN **SLAVIC VILLAGE,** MY NEIGHBORHOOD. IT WAS ONLY FIVE BUCKS.

COHN QUICKLY FORGOT ABOUT PEKAR AND CONCENTRATED ON THE MORE **COLORFUL** RADLOFF. TOBY MADE A DOZEN APPEARANCES ON **MTV**--MANY **MEMORABLE,** LIKE THE ONE DURING WHICH HE DOWNED **TEN** HAMBURGERS.

SAY NO TO DRUGS, SAY **YES** TO **WHITE CASTLE!**

IN 1988, DURING A COMIC BOOK CONVENTION HELD IN CLEVELAND TO HONOR THE 50th ANNIVERSARY OF SUPERMAN, TOBY HOOKED UP WITH PRODUCERS **WAYNE HAROLD** AND **MARK BOSKO,** THEN SHOOTING COMMERCIALS FOR A LOCAL CABLE STATION.

THEY REALIZED HE HAD **HOT** STAR POTENTIAL AND SHOWCASED HIM IN TWO OF THEIR PRODUCTIONS, **KILLER NERD** AND **BRIDE OF KILLER NERD.**

TOBY WAS THEN IN HIS **NERD** PHASE, WHICH HE'S SINCE OUTGROWN.

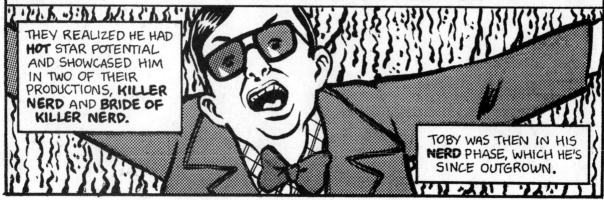

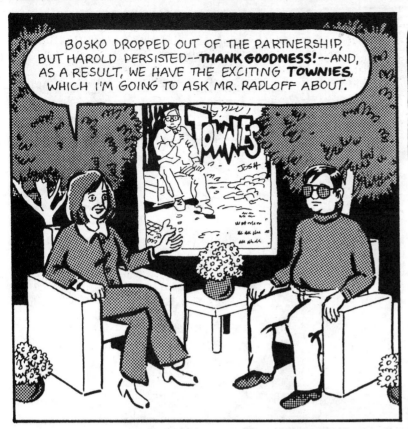

BOSKO DROPPED OUT OF THE PARTNERSHIP, BUT HAROLD PERSISTED--**THANK GOODNESS!**--AND, AS A RESULT, WE HAVE THE EXCITING **TOWNIES**, WHICH I'M GOING TO ASK MR. RADLOFF ABOUT.

THANKS. FIRST I WANNA TELL YOU THAT ALTHOUGH I'LL BE FORTY-TWO IN DECEMBER, I COULD PASS FOR **TWENTY-NINE**. THE REASON I KNOW IS B'CAUSE I WAS AT A HIGH SCHOOL REUNION AND A LOTTA THE PEOPLE THERE WERE BALDING OR HAD GRAY HAIR. PLUS, I DON'T HAVE WRINKLES LIKE THEM.

"I GOTTA LOSE SOME WEIGHT, THOUGH. THE REASON I'M SO HEAVY HAS TO DO WITH THE FACT THAT I HAVE A TENDENCY TO EAT UNTIL MY STOMACH FILLS UP. PLUS, I'VE BEEN **PIGGIN' OUT** LATELY, LIKE AT THE STATE FAIR LAST WEEKEND."

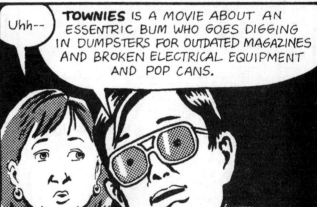

Uhh--

TOWNIES IS A MOVIE ABOUT AN ESSENTRIC BUM WHO GOES DIGGING IN DUMPSTERS FOR OUTDATED MAGAZINES AND BROKEN ELECTRICAL EQUIPMENT AND POP CANS.

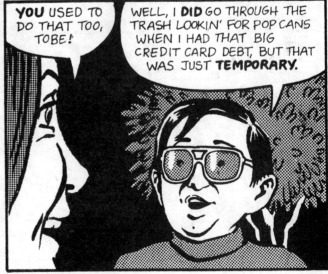

YOU USED TO DO THAT TOO, TOBE!

WELL, I **DID** GO THROUGH THE TRASH LOOKIN' FOR POP CANS WHEN I HAD THAT BIG CREDIT CARD DEBT, BUT THAT WAS JUST **TEMPORARY**.

"SO, ANYWAY, THIS GUY FINDS A DEAD WOMAN IN THE DUMPSTER AND TAKES HER HOME WITH HIM.

"THEY HAVE SEX, BUT IT'S **TASTEFULLY** DONE."

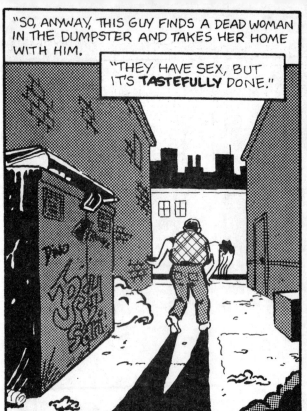

WHERE'S THE FILM SET, TOBE?

IT TAKES PLACE IN THE SMALL OHIO TOWN OF **SCHLARB**.

THAT'S A **FICTIONAL** NAME.

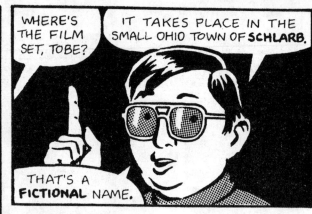

IN ADDITION TO YOUR CHARACTER, WHO ELSE IS PORTRAYED IN THE FILM?

"A LOT OF **CRAZIES** AND WEIRDOS ARE WALKING THE STREETS DOING VARIOUS CRAZY STUFF. ONE PERSON PICKS BUBBLE GUM AND POPSICLE STICKS OFF THE STREET AND **LICKS** 'EM.

"ANOTHER IS ALWAYS WALKING THE STREETS WITH A **FISHING ROD** IN HIS HAND. HE FISHES FOR THINGS ON THE GRASS."

SOUNDS LIKE A **GREAT** FLICK, TOBY. ANY PLANS FOR THE FUTURE?

YEAH, MY NEXT MOVIE WILL BE CALLED **FANBOY**. IT'LL BE ABOUT A **CRAZED** COMIC BOOK FAN WHO FOLLOWS THIS **COMIC WRITER** AROUND.

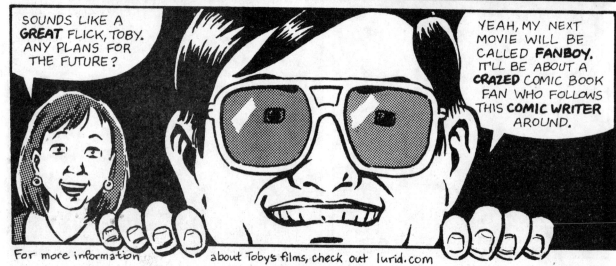

For more information about Toby's films, check out lurid.com

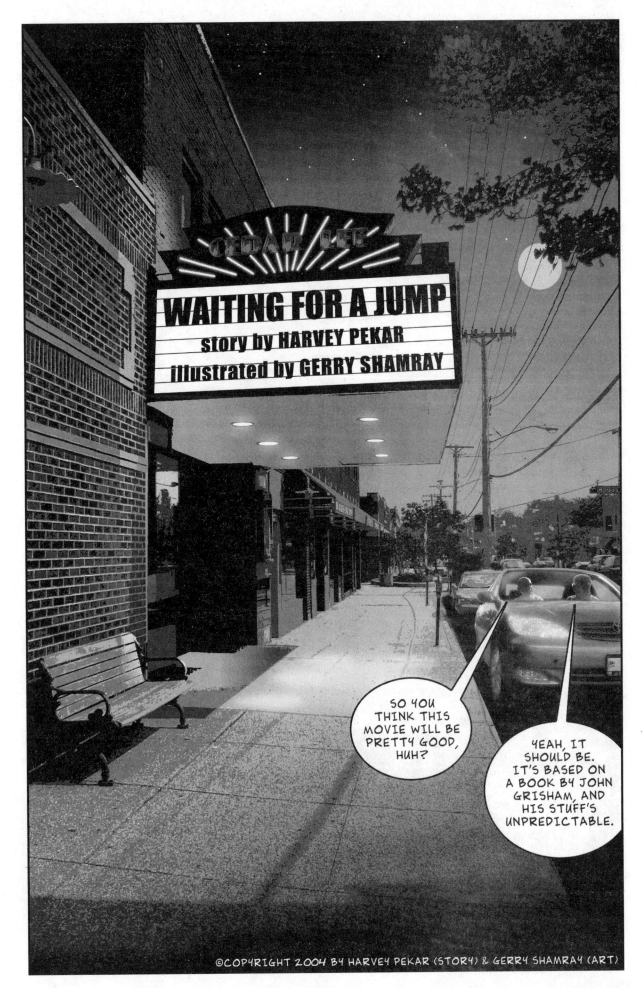

WELL, IT'S GOTTA GOOD CAST — GENE HACKMAN, DUSTIN HOFFMAN, JOHN CUSACK.

TWO SENIORS, PLEASE.

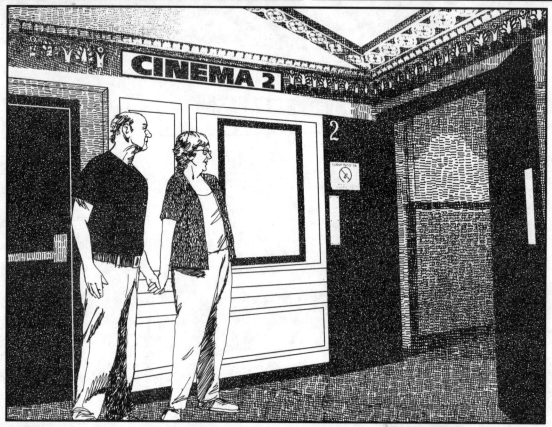

MAN, WATCHIN' ALL THESE PREVIEWS IS A NUISANCE. WONDER HOW MUCH TIME IT WASTES? MAYBE A HALF HOUR.

BE PATIENT, WILL YOU?

A HALF HOUR LATER.

THIS AIN'T BAD. IT'S A TYPICAL HOLLYWOOD FLIC BUT IT'S WELL MADE, THE DIALOG'S SHARP.

YEAH, THAT WAS ONE OF THE BETTER HOLLYWOOD FORMULA MOVIES I'VE SEEN. YOU'RE RIGHT, IT WAS UNPREDICTABLE. COURSE IT WAS PREDICTABLY UNPREDICTABLE.

FILM'S OVER.

WHAT'S THE MATTER? WON'T IT TURN OVER?

BATTERY'S DEAD. I THINK WHEN I THOUGHT I WAS TURNING THE LIGHTS OFF I TURNED 'EM ON.

CLIK, CLIK.

WE'LL HAVE TO CALL TRIPLE A FOR A JUMP START.

WE DON'T BELONG TO TRIPLE A.

YEAH, BUT I THINK THEY'LL SEND SOMEONE OVER IF WE PAY CASH. I'VE GOT THE CELL PHONE. DO YOU HAVE AT LEAST FIFTY DOLLARS ON YOU?

YEAH, I GOT PLENTY A' CASH ON ME TADAY.

A COUPLE OF MINUTES LATER.

I TALKED HER INTO IT. THEY'LL BE HERE WITHIN AN HOUR.

WHERE DID SHE SAY THEY'D MEET US?

IN FRONT OF THE THEATRE...

HEY, I'M PRETTY SURE WE'RE INSURED FOR THE FORTY BUCKS.

LOOK, I'M GOING TO WAIT IN THE LOBBY. IT'S COLD OUT HERE. I CAN SEE WHAT'S HAPPENING FROM THERE.

O.K. I'M NOT COLD SO I'LL JUST WAIT IN FRONT HERE. I WANNA MAKE SURE I DON'T MISS THE GUY.

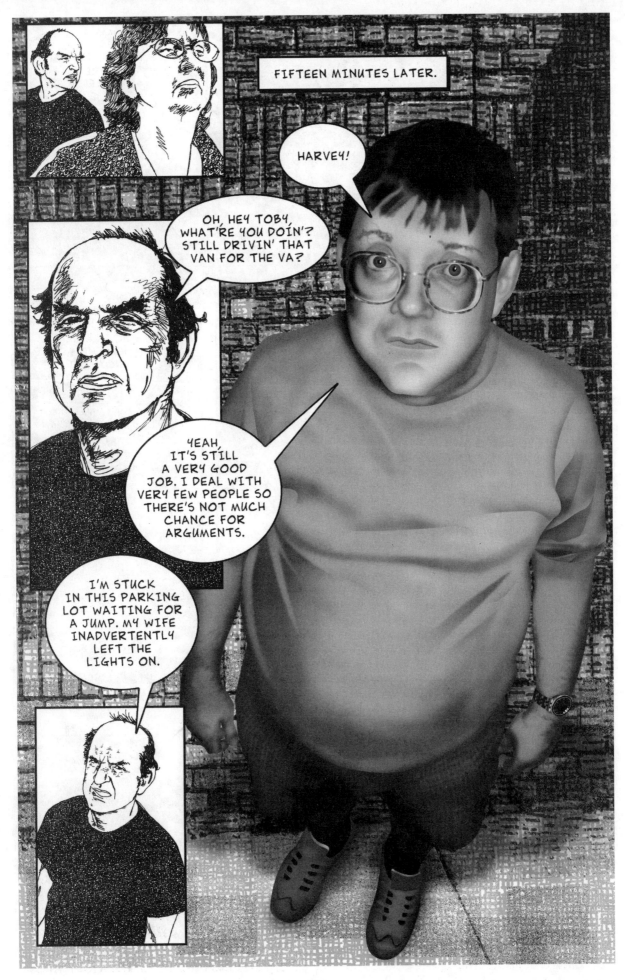

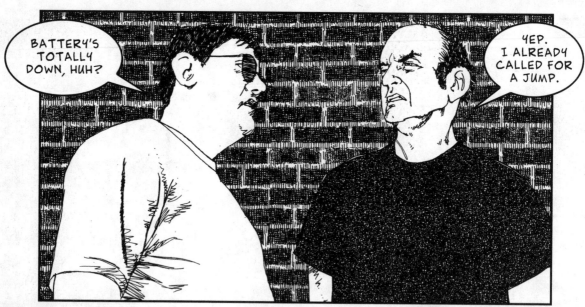

28

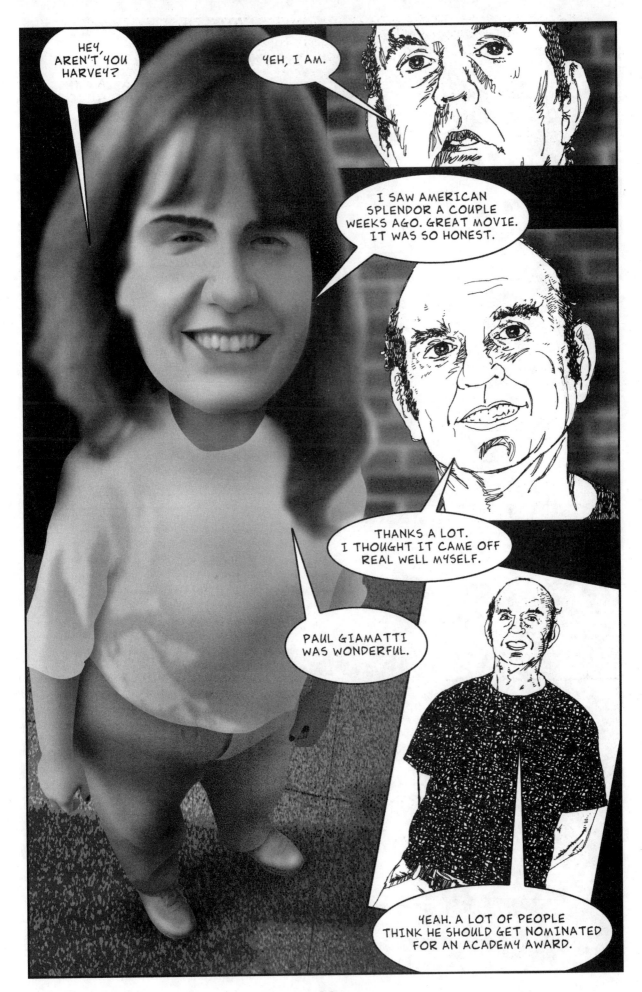

29

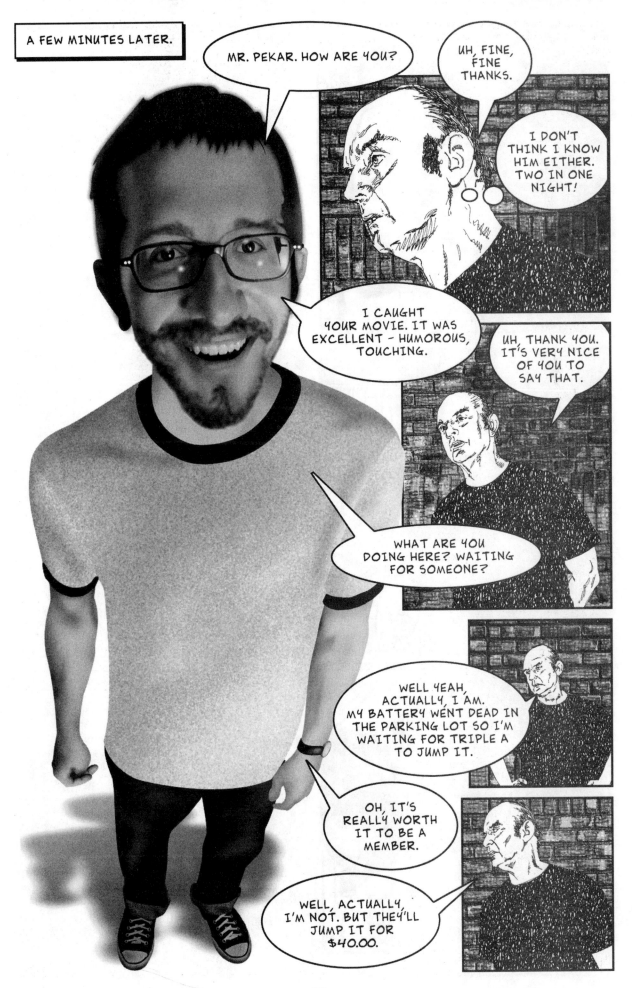

31

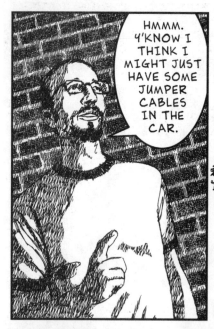

HMMM. Y'KNOW I THINK I MIGHT JUST HAVE SOME JUMPER CABLES IN THE CAR.

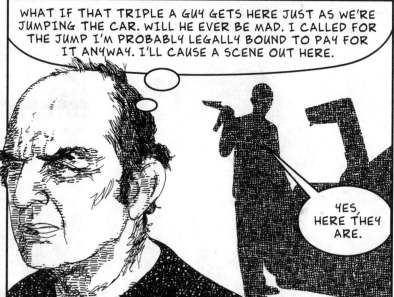

WHAT IF THAT TRIPLE A GUY GETS HERE JUST AS WE'RE JUMPING THE CAR. WILL HE EVER BE MAD. I CALLED FOR THE JUMP I'M PROBABLY LEGALLY BOUND TO PAY FOR IT ANYWAY. I'LL CAUSE A SCENE OUT HERE.

YES, HERE THEY ARE.

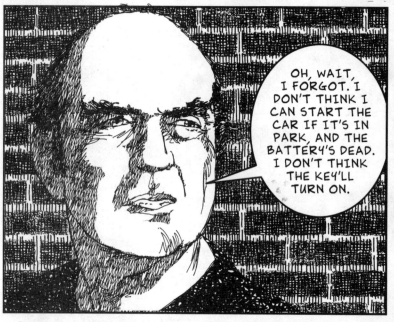

OH, WAIT, I FORGOT. I DON'T THINK I CAN START THE CAR IF IT'S IN PARK, AND THE BATTERY'S DEAD. I DON'T THINK THE KEY'LL TURN ON.

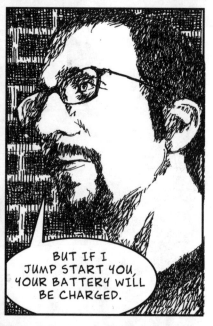

BUT IF I JUMP START YOU, YOUR BATTERY WILL BE CHARGED.

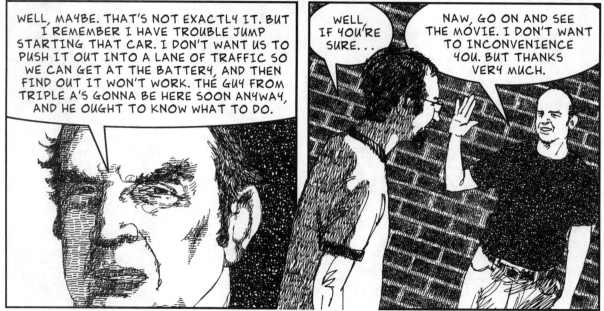

WELL, MAYBE. THAT'S NOT EXACTLY IT. BUT I REMEMBER I HAVE TROUBLE JUMP STARTING THAT CAR. I DON'T WANT US TO PUSH IT OUT INTO A LANE OF TRAFFIC SO WE CAN GET AT THE BATTERY, AND THEN FIND OUT IT WON'T WORK. THE GUY FROM TRIPLE A'S GONNA BE HERE SOON ANYWAY, AND HE OUGHT TO KNOW WHAT TO DO.

WELL, IF YOU'RE SURE...

NAW, GO ON AND SEE THE MOVIE. I DON'T WANT TO INCONVENIENCE YOU. BUT THANKS VERY MUCH.

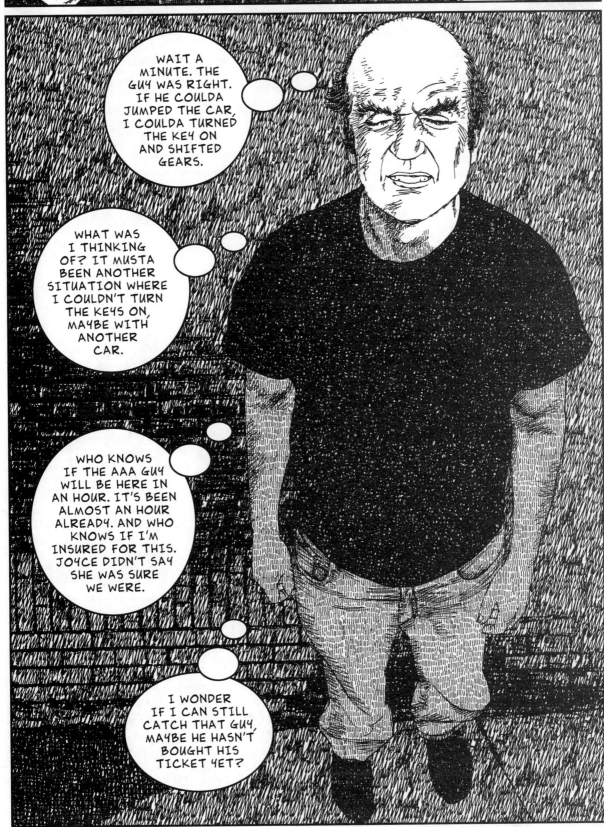

IN LOBBY

HE'S NOT HERE.

LEMME THINK THIS OUT. WHY DID I TELL THE GUY HE WOULDN'T BE ABLE TO GET THE CAR GOING? HE MUSTA KNOWN I DIDN'T KNOW WHAT I WAS TALKING ABOUT. AND WHY DID HE WALK AWAY SO FAST IF HE KNEW I WAS WRONG? MAYBE HE DIDN'T REALLY KNOW I WAS WRONG. MAYBE HE WAS AS UNMECHANICAL AS I AM. OR MAYBE HE THOUGHT I WAS NUTS, CHANGING MY MIND IN A SPLIT SECOND LIKE THAT AND WANTED TO GET AWAY FROM ME; THAT'S A DISTINCT POSSIBILITY. OR MAYBE BOTH. I DON'T BLAME HIM FOR TAKIN' OFF.

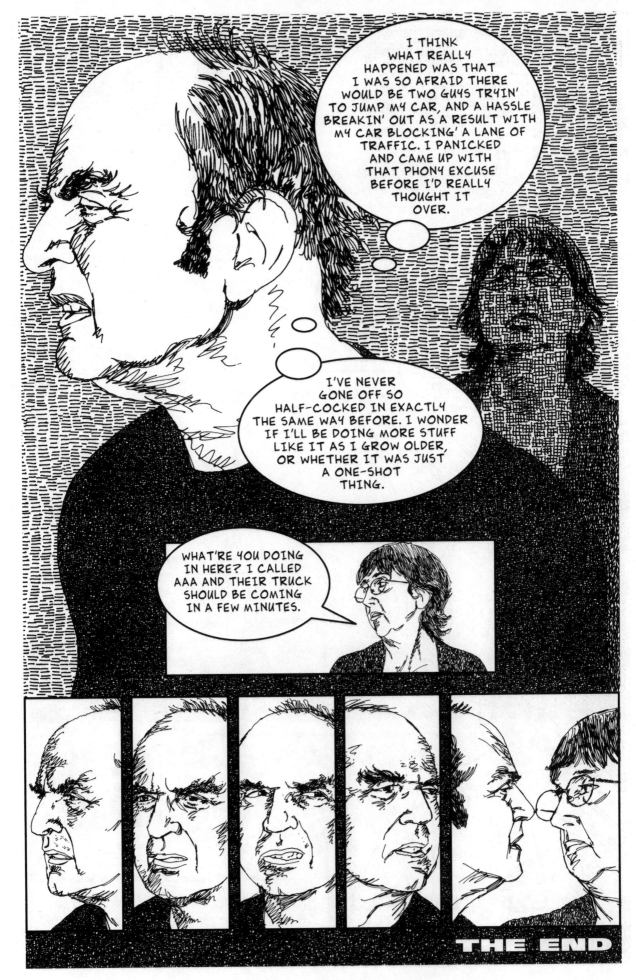

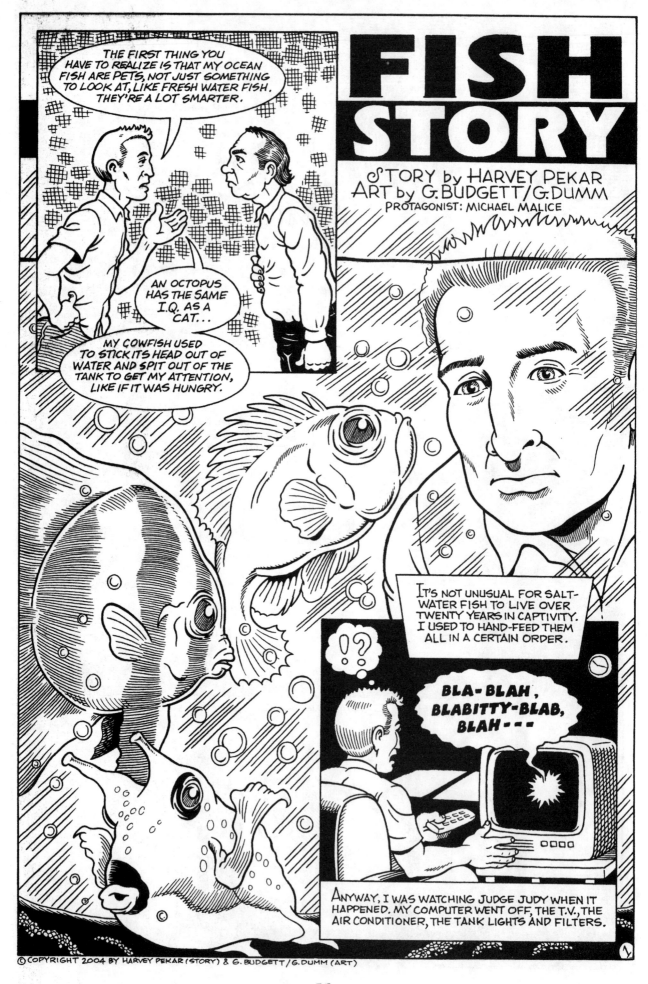

I DID TECH SUPPORT FOR COMPUTERS FOR A LIVING, SO I AM USED TO TROUBLESHOOTING. I OPENED THE CIRCUIT BOARD AND FLIPPED ALL THE CIRCUITS BACK AND FORTH. NOTHING. THAT GOT ME A LITTLE WORRIED BECAUSE THERE WAS A CHANCE THE FILTRATION IN MY TANK WOULD GET SCREWED UP.

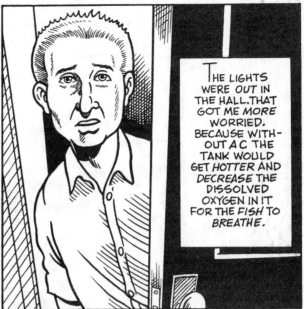

THE LIGHTS WERE OUT IN THE HALL. THAT GOT ME MORE WORRIED. BECAUSE WITHOUT A C THE TANK WOULD GET HOTTER AND DECREASE THE DISSOLVED OXYGEN IN IT FOR THE FISH TO BREATHE.

I WENT OUT ON THE STREET. SOME GUY WAS SAYING THAT HE'D LOST POWER. THIS IS WHEN I REALIZED WHAT A BIG DEAL THIS WOULD BE.

I GOT MY CAMERA AND WENT OUTSIDE. I TOOK PICTURES OF PEOPLE STOCKING UP ON BATTERIES. I WENT OVER TO THE PET STORE TO GET A BATTERY-POWERED PUMP FOR MY TANK, BUT THEY WOULDN'T LET ME IN.

PETLAND DISCOUNTS

TROPICAL FISH

PARAKEETS RABBITS

THEN I HEARD AN OLD LADY SAY THE BLACKOUT WAS ALL THE WAY UP TO CANADA. I KNEW THEN THAT I WOULD BE OUT OF POWER FOR A VERY LONG TIME AND THAT MY ANIMALS WERE PROBABLY DOOMED.

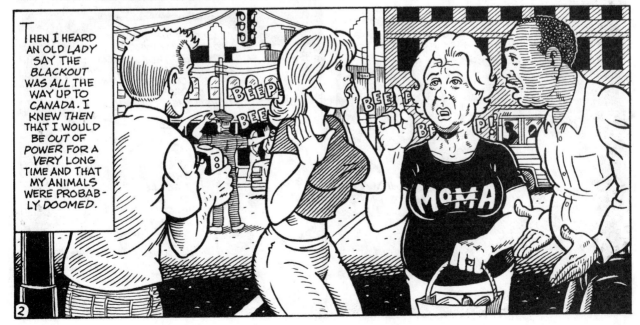

I FOLLOWED THE ELEVATED TRAIN TRACKS 'TIL I SAW A STOPPED TRAIN HALFWAY *BETWEEN* STOPS. IT WAS *EERIE* TO SEE. I *DIDN'T* WANT TO BE IN MY HOUSE WITH MY FISH *DYING*.

I HEARD SOME GUY *LISTENING* TO THE *RADIO* AND TALKING TO HIS FRIEND ABOUT HOW *GREAT* IT WAS THAT PEOPLE WERE STICKING *TOGETHER* THROUGH THIS. I COULDN'T CARE *LESS* IF HE *DIED* AS LONG AS MY *FISH* WERE GOING TO BE OKAY.

I CAME BACK AND THANK-FULLY IT WAS *DARK*. THAT MADE IT *COOLER* AND WOULD MAKE THE FISH *SLEEP*.

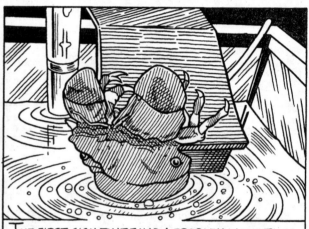

THE *FIRST* SIGN THAT I HAD A *PROBLEM* IN THE TANK WAS THE *LOBSTER* TRYING TO *ESCAPE*. SHE CLIMBED UP THE FILTER BOX AND WAS *HOLDING* IT WITH HER TWO BACK LEGS. HER OTHER EIGHT LEGS WERE BREAKING THE SURFACE WRITHING FOR PURCHASE.

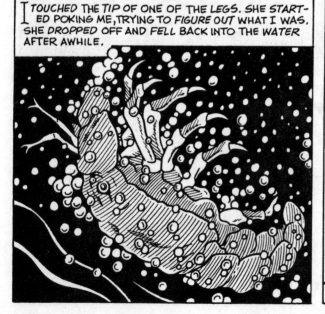

I TOUCHED THE *TIP* OF ONE OF THE LEGS. SHE START-ED POKING ME, TRYING TO *FIGURE OUT* WHAT I WAS. SHE *DROPPED* OFF AND *FELL* BACK INTO THE WATER AFTER AWHILE.

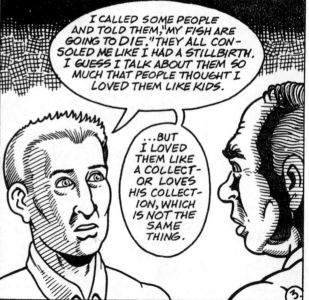

I CALLED SOME PEOPLE AND TOLD THEM, "MY FISH ARE GOING TO DIE." THEY ALL CON-SOLED ME LIKE I HAD A STILLBIRTH. I GUESS I TALK ABOUT THEM SO MUCH THAT PEOPLE THOUGHT I LOVED THEM LIKE KIDS.

...BUT I LOVED THEM LIKE A COLLECT-OR LOVES HIS COLLECT-ION, WHICH IS NOT THE SAME THING.

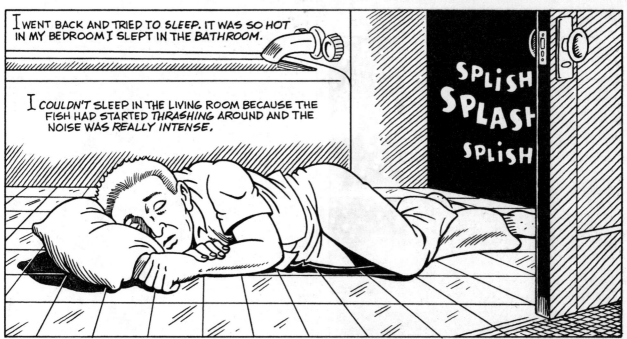

I WENT BACK AND TRIED TO SLEEP. IT WAS SO HOT IN MY BEDROOM I SLEPT IN THE BATHROOM.

I COULDN'T SLEEP IN THE LIVING ROOM BECAUSE THE FISH HAD STARTED *THRASHING* AROUND AND THE NOISE WAS *REALLY INTENSE.*

SPLISH
SPLASH
SPLISH

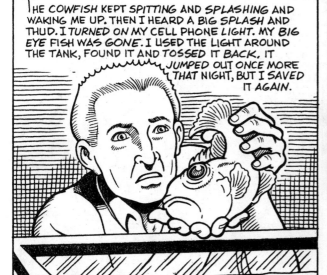

THE COWFISH KEPT *SPITTING* AND *SPLASHING* AND WAKING ME UP. THEN I HEARD A BIG *SPLASH* AND *THUD.* I *TURNED* ON MY CELL PHONE *LIGHT.* MY *BIG EYE* FISH WAS GONE. I USED THE LIGHT AROUND THE TANK, FOUND IT AND TOSSED IT *BACK.* IT JUMPED OUT ONCE MORE THAT NIGHT, BUT I *SAVED* IT AGAIN.

I WOKE AT *DAWN* AND WENT OUTSIDE. IT WAS A *GHOSTTOWN.* I WAITED FOR A LIGHT TO CHANGE, THEN IT *HIT* ME: *I WAS WAITING FOR A LIGHT TO CHANGE!* I STARTED *RUNNING* HOME. I COULD STILL SAVE THEM.

DON'T WALK

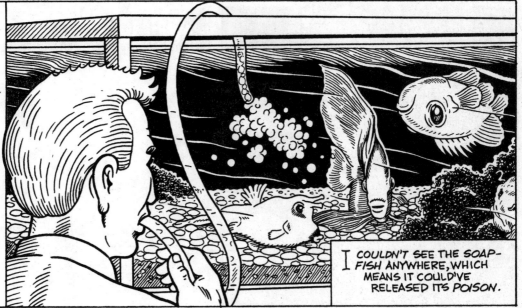

I KEPT BLOWING BUBBLES IN THE TANK. THAT *BREAKS UP* TENSION AND PERMITS OXYGEN EX-CHANGE. THEN I *LOOKED* IN THE TANK. THE FISH WERE SERIOUSLY MESSED UP. THE COWFISH WAS SITTING ON THE BOTTOM; THE BATFISH TOO. AND THE BIG EYE WAS UPSIDE-DOWN BUT STILL BREATHING.

I COULDN'T SEE THE SOAP-FISH ANYWHERE, WHICH MEANS IT COULD'VE RELEASED ITS *POISON.*

④

39

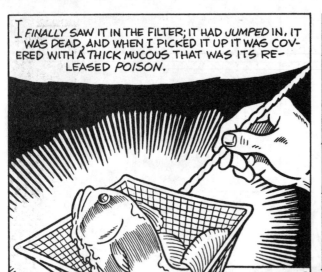

I FINALLY SAW IT IN THE FILTER; IT HAD JUMPED IN. IT WAS DEAD, AND WHEN I PICKED IT UP IT WAS COVERED WITH A THICK MUCOUS THAT WAS ITS RELEASED POISON.

THAT MEANT THEY WEREN'T JUST SUFFOCATING, BUT SUFFERING, INHALING WHAT I IMAGINED TO BE THE EQUIVALENT OF TEAR GAS. IF THE FILTERS WERE WORKING THERE MIGHT HAVE BEEN A CHANCE, BUT I HAD TO PUT THEM DOWN.

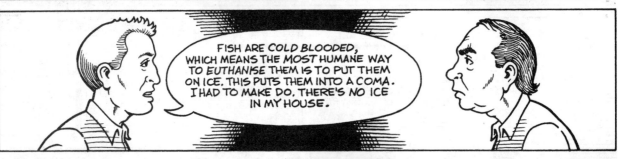

FISH ARE COLD BLOODED, WHICH MEANS THE MOST HUMANE WAY TO EUTHANISE THEM IS TO PUT THEM ON ICE. THIS PUTS THEM INTO A COMA. I HAD TO MAKE DO, THERE'S NO ICE IN MY HOUSE.

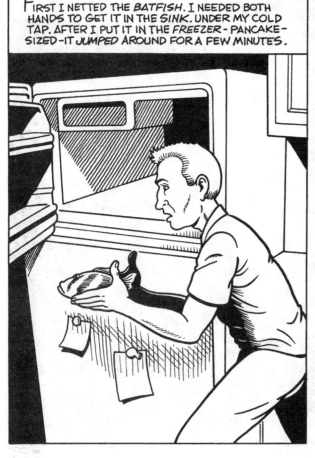

FIRST I NETTED THE BATFISH. I NEEDED BOTH HANDS TO GET IT IN THE SINK. UNDER MY COLD TAP. AFTER I PUT IT IN THE FREEZER - PANCAKE-SIZED - IT JUMPED AROUND FOR A FEW MINUTES.

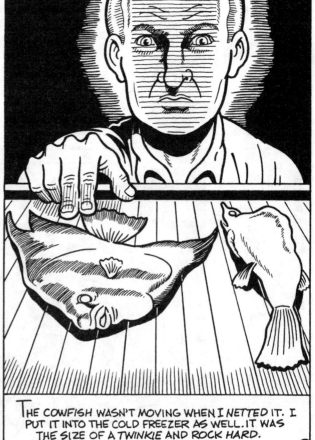

THE COWFISH WASN'T MOVING WHEN I NETTED IT. I PUT IT INTO THE COLD FREEZER AS WELL. IT WAS THE SIZE OF A TWINKIE AND ROCK HARD.

5

40

THE BIG EYE'S GILLS WERE ENORMOUS AS IT GASPED FOR AIR, COMPLETELY WITHOUT MOTOR CONTROL. IT WAS DOING SOMERSAULTS UNDERWATER. THE COLD WATER PUT IT INTO SHOCK AND IT WENT IN THE FREEZER WITH THE OTHERS.

I REMOVED THE SAND FILTER FROM THE TANK. IT'S A PILE OF SAND KEPT IN SUSPENSION BY A PUMP AND COLONIZED BY BACTERIA, WHICH BREAKS DOWN WASTE. BUT IF THE SAND SETTLES WHEN THE POWER GOES, THE BACTERIA SUFFOCATES. I REMOVED THE SAND FILTER FROM THE TANK LEST THE NOW DEAD BACTERIA BE INTRODUCED INTO THE TANK.

EVENTUALLY THE POWER CAME BACK, THE PUMPS FROTHED UP MY AQUARIUM'S SALT WATER. THE LOBSTER HUNKERED IN A CORNER. THE ANGLERFISH SAT ON A ROCK LIKE ALWAYS.

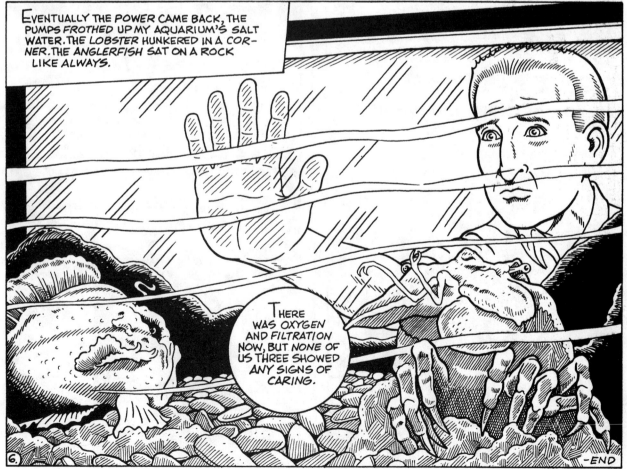

THERE WAS OXYGEN AND FILTRATION NOW, BUT NONE OF US THREE SHOWED ANY SIGNS OF CARING.

6.

—END

41

BLACKOUT

*It's Thursday, August 14. My wife, my kid and I have been in New York helping hype **American Splendor** which is supposed to open tomorrow afternoon and I'm in my hotel room. In a few days we take the promotion to England and Scotland.*

Story by Harvey Pekar
Art by Mark Zingarelli

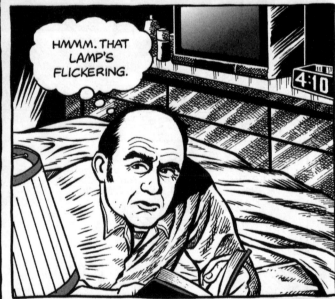

HMMM. THAT LAMP'S FLICKERING.

NOW THE CLOCK'S GOING OFF AND ON. I WONDER IF THERE'S AN ELECTRICITY PROBLEM HERE.

I CALL THE DESK.

IS THERE SOME KIND OF ELECTRICITY MALFUNCTION IN THE HOTEL?

NOT ONLY THE HOTEL, SIR, BUT ALL OVER NEW YORK AND IN THE MIDDLE WEST. IN CLEVELAND AND DETROIT, IN THE NORTHEAST AND IN CANADA. I'M AFRAID WE CAN'T DO ANYTHING ABOUT IT.

OH *NO*...WHAT'S GONNA HAPPEN? THREE OF THE FOUR CITIES THAT THE MOVIE'S SUPPOSED TO RUN IN HAVE BEEN BLACKED OUT. IF THEY CAN'T FIX THIS MESS SOON, ALL THESE PRIZES AND EXCELLENT REVIEWS WE'VE BEEN GETTING ARE GONNA GO DOWN THE DRAIN. PEOPLE WILL *FORGET!*

AND THE SUBWAYS AREN'T RUNNING. HOW ARE PEOPLE GONNA GET TO THE FLICKS?

JUST WHEN IT LOOKED LIKE THERE MIGHT BE A CHANCE TO AVOID POVERTY IN MY OLD AGE, *THIS* HADDA HAPPEN!

WHEN'M I EVER GONNA HAVE A CHANCE LIKE THIS AGAIN?

MAN, THIS HAS GOT TO BE THE BIGGEST ELECTRICITY BLACKOUT IN AMERICAN HISTORY. IT COULD TAKE DAYS TO FIX UP. ALL THE REVIEWS AND MONEY AND EFFORT THAT WENT INTO PROMOTING IT COULD BE WASTED!

R I N G

H'LO.

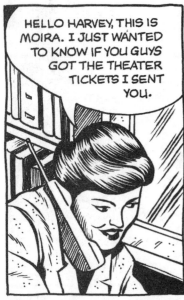

HELLO HARVEY, THIS IS MOIRA. I JUST WANTED TO KNOW IF YOU GUYS GOT THE THEATER TICKETS I SENT YOU.

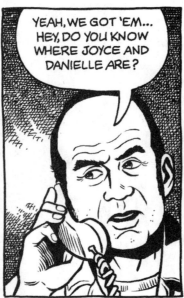

YEAH, WE GOT 'EM... HEY, DO YOU KNOW WHERE JOYCE AND DANIELLE ARE?

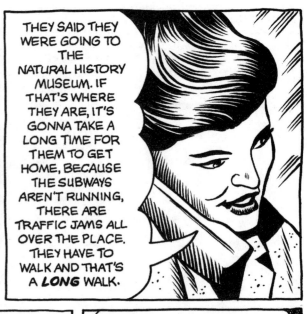

THEY SAID THEY WERE GOING TO THE NATURAL HISTORY MUSEUM. IF THAT'S WHERE THEY ARE, IT'S GONNA TAKE A LONG TIME FOR THEM TO GET HOME, BECAUSE THE SUBWAYS AREN'T RUNNING, THERE ARE TRAFFIC JAMS ALL OVER THE PLACE. THEY HAVE TO WALK AND THAT'S A *LONG* WALK.

YEAH, THANKS FOR TELLING ME. I'M KINDA WORRIED ABOUT THEM NOW THAT I KNOW WHAT KINDA CHAOS THE CITY IS IN, BUT I GUESS I'LL JUST HAVETA SIT TIGHT.

EXACTLY. JUST STAY IN YOUR ROOM. DON'T GO ON THE ELEVATORS, THEY MAY SHUT DOWN AT ANY TIME.

DAMMIT, THAT'S A LONG HIKE FROM THE NATURAL HISTORY MUSEUM, AND JOYCE HASN'T BEEN FEELING ALL THAT GOOD. I HOPE THEY'RE O.K..

AN HOUR LATER...

TAP
TAP-TAP
TAPPITY
TAP-TAP

STILL NOT BACK YET! I WISH SHE'D GET HERE. THE ELECTRICITY'S STILL OFF TOO.

AN HOUR AND A QUARTER LATER...

KNOCK! KNOCK!

DANIELLE, JOYCE!

HIYA. HOW YOU GUYS FEEL FROM THE WALKING?

WE'RE A LITTLE TIRED, BUT I WANTED TO WALK BECAUSE I DIDN'T WANT TO GET STUCK IN A BUS THAT WOULD GET CAUGHT IN A TRAFFIC JAM.

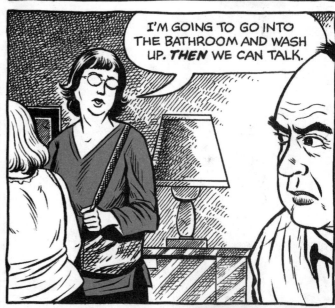

I'M GOING TO GO INTO THE BATHROOM AND WASH UP. *THEN* WE CAN TALK.

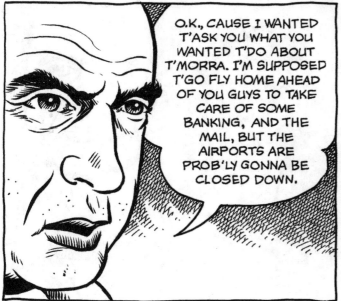

O.K., CAUSE I WANTED T'ASK YOU WHAT YOU WANTED T'DO ABOUT T'MORRA. I'M SUPPOSED T'GO FLY HOME AHEAD OF YOU GUYS TO TAKE CARE OF SOME BANKING, AND THE MAIL, BUT THE AIRPORTS ARE PROB'LY GONNA BE CLOSED DOWN.

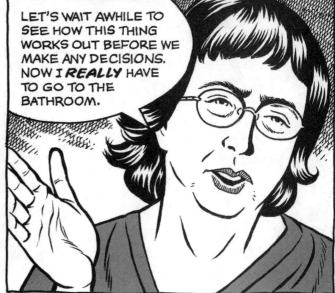

LET'S WAIT AWHILE TO SEE HOW THIS THING WORKS OUT BEFORE WE MAKE ANY DECISIONS. NOW I *REALLY* HAVE TO GO TO THE BATHROOM.

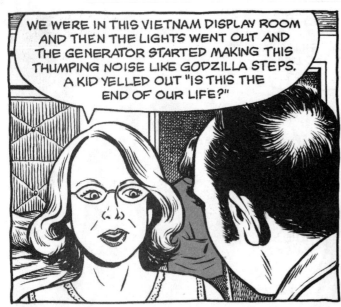

WE WERE IN THIS VIETNAM DISPLAY ROOM AND THEN THE LIGHTS WENT OUT AND THE GENERATOR STARTED MAKING THIS THUMPING NOISE LIKE GODZILLA STEPS. A KID YELLED OUT "IS THIS THE END OF OUR LIFE?"

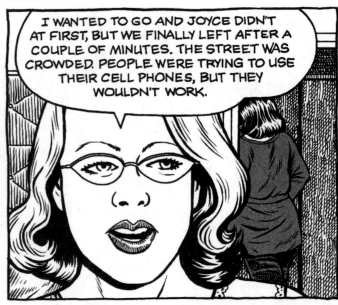

I WANTED TO GO AND JOYCE DIDN'T AT FIRST, BUT WE FINALLY LEFT AFTER A COUPLE OF MINUTES. THE STREET WAS CROWDED. PEOPLE WERE TRYING TO USE THEIR CELL PHONES, BUT THEY WOULDN'T WORK.

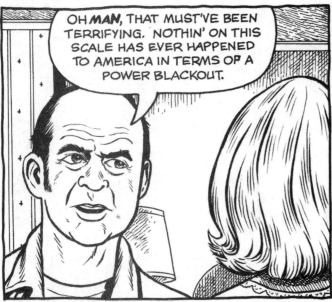

OH *MAN*, THAT MUST'VE BEEN TERRIFYING. NOTHIN' ON THIS SCALE HAS EVER HAPPENED TO AMERICA IN TERMS OF A POWER BLACKOUT.

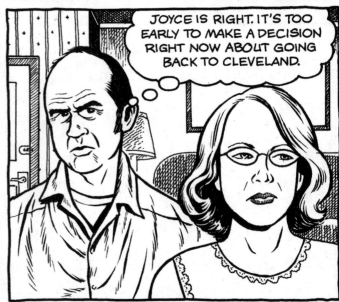

JOYCE IS RIGHT. IT'S TOO EARLY TO MAKE A DECISION RIGHT NOW ABOUT GOING BACK TO CLEVELAND.

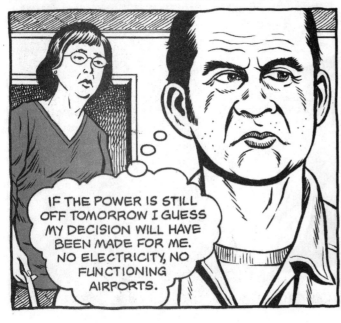

IF THE POWER IS STILL OFF TOMORROW I GUESS MY DECISION WILL HAVE BEEN MADE FOR ME. NO ELECTRICITY, NO FUNCTIONING AIRPORTS.

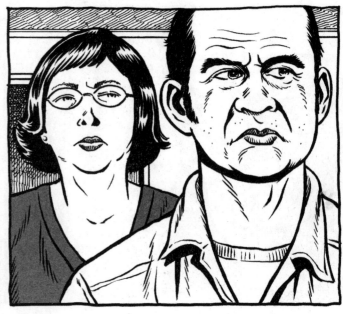

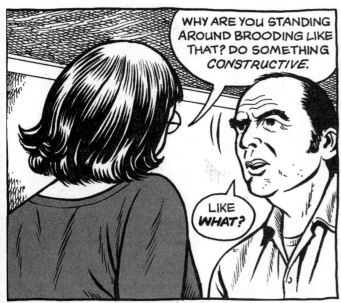

WHY ARE YOU STANDING AROUND BROODING LIKE THAT? DO SOMETHING *CONSTRUCTIVE.*

LIKE *WHAT?*

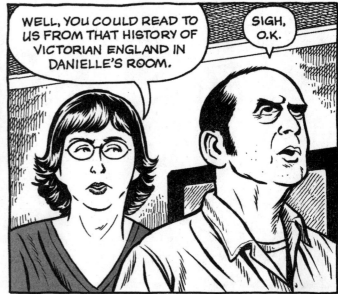

WELL, YOU COULD READ TO US FROM THAT HISTORY OF VICTORIAN ENGLAND IN DANIELLE'S ROOM.

SIGH, O.K.

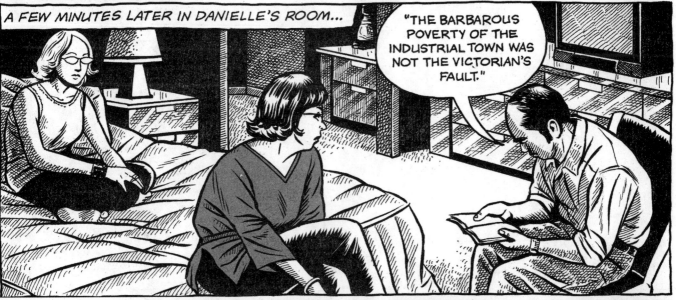

A FEW MINUTES LATER IN DANIELLE'S ROOM...

"THE BARBAROUS POVERTY OF THE INDUSTRIAL TOWN WAS NOT THE VICTORIAN'S FAULT."

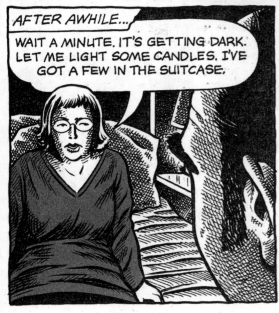

AFTER AWHILE...

WAIT A MINUTE. IT'S GETTING DARK. LET ME LIGHT SOME CANDLES. I'VE GOT A FEW IN THE SUITCASE.

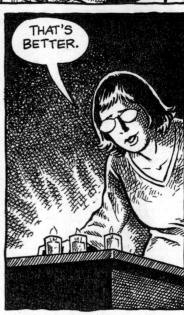

THAT'S BETTER.

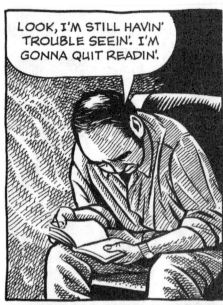

LOOK, I'M STILL HAVIN' TROUBLE SEEIN'. I'M GONNA QUIT READIN'.

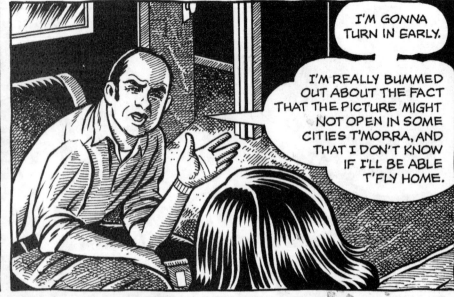

I'M GONNA TURN IN EARLY.

I'M REALLY BUMMED OUT ABOUT THE FACT THAT THE PICTURE MIGHT NOT OPEN IN SOME CITIES T'MORRA, AND THAT I DON'T KNOW IF I'LL BE ABLE T'FLY HOME.

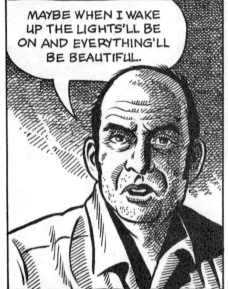

MAYBE WHEN I WAKE UP THE LIGHTS'LL BE ON AND EVERYTHING'LL BE BEAUTIFUL.

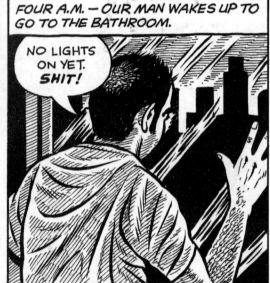

FOUR A.M. — OUR MAN WAKES UP TO GO TO THE BATHROOM.

NO LIGHTS ON YET. *SHIT!*

SEVEN A.M.

YAWN...WELL, I BETTER GET UP NOW.

IN THE BATHROOM...

STILL NO LIGHTS ON.

CLICK CLICK CLICK

WELL, LET'S SEE WHAT HAPPENS. MAYBE IF THEY CAN'T SHOW THE MOVIE FOR A DAY OR TWO IT WON'T BE THAT BAD.

48

WHAT? DO MY EYE'S DECEIVE ME?

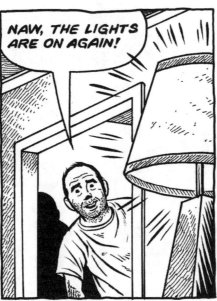

NAW, THE LIGHTS ARE ON AGAIN!

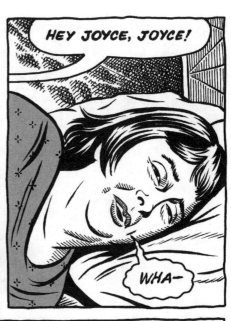

HEY JOYCE, JOYCE!

WHA—

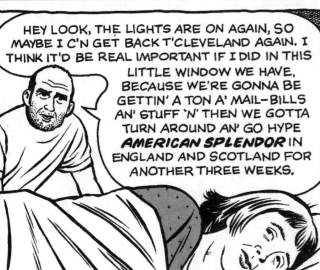

HEY LOOK, THE LIGHTS ARE ON AGAIN, SO MAYBE I C'N GET BACK T'CLEVELAND AGAIN. I THINK IT'D BE REAL IMPORTANT IF I DID IN THIS LITTLE WINDOW WE HAVE, BECAUSE WE'RE GONNA BE GETTIN' A TON A' MAIL—BILLS AN' STUFF 'N' THEN WE GOTTA TURN AROUND AN' GO HYPE *AMERICAN SPLENDOR* IN ENGLAND AND SCOTLAND FOR ANOTHER THREE WEEKS.

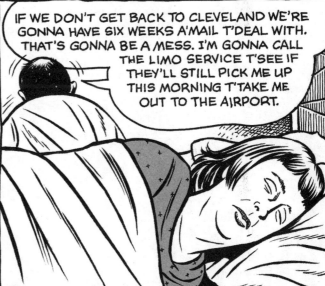

IF WE DON'T GET BACK TO CLEVELAND WE'RE GONNA HAVE SIX WEEKS A' MAIL T'DEAL WITH. THAT'S GONNA BE A MESS. I'M GONNA CALL THE LIMO SERVICE T'SEE IF THEY'LL STILL PICK ME UP THIS MORNING T'TAKE ME OUT TO THE AIRPORT.

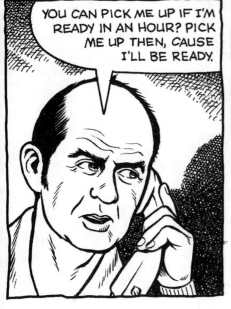

YOU CAN PICK ME UP IF I'M READY IN AN HOUR? PICK ME UP THEN, CAUSE I'LL BE READY.

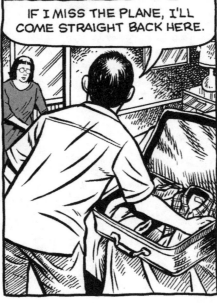

IF I MISS THE PLANE, I'LL COME STRAIGHT BACK HERE.

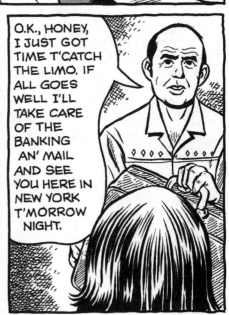

O.K., HONEY, I JUST GOT TIME T'CATCH THE LIMO. IF ALL GOES WELL I'LL TAKE CARE OF THE BANKING AN' MAIL AND SEE YOU HERE IN NEW YORK T'MORROW NIGHT.

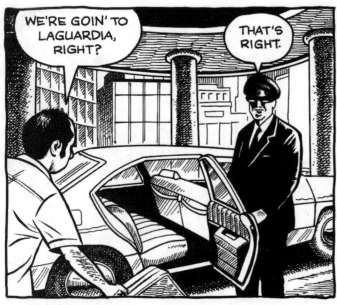

WE'RE GOIN' TO LAGUARDIA, RIGHT?

THAT'S RIGHT.

OH, MAN, I CAN GET OUT THERE IN TIME TO CATCH THE 10:45 PLANE. MAYBE I'LL BE IN CLEVELAND ON SCHEDULE.

BUT ONCE AT THE AIRPORT...

MAN, WHATTA MESS! THESE PEOPLE MUSTA SLEPT OVER FROM YESTERDAY. WONDER IF MY FLIGHT'S STILL ON

EXCUSE ME M'AM, IS FLIGHT 1010 TO CLEVELAND STILL SCHEDULED?

YES, IT HASN'T BEEN CANCELED. BUT THE ELECTRICITY STILL HASN'T COME BACK TO OUR LITTLE CORNER OF THE AIRPORT, AND WITHOUT IT WE CAN'T PROCESS CUSTOMERS.

WELL, THE LIGHTS ARE ON IN THE REST OF THE TERMINAL. MAYBE IT'S JUST A MATTER A'TIME BEFORE THEY COME ON HERE. I JUST GOTTA WAIT IT OUT AN' SEE. AT LEAST THEY HAVEN'T CANCELED MY FLIGHT.

THE MORNING PAPERS ARE OUT WITH REVIEWS OF *AMERICAN SPLENDOR*. LEMME SEE IF I CAN GET A COUPLE.

A FEW MINUTES LATER...

T'DAY'S PAPERS DON'T SEEM T'BE ON SALE HERE. MAYBE I C'N BORROW SOME FROM THE PEOPLE HERE. THEY COULDA GOT 'EM SOMEWHERE ELSE IN THE CITY.

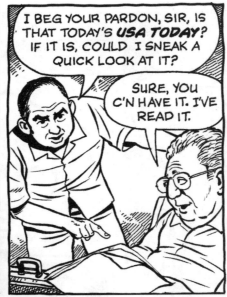

I BEG YOUR PARDON, SIR, IS THAT TODAY'S *USA TODAY*? IF IT IS, COULD I SNEAK A QUICK LOOK AT IT?

SURE, YOU C'N HAVE IT. I'VE READ IT.

WOW! THIS IS AN EXCELLENT REVIEW. GREAT!

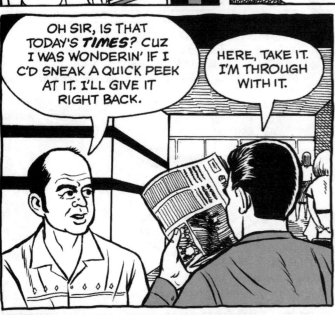

OH SIR, IS THAT TODAY'S *TIMES*? CUZ I WAS WONDERIN' IF I C'D SNEAK A QUICK PEEK AT IT. I'LL GIVE IT RIGHT BACK.

HERE, TAKE IT. I'M THROUGH WITH IT.

THANKS!

WELL, I'M GETTIN' LUCKY IN ONE RESPECT.

A GREAT REVIEW. AND LONG TOO. GOOD OL' ELVIS MITCHELL.

WELL, I'LL JUST PUT THE *TIMES* WITH THE *USA* AND TAKE 'EM HOME WITH ME. THEY OUGHTA HELP THE MOVIE OUT.

AND IT SEEMS LIKE THE ELECTRICITY IS ON IN MOST PLACES, SO MAYBE PEOPLE'LL BE ABLE TO SEE IT TONIGHT. NOW IF THEY COULD JUST GET IT ON OVER THIS AIRLINES SPOT, MAYBE I C'D GET ON MY PLANE.

TIME DRAGS...

YEAH, I BEEN HERE SINCE FOUR O'CLOCK YESTERDAY AFTERNOON. I SURE HOPE THEY CAN GET SOMETHIN' GOIN' AGAIN.

I GUESS IT DEPENDS ON WHETHER THEY CAN GET ELECTRICITY TO THEIR COUNTER.

A FEW HOURS PASS...

I DON'T MIND WAITING IF THEY COULD JUST GET THAT ELECTRICITY RUNNING AGAIN.

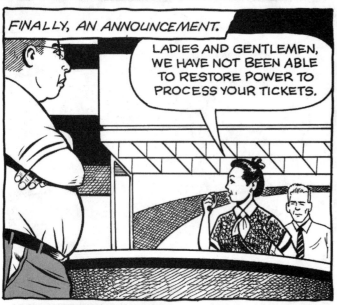

FINALLY, AN ANNOUNCEMENT.

LADIES AND GENTLEMEN, WE HAVE NOT BEEN ABLE TO RESTORE POWER TO PROCESS YOUR TICKETS.

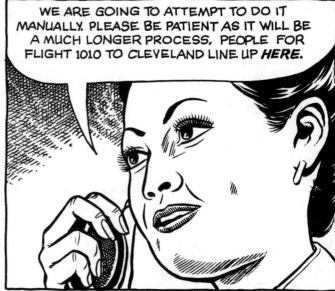

WE ARE GOING TO ATTEMPT TO DO IT MANUALLY. PLEASE BE PATIENT AS IT WILL BE A MUCH LONGER PROCESS. PEOPLE FOR FLIGHT 1010 TO CLEVELAND LINE UP *HERE*.

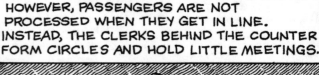

HOWEVER, PASSENGERS ARE NOT PROCESSED WHEN THEY GET IN LINE. INSTEAD, THE CLERKS BEHIND THE COUNTER FORM CIRCLES AND HOLD LITTLE MEETINGS.

THIS GOES ON FOR ANOTHER HALF HOUR AND AFTER AWHILE THE PASSENGERS BEGIN TO GET ANNOYED.

WHAT'S GOIN' ON? WHY ARE THEY STANDIN' BACK THERE TALKIN' INSTEAD OF PROCESSING US?

FINALLY, THE GUY WHO SEEMS TO BE IN CHARGE COMES BACK.

LADIES AND GENTLEMEN...

...WE HAVE DETERMINED THAT WE CANNOT PROCESS YOU SAFELY BY MANUAL MEANS. THEREFORE, ALL THE FLIGHTS HAVE BEEN CANCELED. YOU WILL HAVE TO CALL IN FOR *NEW* RESERVATIONS.

PEOPLE ARE ENRAGED.

WHATTA YA *MEAN?* MY TICKET'S NO *GOOD* ANYMORE?

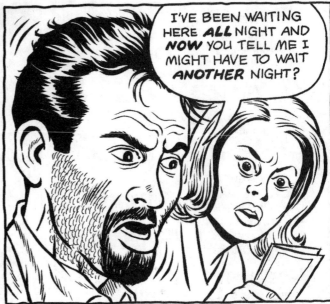

I'VE BEEN WAITING HERE *ALL* NIGHT AND *NOW* YOU TELL ME I MIGHT HAVE TO WAIT *ANOTHER* NIGHT?

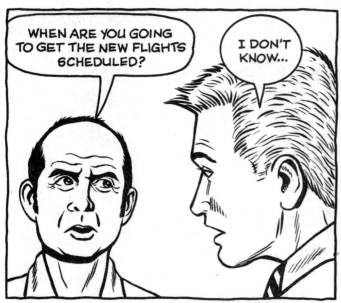

WHEN ARE YOU GOING TO GET THE NEW FLIGHTS SCHEDULED?

I DON'T KNOW...

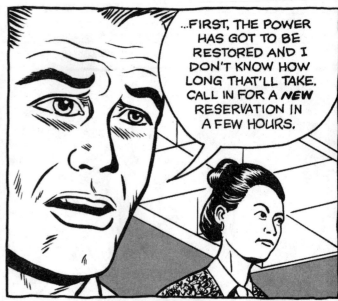

...FIRST, THE POWER HAS GOT TO BE RESTORED AND I DON'T KNOW HOW LONG THAT'LL TAKE. CALL IN FOR A *NEW* RESERVATION IN A FEW HOURS.

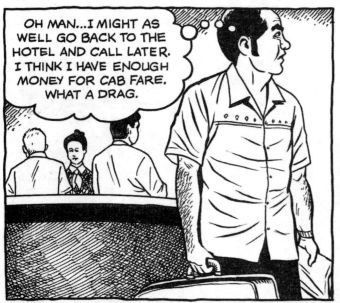

OH MAN...I MIGHT AS WELL GO BACK TO THE HOTEL AND CALL LATER. I THINK I HAVE ENOUGH MONEY FOR CAB FARE. WHAT A DRAG.

WELL, AT LEAST THE ELECTRICITY'LL BE ON IN A FEW THEATERS WHERE *AMERICAN SPLENDOR'S* GONNA BE PLAYIN! AND IT *DID* GET GREAT REVIEWS. THAT'S SOME CONSOLATION.

MAYBE I WON'T BE ABLE T'GET BACK TO CLEVELAND T'DEAL WITH THAT MAIL. MAYBE WE'LL JUST HAVE HAFFTA GO DIRECTLY TO ENGLAND AND SCOTLAND.

SIX WEEKS WORTHA MAIL T'DEAL WITH WHEN WE COME BACK. OH WELL, WE GOT NO CHOICE.

! TAXI! TAXI! TAXI! TAXI! TAXI! TAXI! TAXI! TAXI! TAXI!

END

REUNION

Story by Harvey Pekar
Art by R. Crumb

⊙☆⋒

BLE·E·
E·E·DL'E·
E·E·DL'E·
E·E·DL'E·

H'LO?

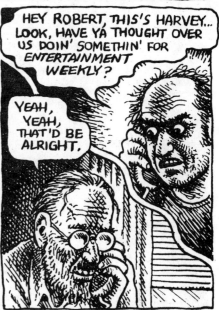

HEY ROBERT, THIS'S HARVEY... LOOK, HAVE YA THOUGHT OVER US DOIN' SOMETHIN' FOR *ENTERTAINMENT WEEKLY*?

YEAH, YEAH, THAT'D BE ALRIGHT.

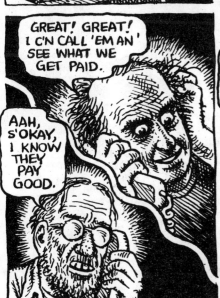

GREAT! GREAT! I C'N CALL 'EM AN' SEE WHAT WE GET PAID.

AAH, S'OKAY, I KNOW THEY PAY GOOD.

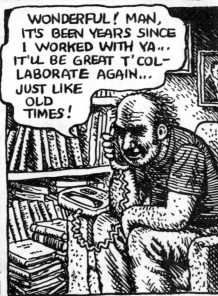

WONDERFUL! MAN, IT'S BEEN YEARS SINCE I WORKED WITH YA... IT'LL BE GREAT T'COL-LABORATE AGAIN... JUST LIKE OLD TIMES!

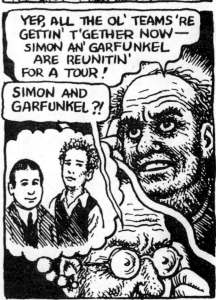

YEP, ALL THE OL' TEAMS 'RE GETTIN' T'GETHER NOW— SIMON AN' GARFUNKEL ARE REUNITIN' FOR A TOUR!

SIMON AND GARFUNKEL?!

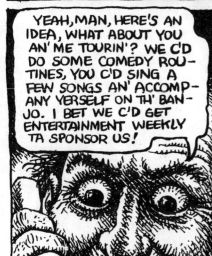

YEAH, MAN, HERE'S AN IDEA, WHAT ABOUT YOU AN' ME TOURIN'? WE C'D DO SOME COMEDY ROU-TINES, YOU C'D SING A FEW SONGS AN' ACCOMP-ANY YERSELF ON TH' BAN-JO. I BET WE C'D GET ENTERTAINMENT WEEKLY TA SPONSOR US!

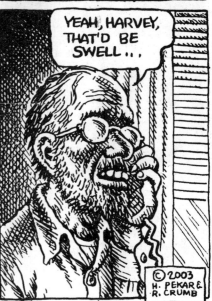

YEAH, HARVEY, THAT'D BE SWELL...,

© 2003 H. PEKAR & R. CRUMB

55

BILLY BRAGG IN AMERICA

STORY BY HARVEY PEKAR
ART BY R. CRUMB
© 2004

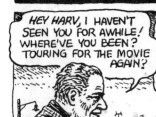

HEY HARV, I HAVEN'T SEEN YOU FOR AWHILE! WHERE'VE YOU BEEN? TOURING FOR THE MOVIE AGAIN?

NAH! I TOOK A *REAL* VACATION THIS TIME, WENT DOWN TA NASHVILLE TA CATCH A SINGER/SONGWRITER FRIEND O' MINE, *BILLY BRAGG*...

NEVER HEARD OF HIM... HE ANY GOOD?

YEAH, HE'S REAL GOOD! HE'S A BRITISH GUY, AND HIS STYLE'S REAL UNIQUE, A SYNTHESIS OF PUNK, LIKE *THE CLASH*, AND FOLK, LIKE *DYLAN*. HE DOES ALOT OF STUFF WITH *POPULIST* THEMES.

LIKE, UHH, IN NASHVILLE HE WAS ON A TOUR CALLED, "TELL US THE TRUTH," WHICH WAS TAKIN' A STAND AGAINST MEDIA CONSOLIDATION. YA KNOW, LATELY THE F.C.C.* BEEN TRYIN' TO LET COMPANIES OWN LARGER AN' LARGER SHARES OF THE MEDIA. IT RESULTS IN HOMOGENIZED RADIO PLAY LISTS AN' LESS EMPHASIS ON LOCAL NEWS AN' LOCAL ARTISTS.

* FEDERAL COMMUNICATIONS COMMISSION

LOTS OF FOLKS, FROM THE FAR LEFT TO THE FAR RIGHT, ARE AGAINST IT! Y' KNOW, IT'S NOT OFTEN YA SEE ORGANIZATIONS LIKE THE N.R.A.* AND COMMON CAUSE JOIN FORCES TO FIGHT TH' SAME GOVER'MENT DECISIONS. MORE THAN TWO MILLION PEOPLE HAVE CONTACTED THE F.C.C. AND CONGRESS TO PROTEST THE F.C.C.'S ATTEMPT TO FOSTER CONSOLIDATION!

* NATIONAL RIFLE ASSOCIATION

BUT YOU SAID THAT BRAGG'S ENGLISH... WHO'S GONNA LISTEN TO A GUY FROM ENGLAND TALKIN' ABOUT OUR U.S. PROGRAMS??

THERE'S SOME AMERICANS ON THIS TOUR, TOO, LIKE STEVE EARLE AND LESTER CHAMBERS. PLUS, BILLY'S GETTIN' MORE AN' MORE INTERNATIONAL RECOGNITION THESE DAYS, AN' I THINK MORE AN' MORE PEOPLE ARE WILLING TO LISTEN TA HIM, ESPECIALLY SINCE HE DID THIS WOODY GUTHRIE PROJECT...

OH YEAH? WHAT WOODY GUTHRIE PROJECT?

WOODY GUTHRIE'S DAUGHTER, NORA, WAS LOOKIN' THROUGH HIS PAPERS AN' SHE FOUND SCADS OF LYRICS HE'D WRITTEN WITH NO MUSIC TO THEM! SO SHE WANTED TO PICK A MUSICIAN WHO HAD SOME TIES TO WOODY TO WRITE TH' MUSIC. SHE DIDN'T GET A GUY LIKE BOB DYLAN CUZ SHE FIGURED HE WAS TOO CLOSE TO WOODY, BUT BILLY HAD JUST ENOUGH DISTANCE FROM HIM TO DO A REAL FRESH JOB ON TH' MUSIC, SO HE GOT CHOSEN, Y'KNOW?

YEAH YEAH...

THEN BILLY TURNED AROUND AN' HIRED THIS CHICAGO "ALT-COUNTRY" ROCK BAND, "WILCO," TO HELP 'IM WITH TH' MUSIC. SO FAR, BILLY AN' WILCO HAVE CUT TWO C.D.'S WORTH A' WOODY'S STUFF WITH BILLY AN' WILCO'S MUSIC, "MERMAID AVENUE," VOLUMES 1 AN' 2. BOTH HAVE GOTTEN EXCELLENT CRITICAL REACTION, AN' I THINK BILLY'S STATUS MIGHT'VE GONE UP A NOTCH OR TWO JUST BECAUSE WOODY'S SUCH A BELOVED PERSONAGE.

IN SOME PEOPLE'S EYES BILLY MAY HAVE GONE OVER THE YEARS FROM BEING SOME KIND OF POP REBEL TO ALMOST A *MUSICAL ELDER STATESMAN!*

END

Cat Treatment

STORY by **HARVEY PEKAR**
ART by **JOSH '04**
Copyright ©2004 by Harvey Pekar

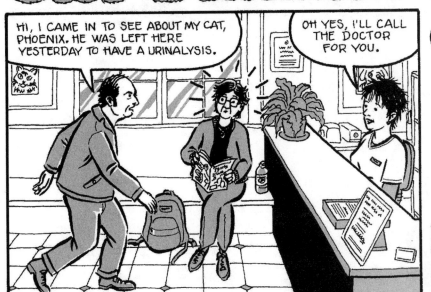

HI, I CAME IN TO SEE ABOUT MY CAT, PHOENIX. HE WAS LEFT HERE YESTERDAY TO HAVE A URINALYSIS.

OH YES, I'LL CALL THE DOCTOR FOR YOU.

HEY, AREN'T YOU HARVEY PEKAR?

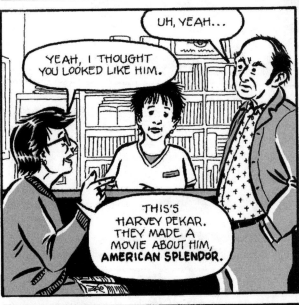

UH, YEAH...

YEAH, I THOUGHT YOU LOOKED LIKE HIM.

THIS'S HARVEY PEKAR. THEY MADE A MOVIE ABOUT HIM, **AMERICAN SPLENDOR.**

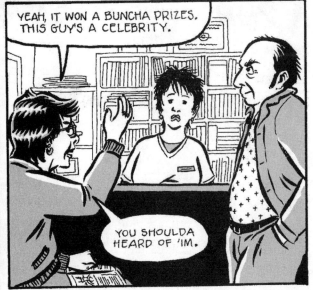

YEAH, IT WON A BUNCHA PRIZES. THIS GUY'S A CELEBRITY.

YOU SHOULDA HEARD OF 'IM.

WOW, I NEVER READ ABOUT IT. WHICH PRIZES DID IT WIN?

WELL, IT WON IN SUNDANCE, CANNES...

OH, I'M SO SORRY. I DIDN'T SEE IT.

'S NO BIG DEAL. I HAVEN'T HEARD OF A LOTTA MOVIES MYSELF.

MR. PEKAR, I'M DR. JAMES. I'VE JUST FINISHED LOOKING AT PHOENIX. HE'S GOT A LOT OF BLOOD IN HIS URINE.

I'VE GOT SOME MEDICATION YOU CAN GIVE HIM FOR TEN DAYS. THEN BRING HIM BACK AND WE'LL SEE HOW HE'S DOING.

WELL, UH, I GOTTA LEAVE TOWN IN LESS THAN TEN DAYS. COULD I BRING HIM IN EARLIER?

SURE, BRING HIM BACK IN SEVEN DAYS. THAT'S A MONDAY. JUST LEAVE HIM HERE IN THE MORNING AND WE'LL CHECK HIM AGAIN.

Blue✚Cross ANIMAL HOSPITAL

SEVEN DAYS LATER.

HI, I'M BRINGING MY CAT IN TO BE TESTED FOR HIS URINARY PROBLEMS.

OH SURE, I REMEMBER. LEAVE HIM HERE AND CALL US IN THE AFTERNOON. WE SHOULD KNOW SOMETHING BY THEN.

THAT AFTERNOON.

H'LO, THIS'S HARVEY PEKAR. I'M CALLIN' ABOUT THE CAT I LEFT THERE THIS MORNING.

OH YES, MR. PEKAR. HOLD WHILE I GET THE DOCTOR.

MR. PEKAR, WE'RE STILL SEEING A LOT OF BLOOD IN PHOENIX'S URINE. AND HE'S LOST ABOUT A HALF-POUND SINCE HE WAS HERE LAST WEEK. DO YOU MIND IF WE SEND HIS URINE OUT TO BE CHECKED? WE DON'T ASSOCIATE WEIGHT LOSS WITH BLADDER PROBLEMS. IT MAY BE HIS KIDNEYS.

SURE, SEND IT OUT. BUT IT LOOKS LIKE I HAVE A PROBLEM.

PHOENIX OBVIOUSLY ISN'T GOING TO GET BETTER OVERNIGHT, AND IN TWO DAYS MY FAMILY AND I LEAVE ON A SIX-WEEK TRIP, MOST OF WHICH WE'LL SPEND OUTSIDE THE COUNTRY IN JAPAN, AUSTRALIA, NEW ZEALAND, IRELAND, AND ENGLAND. HOW AM I GONNA TAKE CARE OF HIM?

I'LL CALL YOU AT 9:00 IN THE MORNING WITH THE TEST RESULTS. THEN WE'LL FIGURE SOMETHING OUT.

OH BROTHER, WHAT'M I GONNA DO? THIS TRIP IS REALLY IMPORTANT. I GOTTA GO. BUT PHOENIX MIGHT NOT BE WELL FOR WEEKS. WHERE AM I GONNA LEAVE HIM? HE'S GONNA NEED CARE AND MEDICATION. BUT WHO CAN TAKE CARE OF HIM?

THE NEXT MORNING.

THE DOCTOR SAYS THE TEST RESULTS DIDN'T SHOW ANYTHING REAL BAD, BUT SHE WANTS TO PUT HIM ON A NEW MEDICATION FOR ANOTHER TEN DAYS.

OH MAN, I'M LEAVING THE COUNTRY TOMORROW. I'VE GOT A FRIEND THAT DROPS IN EVERY COUPLE DAYS TO FEED MY CATS AND CLEAN THE LITTER BOX. BUT PHOENIX HAS GOT TO BE MEDICATED MORE OFTEN THAN THAT. MY BUDDY CAN'T BE COMING OVER TWICE A DAY!

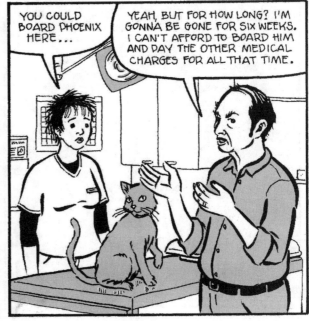

YOU COULD BOARD PHOENIX HERE...

YEAH, BUT FOR HOW LONG? I'M GONNA BE GONE FOR SIX WEEKS. I CAN'T AFFORD TO BOARD HIM AND PAY THE OTHER MEDICAL CHARGES FOR ALL THAT TIME.

WAIT A MINUTE. MAYBE THERE'S AN OPTION WE CAN CHECK OUT.

JANELLE

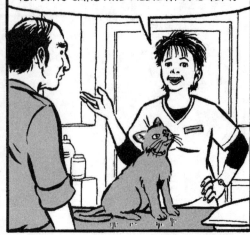

SEVERAL MINUTES LATER.

WELL, AS AN EMPLOYEE HERE, I CAN GET YOU A TWENTY-FIVE PERCENT DISCOUNT. THE TOTAL COST OF BOARDING HIM AND FOR TEN DAYS' CARE AND MEDICATION IS $274.

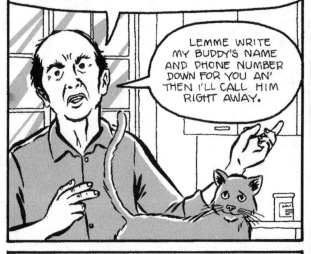

Hmm. YEAH, THAT'D WORK. I CAN PAY YOU $274 NOW, TELL MY FRIEND TO PICK UP PHOENIX IN TEN DAYS, AND DROP HIM OFF AT MY HOUSE. AND PAY YOU THE REST WHEN I GET BACK IF THERE'S MORE COSTS.

LEMME WRITE MY BUDDY'S NAME AND PHONE NUMBER DOWN FOR YOU AN' THEN I'LL CALL HIM RIGHT AWAY.

PHOENIX AN' I HAVE BEEN TOGETHER FOR YEARS. I CAN'T TURN MY BACK ON 'IM.

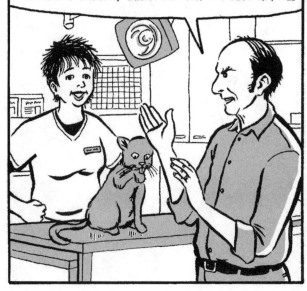

HEY, LOOK, IT WAS AWFULLY NICE A'YOU TO GET ME THAT DISCOUNT, SEEIN' AS HOW YOU JUST MET ME.

I WONDER IF THAT LADY YELLIN' ABOUT MY BEIN' ASSOCIATED WITH A MOVIE HAD ANYTHING T'DO WITH THIS GREAT TREATMENT?

OH WELL, IT COULDNA HURT.

BIRTHDAY

BY Harvey Pekar
PICTURES BY FRANK STACK

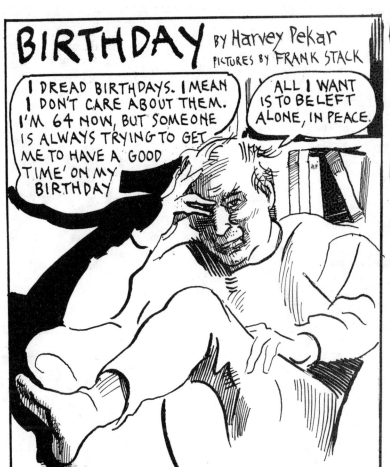

I DREAD BIRTHDAYS. I MEAN I DON'T CARE ABOUT THEM. I'M 64 NOW, BUT SOMEONE IS ALWAYS TRYING TO GET ME TO HAVE A 'GOOD TIME' ON MY BIRTHDAY

ALL I WANT IS TO BE LEFT ALONE, IN PEACE.

SO, TODAY IS MY BIRTHDAY. IT'S OCTOBER 8, 2003, AND IT'S NOT STARTING OFF REAL WELL, ESPECIALLY IN VIEW OF THE FACT THAT IN AN HOUR OR SO I HAVE TO GET A LIMO RIDE TO CATCH A PLANE TO COLUMBIA, MISSOURI, HOME OF THE UNIVERSITY OF MISSOURI, WHERE I'LL GIVE A TALK ABOUT AMERICAN SPLENDOR

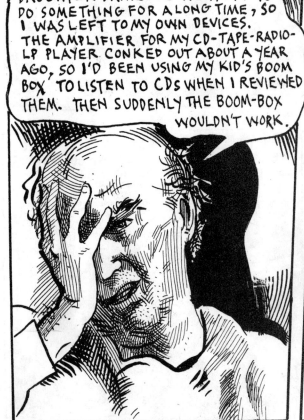

YESTERDAY MY WIFE JOYCE AND DAUGHTER DANIELLE WENT OFF TO DO SOMETHING FOR A LONG TIME, SO I WAS LEFT TO MY OWN DEVICES. THE AMPLIFIER FOR MY CD-TAPE-RADIO-LP PLAYER CONKED OUT ABOUT A YEAR AGO, SO I'D BEEN USING MY KID'S 'BOOM BOX' TO LISTEN TO CDS WHEN I REVIEWED THEM. THEN SUDDENLY THE BOOM-BOX WOULDN'T WORK.

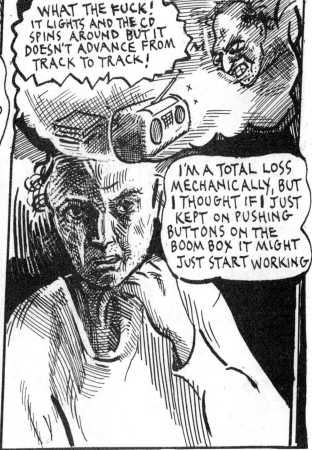

WHAT THE FUCK! IT LIGHTS AND THE CD SPINS AROUND BUT IT DOESN'T ADVANCE FROM TRACK TO TRACK!

I'M A TOTAL LOSS MECHANICALLY, BUT I THOUGHT IF I JUST KEPT ON PUSHING BUTTONS ON THE BOOM BOX IT MIGHT JUST START WORKING

SO I DID THAT, TRYING TO FIGURE OUT WHAT WAS WRONG, WHAT STEP THAT I HADN'T THOUGHT OF THAT WOULD GET THE THING WORKING. I WAS UNSUCCESSFUL IN MAKING SENSE OF ANYTHING

BUT I KEPT ON DOGGEDLY PUSHING BUTTONS AND GRADUALLY IT STARTED TO WORK.

YEAH, THE FACT THAT I SAW IT LIGHT UP GAVE ME HOPE, AND LO AND BEHOLD, MY EFFORTS WERE REWARDED,

SO I WROTE A COUPLE OF CD REVIEWS FOR A LOCAL PAPER, MAKING ME FEEL USEFUL AND PRODUCTIVE.

LEMME TELL YA, I'M IN A WEIRD PLACE PSYCHO-LOGICALLY RIGHT NOW. THERE'S THIS MOVIE, **"AMERICAN SPLENDOR"**, THAT'S BASED ON MY COMICS AND IT'S BEEN KIND OF A HIT, SO I'VE BEEN GETTING MORE FREE LANCE WRITING GIGS. BUT I'M SCARED ABOUT WHAT HAPPENS WHEN THE MOVIE STOPS PLAYIN'.... SEE, THEN MY STEADY INCOME WILL BE MY GOVERNMENT PENSION, AND FOR A FEW YEARS, AN ANNUITY. NOT ENOUGH TO SUPPORT MY FAMILY, I FOUND AFTER I RETIRED.

BUT I COULD MAKE IT IF I COULD MAKE SOME EXTRA MONEY DOING FREE LANCE WRITING. THE DOUGH AND THE JOBS ARE COMIN' IN RIGHT NOW, BUT WILL EDITORS FORGET ABOUT ME WHEN THE MOVIE HOOPLA'S OVER? THAT'S WHAT'S GOT ME REAL SCARED, SO WHEN I GET OR DO FREE LANCE WORK, IT REALLY MAKES ME FEEL BETTER.

AFTER MY UNEXPECTED LUCK WITH THE BOOM BOX MY MOOD WAS UPLIFTED. I GOT THE OKAY TO DO A LONG ARTICLE ON AN OBSCURE WRITER NAMED DOW MOSSMAN FOR **THE VILLAGE VOICE**. HE'D WRITTEN THIS TERRIFIC NOVEL, "THE STONES OF SUMMER" BACK IN 1972, BUT FOR SOME REASON HADN'T BEEN ABLE TO WRITE ANYTHING SINCE. SO HE'D BEEN DOING RATHER MENIAL WORK SINCE. BUT NOW THE BOOK WAS BEING RE-ISSUED AND HE WAS GOING ON TOUR WITH IT AND THE VOICE WANTED ME TO INTERVIEW HIM. GREAT!

THIS MIGHT BE FUN. MOSSMAN'S HAD A CAREER SOMEWHAT LIKE MINE.

THEN I GOT A CALL THAT MY ARTICLE ON THE GREAT EXPERIMENTAL JAZZMAN JOE MANERI WAS GONNA BE PUBLISHED SOON IN A WESTCHESTER COUNTY (N.Y.) NEWSPAPER.

IT'LL BE OUT IN A COUPLA DAYS? CAN YOU SEND ME A COPY?

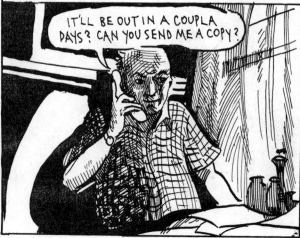

THEN THIS GUY FROM A LOCAL PBS STATION THAT I DO COMMENTARY FOR HAD SENT SOME OF MY BITS TO TERRI GROSS ON FRESH AIR AND HE WAS CALLING TO TELL ME SHE WAS GONNA START REBROADCASTING THEM NATIONALLY AND PAYING ME FOR IT.

WOW! WHAT'S SO GOOD ABOUT THAT IS THAT I GOT THIS AGENT TO SET UP SPEECHES FOR ME AT COLLEGES. MAYBE THIS'LL HELP ME GET SOME SPEAKING GIGS.

OKAY, SO THEN MY WIFE AND FOSTER DAUGHTER COME HOME.

THEY'RE CARRYING BOXES WITH "SONY" ON THEM. OH, NO! THEY WENT OUT AND GOT ME A NEW SOUND SYSTEM FOR MY BIRTHDAY.

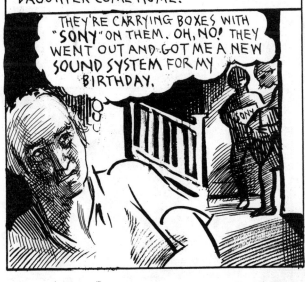

I BET THEY PAID OVER $1,000 BUCKS FOR IT. BUT FOR NOW I JUST WANTED T'GO WITH SOMETHING CHEAP LIKE THE BOOM BOX, TILL I SAW WHAT HAPPENED TO MY ECONOMIC SITUATION AFTER THE MOVIE WAS OVER.

*AND WE GOT YOU THESE SPEAKERS WITH A BETTER BASS RESPONSE. YOU NEED GOOD BASS RESPONSE WHEN YOU'RE REVIEWING JAZZ RECORDS

I COULD'A CRIED. $1,000 BUCKS OR MORE OUT THE WINDOW. I WAS SO TENSE I WASN'T EVEN LISTENING TO THE MUSIC ANY MORE FOR PLEASURE, JUST REVIEWING RECORDS. BUT THEY MEANT WELL, SO I'D BETTER SHOW MY APPRECIATION.

THANKS TO BOTH OF YOU FOR THE NEW MUSIC SYSTEM. I'VE REALLY NEEDED IT.

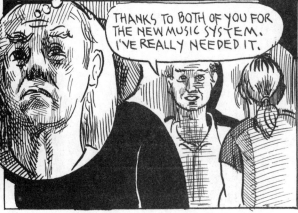

MY WIFE ALSO GOT ME A SET OF TAPES ON THE HISTORY OF THE ENGLISH LANGUAGE AND WE LISTENED TO THE FIRST ONE NARRATED BY ROBERT MACNEILL. IT WAS QUITE INTERESTING

AND THEN THE DANES STARTED INVADING ENGLAND, AND THAT BROUGHT ABOUT MORE CHANGES.

WHILE WE WERE WATCHING IT I GOT A PHONE CALL FROM AUSTRALIA, BELIEVE IT OR NOT, TO ATTEND A LITERARY CONFERENCE THERE AND GIVE A TALK ON COMIC BOOKS.

LEEDLE LEEDLE LEEDLE

YES, WE FINALLY AGREED TO STOP IGNORING COMICS

WELL, I DUNNO IF I CAN COME, UNLESS YOU CAN AFFORD T'FLY MY WIFE AND DAUGHTER IN. WE TRAVEL AS A TEAM.

STILL IT WAS NICE TO KNOW SOMEONE CARED.

THAT NIGHT WE PACKED UP FOR OUR MISSOURI TRIP. I WAS FEELING PRETTY GOOD CONSIDERING THAT I HAD TO TRAVEL THE NEXT DAY. TRAVELLING UPSETS ME. I WORRY ABOUT "DID I SHUT OFF ALL THE LIGHTS, AND TURN OFF THE GAS AND LOCK ALL THE DOORS."

JOYCE GAVE ME THE RESPONSIBILITY OF PACKING FOR MYSELF, WHICH WAS EASY, AS I TRAVEL LIGHT. THEN I WENT TO BED EARLY BECAUSE THE LIMO THAT'D BEEN CALLED FOR ME WAS COMING AT SEVEN-THIRTY AND I HADDA GET UP ABOUT 5:45 AND TAKE CARE OF MY BUSINESS IN THE BATHROOM AND THEN GET JOYCE AND DANIELLE UP. THEY STAYED UP LATER, DOING I DON'T KNOW WHAT.

SO, THAT MORNING I WAS UP BRIGHT AND EARLY, TOOK CARE OF MY BATHROOM STUFF, THEN WOKE JOYCE, WHO TOLD ME TO WAKE DANIELLE TO GET INTO THE BATHROOM NEXT.

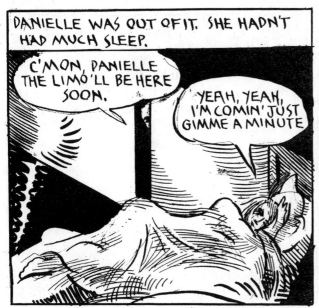

DANIELLE WAS OUT OF IT. SHE HADN'T HAD MUCH SLEEP.

C'MON, DANIELLE THE LIMO'LL BE HERE SOON.

YEAH, YEAH, I'M COMIN' JUST GIMME A MINUTE

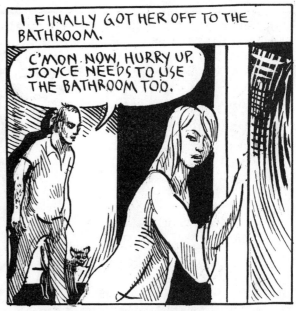

I FINALLY GOT HER OFF TO THE BATHROOM.

C'MON NOW, HURRY UP. JOYCE NEEDS TO USE THE BATHROOM TOO.

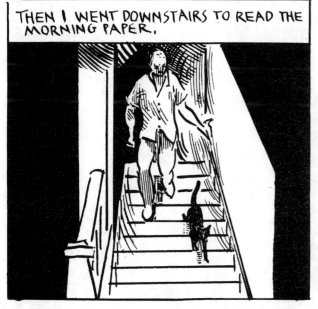

THEN I WENT DOWNSTAIRS TO READ THE MORNING PAPER.

AFTER ABOUT FIFTEEN MINUTES, THOUGH I WAS INTERRUPTED BY A LOUD CRACKLING SOUND IN THE KITCHEN.

I RAN IN THERE AND FOUND...

THE BATHTUB UPSTAIRS WAS OVERFLOWING WITH WATER AND BUBBLE BATH.

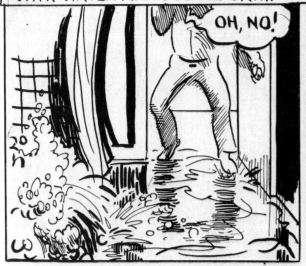

OH, NO!

I QUICKLY YANKED THE PLUG OUT OF THE TUB AND TURNED OFF THE TAP. DANIELLE HAD TURNED ON THE WATER, THEN GONE BACK TO BED WHERE SHE INADVERTANTLY FELL ASLEEP

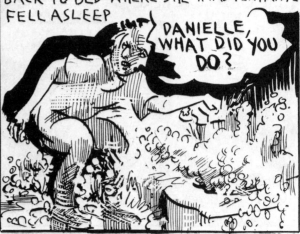

DANIELLE, WHAT DID YOU DO?

FOR THE NEXT HALF HOUR OR SO I RAN BETWEEN THE KITCHEN AND BATHROOM EMPTYING PAILS AND POTS, PLUNGING THE TUB AND MOPPING WATER ON THE FLOOR.

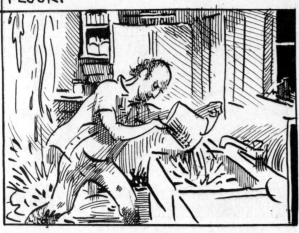

WHILE I WAS DOING THAT I TRIED TO GET JOYCE AND DANIELLE UP AND GOING SO WE COULD CATCH THE LIMO THAT THE MISSOURI THEATER WAS SENDING TO TAKE US TO THE AIRPORT.

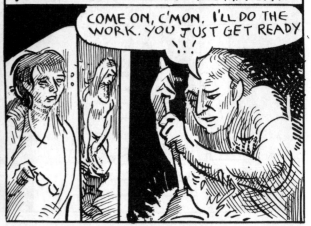

COME ON, C'MON. I'LL DO THE WORK. YOU JUST GET READY !!!

THE WATER WAS LEAKING MUCH MORE SLOWLY. IT WAS DRIPPING NOW. AND THE WATER AND BUBBLES WERE ALMOST GONE FROM THE TUB. THINGS LOOKED LIKE THEY MIGHT BE RESOLVED OKAY.

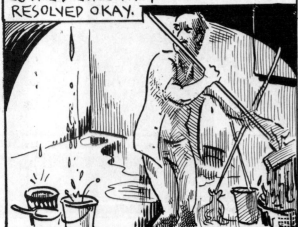

THEN THE LIMO CAME, DRIVEN BY MY GOOD FRIEND, HOLLYWOOD BOB

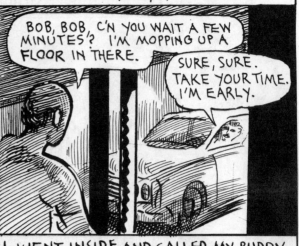

BOB, BOB, C'N YOU WAIT A FEW MINUTES? I'M MOPPING UP A FLOOR IN THERE.

SURE, SURE. TAKE YOUR TIME. I'M EARLY.

I WENT INSIDE AND CALLED MY BUDDY ROB, WHO WAS GONNA LOOK AFTER MY CATS.

ROB, I'M CLEANING UP THE WATER FROM SOME BATHROOM LEAKS WE GOT THIS MONTH DOWN IN THE KITCHEN. WE'RE GONNA TAKE THE LIMO TO THE AIRPORT IN A FEW MINUTES. C'D YOU LOOK IN THE KITCHEN AND MAKE SURE IT'S OKAY THERE WHEN YOU GET HERE? I'LL CALL YOU ON MY CELL PHONE.

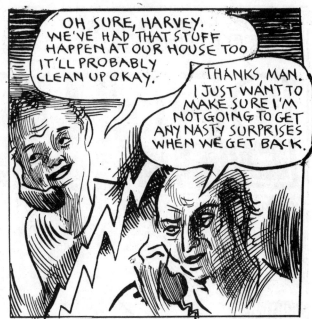
OH SURE, HARVEY. WE'VE HAD THAT STUFF HAPPEN AT OUR HOUSE TOO IT'LL PROBABLY CLEAN UP OKAY.

THANKS MAN. I JUST WANT TO MAKE SURE I'M NOT GOING TO GET ANY NASTY SURPRISES WHEN WE GET BACK.

WITH THE WATER STILL DRIPPING A LITTLE BIT WE LOADED OUR BAGS INTO THE LIMO.

THEN WE WERE OFF TO THE AIRPORT

GOD, I'M TOO NUMB TO EVEN WORRY ABOUT THE AFTERMATH OF THE THING

WHAT A MESS T'HAVE T'DEAL WITH AT THE START OF THE TRIP. AN' Y'KNOW, BOB, IT'S MY SIXTY FOURTH BIRTHDAY T'DAY.

YEAH... WILL YA STILL NEED ME WILL YA STILL FEED ME WHEN I'M SIXTY-FOUR?

End

69

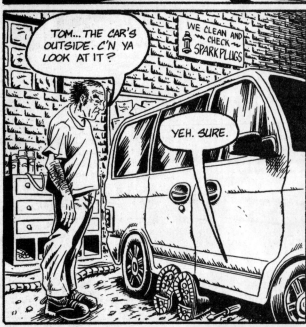

TOM... THE CAR'S OUTSIDE. C'N YA LOOK AT IT?

YEH. SURE.

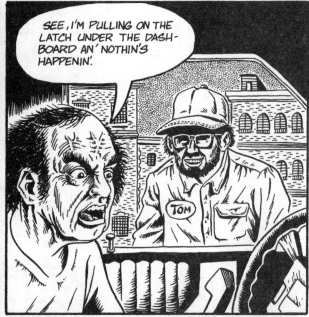

SEE, I'M PULLING ON THE LATCH UNDER THE DASH-BOARD AN' NOTHIN'S HAPPENIN'.

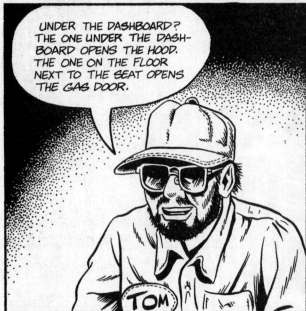

UNDER THE DASHBOARD? THE ONE UNDER THE DASH-BOARD OPENS THE HOOD. THE ONE ON THE FLOOR NEXT TO THE SEAT OPENS THE GAS DOOR.

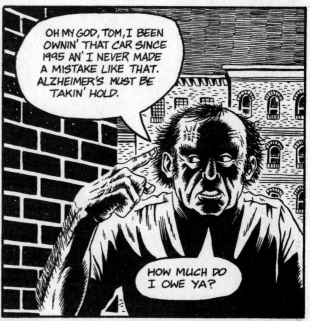
OH MY GOD, TOM, I BEEN OWNIN' THAT CAR SINCE 1995 AN' I NEVER MADE A MISTAKE LIKE THAT. ALZHEIMER'S MUST BE TAKIN' HOLD.

HOW MUCH DO I OWE YA?

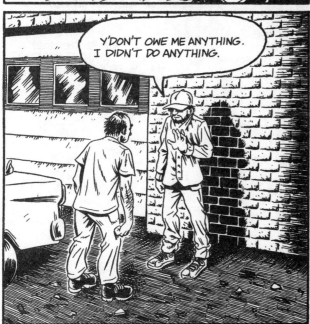
Y'DON'T OWE ME ANYTHING. I DIDN'T DO ANYTHING.

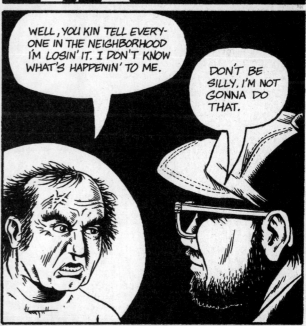
WELL, YOU KIN TELL EVERY-ONE IN THE NEIGHBORHOOD I'M LOSIN' IT. I DON'T KNOW WHAT'S HAPPENIN' TO ME.

DON'T BE SILLY, I'M NOT GONNA DO THAT.

TWO MINUTES LATER...

MAN, EVERY INCOMPETENT KLUTZ LIKE ME NEEDS A GOOD GUY LIKE TOM AS A MECHANIC. WHAT WOULD I DO WITHOUT 'IM?

71

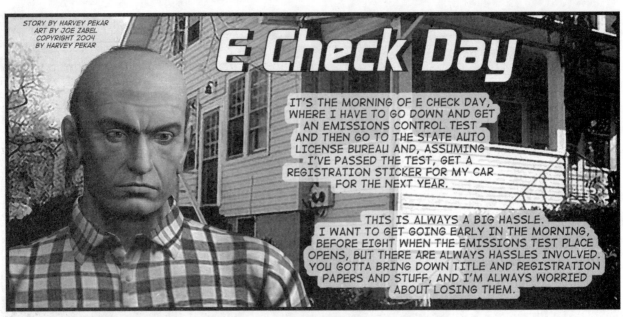

STORY BY HARVEY PEKAR
ART BY JOE ZABEL
COPYRIGHT 2004
BY HARVEY PEKAR

E Check Day

IT'S THE MORNING OF E CHECK DAY, WHERE I HAVE TO GO DOWN AND GET AN EMISSIONS CONTROL TEST AND THEN GO TO THE STATE AUTO LICENSE BUREAU AND, ASSUMING I'VE PASSED THE TEST, GET A REGISTRATION STICKER FOR MY CAR FOR THE NEXT YEAR.

THIS IS ALWAYS A BIG HASSLE. I WANT TO GET GOING EARLY IN THE MORNING, BEFORE EIGHT WHEN THE EMISSIONS TEST PLACE OPENS, BUT THERE ARE ALWAYS HASSLES INVOLVED. YOU GOTTA BRING DOWN TITLE AND REGISTRATION PAPERS AND STUFF, AND I'M ALWAYS WORRIED ABOUT LOSING THEM.

THE FIRST PROBLEM IS, WHEN I GET DOWN THERE, WHAT BAY DO I PUT MY CAR IN FRONT OF. THEY'VE GOT FIVE BAYS, BUT THEY DON'T EMPLOY THEM ALL THE TIME, SO EVEN THOUGH I'LL PROBABLY BE THE FIRST ONE DOWN THERE, WHEN THEY OPEN UP

I MIGHT BE IN FRONT OF A BAY THAT THEY'RE NOT USING. THAT MEANS I HAVE TO GO TO THE BACK OF THE LINE AGAIN BEHIND ALL THESE CARS THAT'VE COME AFTER ME AND I WASTE ABOUT AN HOUR.

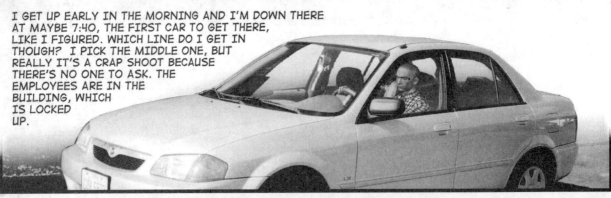

I GET UP EARLY IN THE MORNING AND I'M DOWN THERE AT MAYBE 7:40, THE FIRST CAR TO GET THERE, LIKE I FIGURED. WHICH LINE DO I GET IN THOUGH? I PICK THE MIDDLE ONE, BUT REALLY IT'S A CRAP SHOOT BECAUSE THERE'S NO ONE TO ASK. THE EMPLOYEES ARE IN THE BUILDING, WHICH IS LOCKED UP.

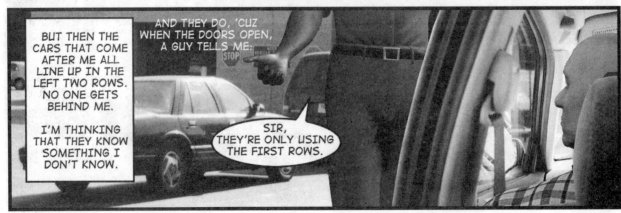

BUT THEN THE CARS THAT COME AFTER ME ALL LINE UP IN THE LEFT TWO ROWS. NO ONE GETS BEHIND ME.

I'M THINKING THAT THEY KNOW SOMETHING I DON'T KNOW.

AND THEY DO, 'CUZ WHEN THE DOORS OPEN, A GUY TELLS ME:

SIR, THEY'RE ONLY USING THE FIRST ROWS.

SO I PULL AROUND INTO THE FIRST ROW, BEHIND TWO OTHER CARS. I'M NOT TOO UPSET BECAUSE THAT'S NOT TOO MANY. THE HOLD UP COULD ONLY BE ABOUT TEN MINUTES.

TO ADD INSULT TO INJURY, THE EMPLOYEES HAVE A LITTLE MEETING AND DECIDE TO OPEN THE MIDDLE BAY TOO-- AFTER I'VE VACATED IT.

KEEP
LE RUNNING
FEE $19.50
CASH OR
CHECK

STOP

MY LINE MOVES THE FASTEST, THOUGH, IT WASN'T LONG BEFORE MY CAR WAS BEING CHECKED OUT.

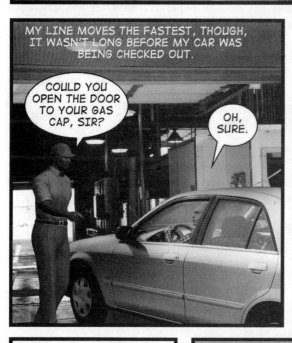

COULD YOU OPEN THE DOOR TO YOUR GAS CAP, SIR?

OH, SURE.

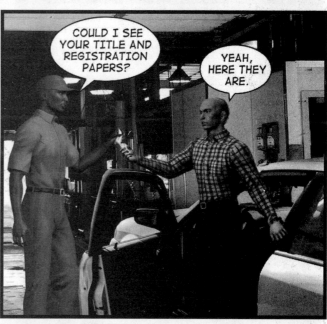

COULD I SEE YOUR TITLE AND REGISTRATION PAPERS?

YEAH, HERE THEY ARE.

NOW WILL YOU GO INTO THAT LITTLE ROOM OVER THERE WHILE I RUN SOME TESTS? I'LL TAKE IT FROM HERE AND I'LL LET YOU KNOW WHEN I'M THROUGH.

SO I GO IN THE LITTLE ROOM AND GET SOME UNEXPECTED SYMPATHY FROM SOMEONE ELSE GETTING THEIR CAR CHECKED.

YOU GOT SCREWED. YOU WERE HERE FIRST AND THEY TOOK THESE PEOPLE IN THE OTHER LINES AHEAD OF YOU.

I ALWAYS LIKE TO RECEIVE SYMPATHY.

YEAH, I GET UP EXTRA EARLY THIS MORNING SO I CAN GET OUTTA HERE AN' TAKE CARE A' SOME OTHER STUFF, AN' I STILL WIND UP AT THE BACK A' THE' LINE.

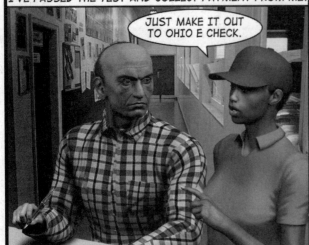

THEN ANOTHER ATTENDANT COMES AROUND TO TELL ME I'VE PASSED THE TEST AND COLLECT PAYMENT FROM ME.

JUST MAKE IT OUT TO OHIO E CHECK.

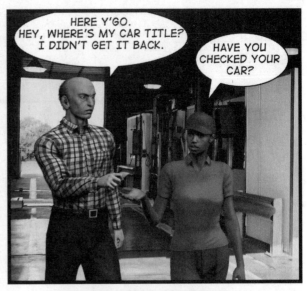

HERE Y'GO. HEY, WHERE'S MY CAR TITLE? I DIDN'T GET IT BACK.

HAVE YOU CHECKED YOUR CAR?

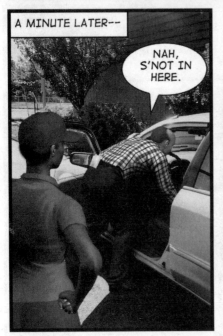

A MINUTE LATER--

NAH, S'NOT IN HERE.

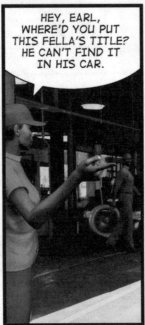

HEY, EARL, WHERE'D YOU PUT THIS FELLA'S TITLE? HE CAN'T FIND IT IN HIS CAR.

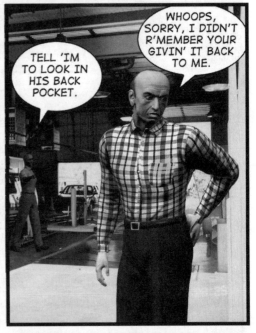

TELL 'IM TO LOOK IN HIS BACK POCKET.

WHOOPS, SORRY, I DIDN'T R'MEMBER YOUR GIVIN' IT BACK TO ME.

THEN I'M OFF TO ANOTHER NEIGHBORHOOD WHERE I GET MY REGISTRATION STICKER FROM THE STATE BUREAU OF AUTO TITLES BRANCH. IT'S A BEAUTIFUL SEPTEMBER MORNING AND I FELT ABOUT AS GOOD AS I HAVE IN SOME TIME.

I PARK THE CAR IN THE LOT BEHIND THE TITLE BRANCH, AND DECIDE TO CHECK MY GAS TANK, TO SEE IF THE E CHECK GUY HAD PUT EVERYTHING TOGETHER RIGHT. HE HADN'T.

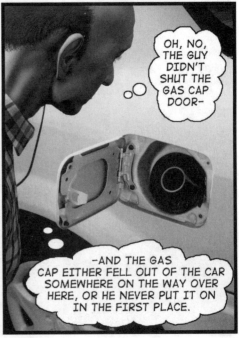

OH, NO, THE GUY DIDN'T SHUT THE GAS CAP DOOR-

-AND THE GAS CAP EITHER FELL OUT OF THE CAR SOMEWHERE ON THE WAY OVER HERE, OR HE NEVER PUT IT ON IN THE FIRST PLACE.

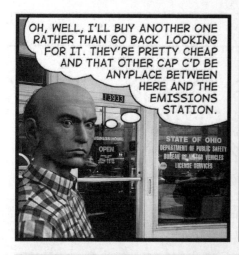

OH, WELL, I'LL BUY ANOTHER ONE RATHER THAN GO BACK LOOKING FOR IT. THEY'RE PRETTY CHEAP AND THAT OTHER CAP C'D BE ANYPLACE BETWEEN HERE AND THE EMISSIONS STATION.

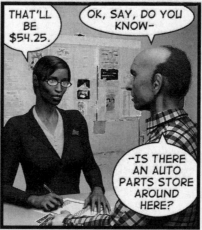

THAT'LL BE $54.25.

OK, SAY, DO YOU KNOW—

—IS THERE AN AUTO PARTS STORE AROUND HERE?

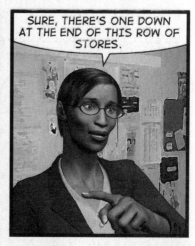

SURE, THERE'S ONE DOWN AT THE END OF THIS ROW OF STORES.

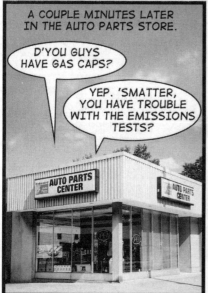

A COUPLE MINUTES LATER IN THE AUTO PARTS STORE.

D'YOU GUYS HAVE GAS CAPS?

YEP. 'SMATTER, YOU HAVE TROUBLE WITH THE EMISSIONS TESTS?

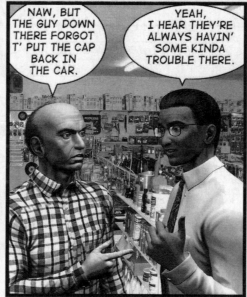

NAW, BUT THE GUY DOWN THERE FORGOT T' PUT THE CAP BACK IN THE CAR.

YEAH, I HEAR THEY'RE ALWAYS HAVIN' SOME KINDA TROUBLE THERE.

AH, IT FITS.

NOW A QUICK TRIP TO THE BANK AND POST OFFICE.

I'D LIKE TO DEPOSIT THE ENTIRE AMOUNT OF THIS CHECK.

WOW, I GOT A COUPLE MORE CHECKS. THEY ONLY ADD UP TO $77.00, BUT THAT HELPS.

AN' LOOKIT THE TIME, IT'S NOT EVEN 10:00 YET. THIS'S BEEN AN ACHIEVEMENT-FILLED DAY SO FAR.

THE END.

RALPH CARnEY

AKRON'S RALPH CARNEY, WHO WILL BE AT THE BEACHLAND ON 7/12, IS ONE OF THE MOST UNIQUE MUSICIANS TO ORIGINATE IN NORTHEAST OHIO.

STORY BY HARVEY PEKAR · ART BY GARY DUMM

RALPH CAME OF AGE DURING THE 1970'S WHEN AKRON WAS PRODUCING GROUPS LIKE THE PRETENDERS AND DEVO. FOR AWHILE HE PLAYED IN A MODERN JAZZ BAND CALLED JAZZ DEATH THAT COVERED THE MUSIC OF ORNETTE COLEMAN, CHARLIE MINGUS AND THELONIUS MONK. RALPH PLAYED MOSTLY TENOR SAX WITH THIS OUTFIT.

CHRISSIE HYNDE of the PRETENDERS

HE RECORDED WITH THE RUBBER CITY BAND, TIN HUEY, THEN SETTLED IN UPSTATE NEW YORK WHERE HE HUNG OUT WITH THE CREATIVE MUSIC STUDIO, A COLLECTIVE CONTAINING SUCH IMPORTANT EXPERIMENTAL JAZZ ARTISTS AS DON CHERRY AND ANTHONY BRAXTON. AT THIS TIME RALPH WAS WORKING IN ROCK & JAZZ SETTINGS.

AFTER THAT RALPH MOVED TO NEW YORK CITY WHERE HE RECORDED AND TOURED WITH THE B-52'S. IN 1985 RECORD PRODUCER HAL WILNER HIPPED TOM WAITS TO RALPH AND SINCE THEN RALPH HAS BEEN PLAYING SAXOPHONE OFF AND ON WITH HIM.

the B-52's

TOM WAITS

IN 1989 RALPH MOVED TO THE SAN FRANCISCO BAY AREA, WHERE HE'S LIVED EVER SINCE. HE PLAYS ALL SORTS OF GIGS THERE — ROCK, DIXIELAND, SWING, FREE JAZZ.

PACIFIC OCEAN · Sausalito · San Francisco · Oakland · Palo Alto · CALIF

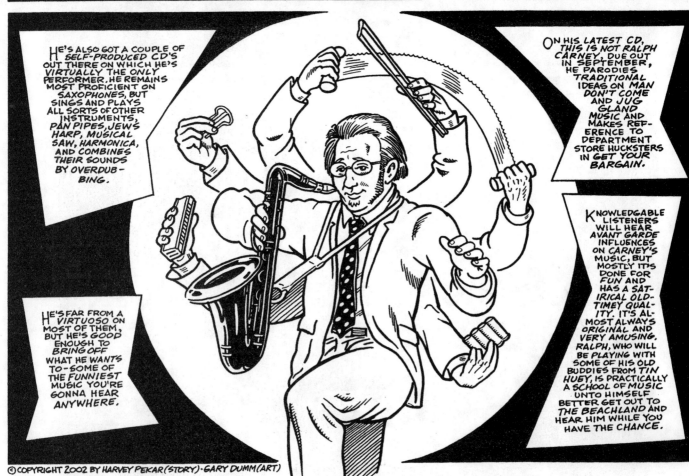

HE'S ALSO GOT A COUPLE OF SELF-PRODUCED CD'S OUT THERE ON WHICH HE'S VIRTUALLY THE ONLY PERFORMER. HE REMAINS MOST PROFICIENT ON SAXOPHONES, BUT SINGS AND PLAYS ALL SORTS OF OTHER INSTRUMENTS, PAN PIPES, JEWS HARP, MUSICAL SAW, HARMONICA, AND COMBINES THEIR SOUNDS BY OVERDUB-BING.

HE'S FAR FROM A VIRTUOSO ON MOST OF THEM, BUT HE'S GOOD ENOUGH TO BRING OFF WHAT HE WANTS TO — SOME OF THE FUNNIEST MUSIC YOU'RE GONNA HEAR ANYWHERE.

ON HIS LATEST CD, THIS IS NOT RALPH CARNEY, DUE OUT IN SEPTEMBER, HE PARODIES TRADITIONAL IDEAS ON MAN DON'T COME AND JUG GLAND MUSIC AND MAKES REFERENCE TO DEPARTMENT STORE HUCKSTERS IN GET YOUR BARGAIN.

KNOWLEDGABLE LISTENERS WILL HEAR AVANT GARDE INFLUENCES ON CARNEY'S MUSIC, BUT MOSTLY IT'S DONE FOR FUN AND HAS A SATIRICAL OLD-TIMEY QUALITY. IT'S ALMOST ALWAYS ORIGINAL AND VERY AMUSING. RALPH, WHO WILL BE PLAYING WITH SOME OF HIS OLD BUDDIES FROM TIN HUEY, IS PRACTICALLY A SCHOOL OF MUSIC UNTO HIMSELF. BETTER GET OUT TO THE BEACHLAND AND HEAR HIM WHILE YOU HAVE THE CHANCE.

IDENTITY CRISIS

©2003 HARVEY PEKAR AND DEAN HASPIEL

FOOD CO-OP

Lliane

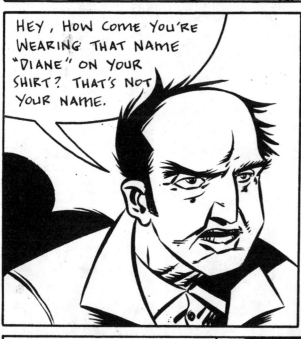

HEY, HOW COME YOU'RE WEARING THAT NAME "DIANE" ON YOUR SHIRT? THAT'S NOT YOUR NAME.

NO, IT'S NOT...

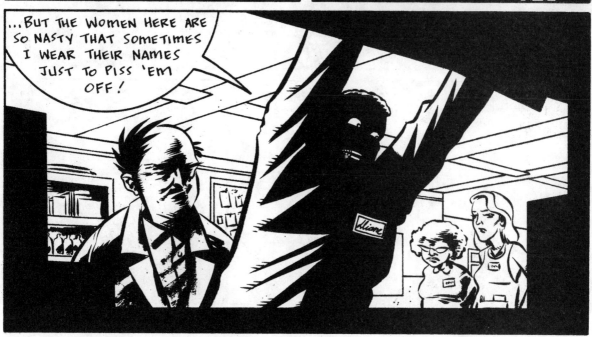

...BUT THE WOMEN HERE ARE SO NASTY THAT SOMETIMES I WEAR THEIR NAMES JUST TO PISS 'EM OFF!

MY MOVIE YEAR

STORY BY HARVEY PEKAR ● ART BY GARY DUMM
COLOR BY LAURA DUMM

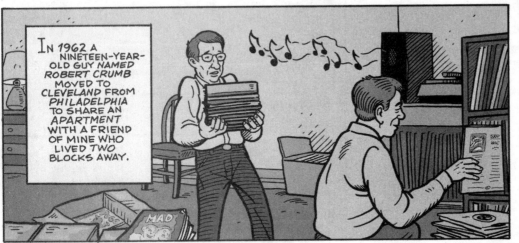

IN 1962 A NINETEEN-YEAR-OLD GUY NAMED ROBERT CRUMB MOVED TO CLEVELAND FROM PHILADELPHIA TO SHARE AN APARTMENT WITH A FRIEND OF MINE WHO LIVED *TWO* BLOCKS AWAY.

CRUMB, WHO GOT A JOB AS A COLOR SEPARATOR FOR THE *AMERICAN GREETINGS* CARD CO., SHARED A PASSION FOR JAZZ RECORD COLLECTING WITH ME, BUT I SOON DEVELOPED AN INTEREST IN HIS ALTERNATIVE CARTOON WORK.

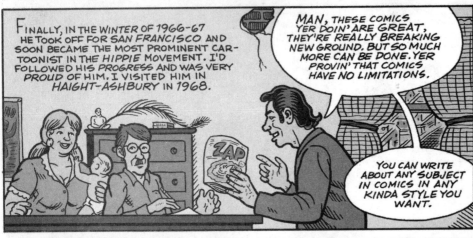

FINALLY, IN THE WINTER OF 1966-67 HE TOOK OFF FOR SAN FRANCISCO AND SOON BECAME THE MOST PROMINENT CARTOONIST IN THE *HIPPIE* MOVEMENT. I'D FOLLOWED HIS PROGRESS AND WAS VERY PROUD OF HIM. I VISITED HIM IN HAIGHT-ASHBURY IN 1968.

MAN, THESE COMICS YER DOIN' ARE GREAT, THEY'RE REALLY BREAKING NEW GROUND. BUT SO MUCH MORE CAN BE DONE. YER PROVIN' THAT COMICS HAVE NO LIMITATIONS.

YOU CAN WRITE ABOUT ANY SUBJECT IN COMICS IN ANY KINDA STYLE YOU WANT.

YOU CAN USE ANY WORDS IN THE DICTIONARY IN COMICS ARRANGED ANY WAY YOU WANT. PLUS YOU CAN USE ANY ILLUSTRATION STYLE.

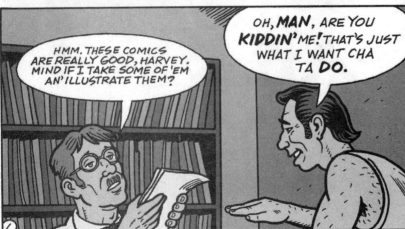

HMM. THESE COMICS ARE REALLY GOOD, HARVEY. MIND IF I TAKE SOME OF 'EM AN' ILLUSTRATE THEM?

OH, **MAN**, ARE YOU **KIDDIN'** ME! THAT'S JUST WHAT I WANT CHA TA **DO.**

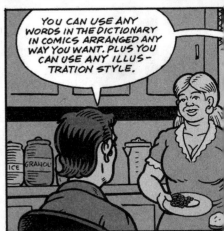

CRUMB ILLUSTRATED A STORY OF MINE CALLED "CRAZY ED" FOR "THE PEOPLE'S COMICS," AND IT WAS PUBLISHED A FEW MONTHS LATER.

PLUS HE GOT SOME ILLUSTRATOR FRIENDS OF HIS TO DRAW SOME OF MY THINGS, WHICH GOT PUBLISHED, SO I WAS ON MY WAY.

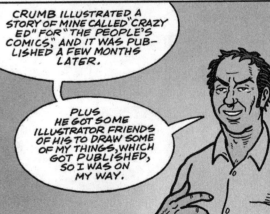

For more than 30 years, Harvey Pekar has been writing comics based on his life in Cleveland, collaborating with R. Crumb and other top illustrators and winning an international cult following. "American Splendor," a movie based on his life and work, was the surprise hit of this year's Sundance Film Festival, where it won the Grand Jury Prize. The film went on to take top honors at Cannes and other festivals. The movie will open in U.S. theaters thru August and September. We asked Pekar to recount his long journey to the big screen. This is the first feature-length comic he has ever published in a national magazine.

THIS "BIG YUM, YUM BOOK" IS **GREAT.** IT'S A REAL NOVEL. WHO YOU WORKIN' ON IT FOR?

NOBODY REALLY. IT'S JUST AN EXERCISE.

AS TIME WENT ON CRUMB GAINED MORE ILLUSTRATING RESPONSIBILITIES AT AMERICAN GREETINGS AND STARTED CONTRIBUTING STORIES TO COMIC MAGAZINES LIKE HARVEY KURTZMAN'S "HELP!"

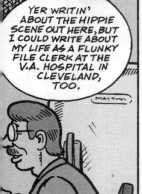

YER WRITIN' ABOUT THE HIPPIE SCENE OUT HERE, BUT I COULD WRITE ABOUT MY LIFE AS A FLUNKY FILE CLERK AT THE V.A. HOSPITAL IN CLEVELAND, TOO.

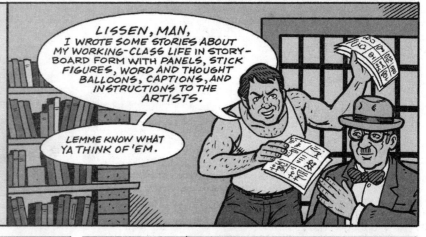

I WENT BACK TO CLEVELAND, CONTINUED TO FOLLOW THE PROGRESS OF UNDERGROUND CARTOONS AND THEORIZE. WHEN CRUMB CAME TO VISIT ME IN 1972, I HAD SOME CONCRETE IDEAS.

LISSEN, MAN, I WROTE SOME STORIES ABOUT MY WORKING-CLASS LIFE IN STORYBOARD FORM WITH PANELS, STICK FIGURES, WORD AND THOUGHT BALLOONS, CAPTIONS, AND INSTRUCTIONS TO THE ARTISTS.

LEMME KNOW WHAT YA THINK OF 'EM.

IN 1975 I WAS LIVIN' ALONE WITH FEW EXPENSES ASIDE FROM RECORD COLLECTING, AND SEVERAL GUYS WERE ILLUSTRATING MY STORIES. I DECIDED IF I QUIT SPENDING MONEY ON RECORDS, I COULD AFFORD TO PUT OUT MY OWN COMIC, WHICH I'D CALL "AMERICAN SPLENDOR."

SO WHAT IF I LOSE A COUPLE THOUSAND A YEAR? AT LEAST I'LL FINALLY BE DOIN' SOMETHIN' CREATIVE.

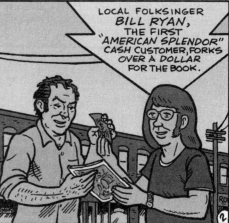

SO IN 1976 I PUBLISHED "AMERICAN SPLENDOR #1." CRUMB ILLUSTRATED A COUPLE OF PAGES FOR ME, BUT I STILL LOST A LOT OF MONEY. THAT WAS OKAY. NOW I WAS AN ARTIST AND I WAS IN IT FOR THE LONG HAUL.

LOCAL FOLKSINGER BILL RYAN, THE FIRST "AMERICAN SPLENDOR" CASH CUSTOMER, FORKS OVER A DOLLAR FOR THE BOOK.

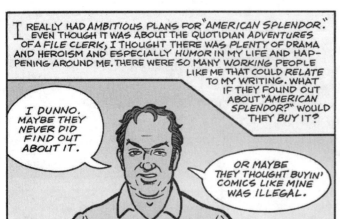

I REALLY HAD AMBITIOUS PLANS FOR "AMERICAN SPLENDOR." EVEN THOUGH IT WAS ABOUT THE QUOTIDIAN ADVENTURES OF A FILE CLERK, I THOUGHT THERE WAS PLENTY OF DRAMA AND HEROISM AND ESPECIALLY HUMOR IN MY LIFE AND HAPPENING AROUND ME. THERE WERE SO MANY WORKING PEOPLE LIKE ME THAT COULD RELATE TO MY WRITING. WHAT IF THEY FOUND OUT ABOUT "AMERICAN SPLENDOR?" WOULD THEY BUY IT?

I DUNNO. MAYBE THEY NEVER DID FIND OUT ABOUT IT.

OR MAYBE THEY THOUGHT BUYIN' COMICS LIKE MINE WAS ILLEGAL.

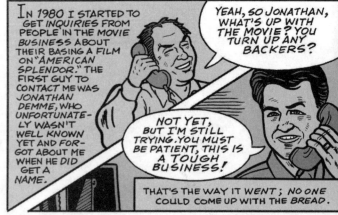

IN 1980 I STARTED TO GET INQUIRIES FROM PEOPLE IN THE MOVIE BUSINESS ABOUT THEIR BASING A FILM ON "AMERICAN SPLENDOR." THE FIRST GUY TO CONTACT ME WAS JONATHAN DEMME, WHO UNFORTUNATELY WASN'T WELL KNOWN YET AND FORGOT ABOUT ME WHEN HE DID GET A NAME.

YEAH, SO JONATHAN, WHAT'S UP WITH THE MOVIE? YOU TURN UP ANY BACKERS?

NOT YET, BUT I'M STILL TRYING. YOU MUST BE PATIENT, THIS IS A TOUGH BUSINESS!

THAT'S THE WAY IT WENT; NO ONE COULD COME UP WITH THE BREAD.

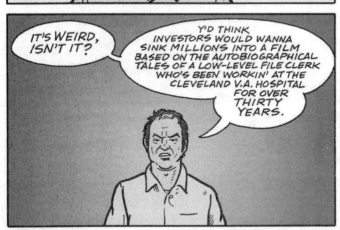

IT'S WEIRD, ISN'T IT?

Y'D THINK INVESTORS WOULD WANNA SINK MILLIONS INTO A FILM BASED ON THE AUTOBIOGRAPHICAL TALES OF A LOW-LEVEL FILE CLERK WHO'S BEEN WORKIN' AT THE CLEVELAND V.A. HOSPITAL FOR OVER THIRTY YEARS.

NOW IF YOU'VE BEEN READING THIS, CHANCES ARE YOU'VE GUESSED THAT MONEY WAS AN IMPORTANT CONSIDERATION FOR ME. NOT SO MUCH IN THE PRESENT, BUT I WAS ALREADY INTO MY FIFTIES AND IN TEN YEARS OR SO WOULD BE THINKING ABOUT RETIRING. IN ADDITION TO MY PENSION I WAS GONNA NEED FREELANCE INCOME TO SUPPORT MYSELF AND MY WIFE WHEN I RETIRED. "AMERICAN SPLENDOR" WAS ONE OF THE FEW VALUABLE ASSETS I HAD. I NEEDED TO GET THE MOST I COULD FOR IT. SO I WAITED AND HOPED.

MONEY BECAME AN EVEN MORE IMPORTANT CONSIDERATION IN 1998, WHEN I BECAME THE GUARDIAN OF A TEN-YEAR-OLD GIRL, I'D LIKE TO AT LEAST HELP HER GET THROUGH COLLEGE IF I COULD.

DANIELLE, NOW FIFTEEN.

THE NINETIES WAS A KIND OF TOUGH DECADE FOR ME TO SURVIVE ...IN 1990, I FOUND OUT THAT I HAD LYMPHOMA, SO GETTING THROUGH THE CHEMOTHERAPY AND RADIATION THERAPY WAS NO FUN.

AND THEN THERE WAS A GENERAL DOWNTURN IN COMIC SALES, AND ALTERNATIVE COMICS, WHICH ARE MARGINAL AT BEST, GOT HIT HARD.

I'VE PUT OUT SOME OF MY BEST BOOKS RECENTLY, LIKE "TRANSATLANTIC COMICS," BUT NOBODY READS THEM.

AT VARIOUS TIMES DURING THE 1990s AN L.A.-BASED ART DIRECTOR, BERNT CAPRA, BROTHER OF THE FAMOUS SCIENCE WRITER FRITJOF CAPRA ("THE TAO OF PHYSICS"), OPTIONED MY WORK. HE'D WORKED ON THAT LEONARDO DICAPRIO "GILBERT GRAPE" MOVIE AND I WAS AN OLD FRIEND OF LEONARDO'S FATHER GEORGE, AN OLD UNDERGROUND COMICS WRITER ("GREASER COMICS"), WHO HELPED US TRY TO SECURE FINANCING FOR THE FILM. BUT...

I DUNNO, HARV, THINGS SEEM PRETTY TIGHT RIGHT NOW.

BERNT'S OPTION RAN OUT, BUT BY THAT TIME HE'D HOOKED UP WITH *ROB SCHNEIDER*, THE GIFTED POPULAR MOVIE AND TV COMEDIAN.

SCHNEIDER SAW "AMERICAN SPLENDOR," AS AN EXCELLENT VEHICLE FOR HIS TALENTS, AND WANTED TO WORK SOMETHING OUT WITH BERNT AND ME. IT PROBABLY WOULD'VE BEEN A FLICK FEATURING SITCOM-TYPE HUMOR, MAYBE VERY GOOD OF ITS KIND, BUT...

FINALLY IN 1999, I CAUGHT A *BREAK*. A FRIEND THAT HAD ILLUSTRATED SOME OF MY STORIES HIPPED ME TO THE FACT THAT A *PRODUCER* NAMED *TED HOPE* AT A COMPANY CALLED *GOOD MACHINE* THAT HE'D WORKED FOR WANTED TO BASE A MOVIE ON MY COMIC BOOK SERIES.

THANKS, DEAN, WE'LL CALL 'IM. MY WIFE *JOYCE* SHOULD HAVE SOME SAY IN THIS. SHE'S SHARPER IN BUSINESS MATTERS THAN I AM.

IT TURNED OUT THAT *TED* WAS A HUMANE, REASONABLE GUY. IN A MATTER OF A FEW MINUTES HE AND JOYCE HAD WORKED OUT A DECISION ON AN OPTION AGREEMENT, WHICH I SIGNED SHORTLY THEREAFTER.

WORKING WITH SCHNEIDER WOULD CERTAINLY HAVE BEEN A VIABLE OPTION, AND I CONSIDERED IT, BUT IN THE LONG RUN I FIGURED I'D HAVE THE BEST SHOT WITH TED, WHO'D BEEN INVOLVED IN MAKING SOME TOP-NOTCH MOVIES LIKE "*THE ICE STORM*."

TED GAVE THE SCRIPTWRITER'S AND DIRECTOR'S JOBS TO A HUSBAND-AND-WIFE TEAM, *BOB PULCINI* AND *SHARI SPRINGER BERMAN*. THEY ALL AGREED THAT JOYCE AND I SHOULD BE IN THE MOVIE OURSELVES AS WELL AS THE ACTORS WHO PORTRAYED US.

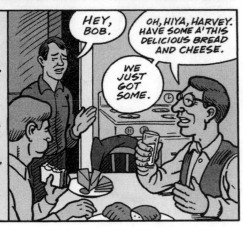

SEE, TED? WE GOT THIS IDEA FROM HARVEY'S COMICS WHERE HE'S DRAWN ALL KINDS OF WAYS BY DIFFERENT ARTISTS. SO WE THOUGHT IT'D BE APPROPRIATE TO GIVE HIM DIFFERENT LOOKS AT DIFFERENT POINTS IN THE FILM.

THE CASTING, AGAIN, *DIRECTLY OR INDIRECTLY* DUE TO TED, WAS ABOUT AS GOOD AS ONE COULD ASK FOR. *PAUL GIAMATTI* AND *HOPE DAVIS* WERE EXCELLENT, YOUNG, PERCEPTIVE, AND EXPERIENCED. THEY PLAYED JOYCE AND ME WITH THE RIGHT *FEELING*, YET BROUGHT SOMETHING IMPORTANT OF THEMSELVES TO THE ROLES.

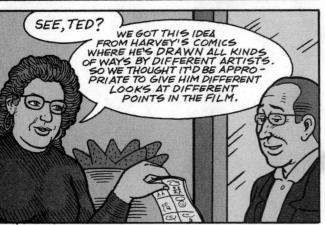

AND THEN TED PULLED OFF A *MIRACLE*. HE GOT HBO TO FINANCE THE FILM.

AND I REALLY ENJOYED *JAMES URBANIAK* AS *CRUMB*. SOME PEOPLE THOUGHT, BASED ON TERRY ZWIGOFF'S EXCELLENT DOCUMENTARY OF *CRUMB*, THAT HE WAS A KIND OF A COLD GUY. BUT HE WAS ALWAYS WARM, UNDERSTANDING, AND HELPFUL TO ME. I THOUGHT JAMES CAUGHT THAT SIDE OF HIM VERY WELL.

HEY, BOB.

OH, HIYA, HARVEY. HAVE SOME A' THIS DELICIOUS BREAD AND CHEESE. WE JUST GOT SOME.

IN THE SUMMER OF 2001 I STARTED GETTING THESE *NERVOUS ATTACKS* EVERY MORNING AT WORK. I DON'T KNOW WHAT CAUSED THEM, BUT THEY WERE PRETTY SEVERE. FINALLY I DECIDED I WOULD *RETIRE* IN OCTOBER. IT DIDN'T SEEM TO MAKE MUCH *SENSE* STAYING LONGER THAN THAT.

Y'OKAY, MAN?

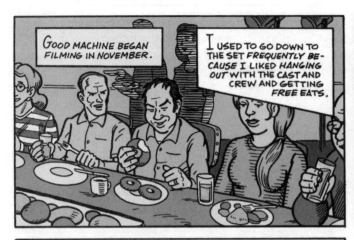

GOOD MACHINE BEGAN FILMING IN NOVEMBER.

I USED TO GO DOWN TO THE SET FREQUENTLY BECAUSE I LIKED HANGING OUT WITH THE CAST AND CREW AND GETTING FREE EATS.

WHEN THE SHOOTING WAS OVER I WAS REALLY SAD. I HADN'T HAD MUCH OF A SOCIAL LIFE FOR A WHILE, AND MY NEW ACQUAINTANCES FROM THE MOVIE BIZ HAD BROUGHT SOME REAL JOY TO MY LIFE.

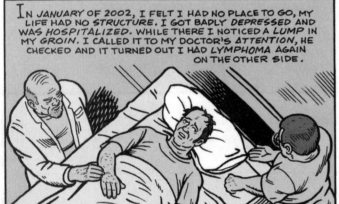

IN JANUARY OF 2002, I FELT I HAD NO PLACE TO GO, MY LIFE HAD NO STRUCTURE. I GOT BADLY DEPRESSED AND WAS HOSPITALIZED. WHILE THERE I NOTICED A LUMP IN MY GROIN. I CALLED IT TO MY DOCTOR'S ATTENTION, HE CHECKED AND IT TURNED OUT I HAD LYMPHOMA AGAIN ON THE OTHER SIDE.

BETWEEN THE TREATMENT FOR DEPRESSION AND LYMPHOMA, THE WHOLE NEXT YEAR AND A HALF IS KIND OF A BLUR TO ME. I HAD EVERYTHING FROM ELECTRIC SHOCK TREATMENTS TO CHEMOTHERAPY.

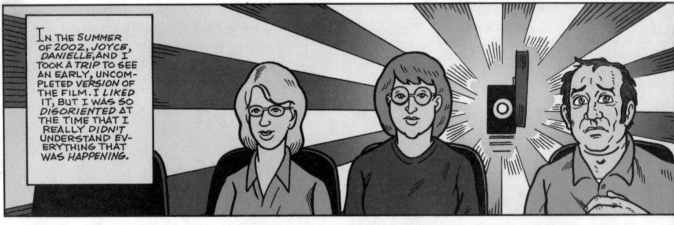

IN THE SUMMER OF 2002, JOYCE, DANIELLE, AND I TOOK A TRIP TO SEE AN EARLY, UNCOMPLETED VERSION OF THE FILM. I LIKED IT, BUT I WAS SO DISORIENTED AT THE TIME THAT I REALLY DIDN'T UNDERSTAND EVERYTHING THAT WAS HAPPENING.

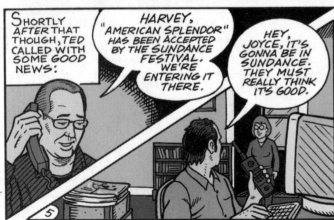

SHORTLY AFTER THAT THOUGH, TED CALLED WITH SOME GOOD NEWS:

HARVEY, "AMERICAN SPLENDOR" HAS BEEN ACCEPTED BY THE SUNDANCE FESTIVAL. WE'RE ENTERING IT THERE.

HEY, JOYCE, IT'S GONNA BE IN SUNDANCE. THEY MUST REALLY THINK IT'S GOOD.

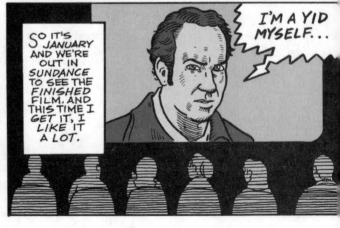

SO IT'S JANUARY AND WE'RE OUT IN SUNDANCE TO SEE THE FINISHED FILM. AND THIS TIME I GET IT, I LIKE IT A LOT.

I'M A YID MYSELF...

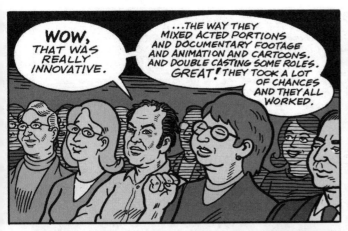

WOW, THAT WAS REALLY INNOVATIVE.

...THE WAY THEY MIXED ACTED PORTIONS AND DOCUMENTARY FOOTAGE AND ANIMATION AND CARTOONS. AND DOUBLE CASTING SOME ROLES. **GREAT!** THEY TOOK A LOT OF CHANCES AND THEY ALL WORKED.

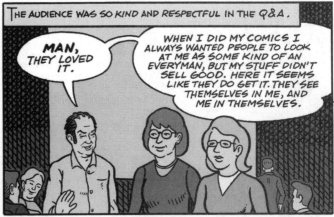

THE AUDIENCE WAS SO KIND AND RESPECTFUL IN THE Q&A.

MAN, THEY LOVED IT.

WHEN I DID MY COMICS I ALWAYS WANTED PEOPLE TO LOOK AT ME AS SOME KIND OF AN EVERYMAN, BUT MY STUFF DIDN'T SELL GOOD. HERE IT SEEMS LIKE THEY DO GET IT. THEY SEE THEMSELVES IN ME, AND ME IN THEMSELVES.

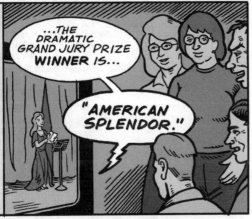

WE LEFT *SUNDANCE* BEFORE THE CLOSING CEREMONIES, BUT THIS GUY IN THE *NEIGHBORHOOD* GETS THE SUNDANCE CHANNEL ON CABLE SO WE WENT OVER TO SEE THEM AND:

...THE DRAMATIC GRAND JURY PRIZE **WINNER IS...**

"AMERICAN SPLENDOR."

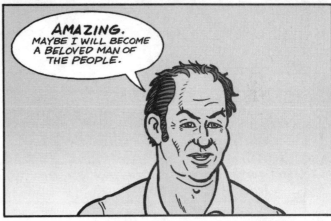

AMAZING. MAYBE I WILL BECOME A BELOVED MAN OF THE PEOPLE.

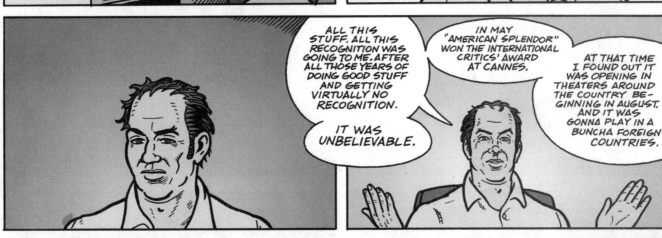

ALL THIS STUFF. ALL THIS RECOGNITION WAS GOING TO ME. AFTER ALL THOSE YEARS OF DOING GOOD STUFF AND GETTING VIRTUALLY NO RECOGNITION.

IT WAS UNBELIEVABLE.

IN MAY "AMERICAN SPLENDOR" WON THE INTERNATIONAL CRITICS' AWARD AT CANNES.

AT THAT TIME I FOUND OUT IT WAS OPENING IN THEATERS AROUND THE COUNTRY BEGINNING IN AUGUST. AND IT WAS GONNA PLAY IN A BUNCHA FOREIGN COUNTRIES.

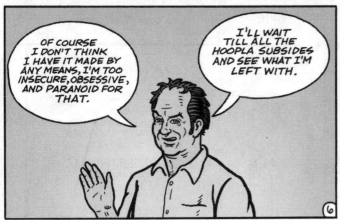

OF COURSE I DON'T THINK I HAVE IT MADE BY ANY MEANS, I'M TOO INSECURE, OBSESSIVE, AND PARANOID FOR THAT.

I'LL WAIT TILL ALL THE HOOPLA SUBSIDES AND SEE WHAT I'M LEFT WITH.

⑥

IF I CAN JUST GET SEVERAL STEADY FREELANCE GIGS OUT OF THIS AND MAKE A LITTLE MONEY FROM WRITING COMICS, IF THEY GET MORE POPULAR...

WELL, WHO KNOWS? THE ONLY WAY A SCREWED-UP GUY LIKE ME CAN TAKE IT IS ONE DAY AT A TIME.

THE END

COMICS ARE MY THING

STORY BY HARVEY PEKAR
ART BY GARY DUMM · COLOR BY LAURA DUMM

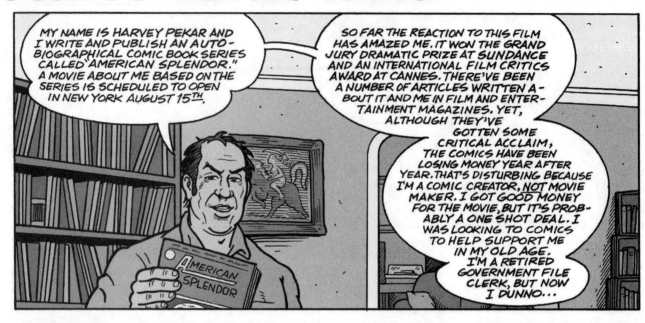

MY NAME IS HARVEY PEKAR AND I WRITE AND PUBLISH AN AUTO-BIOGRAPHICAL COMIC BOOK SERIES CALLED "AMERICAN SPLENDOR." A MOVIE ABOUT ME BASED ON THE SERIES IS SCHEDULED TO OPEN IN NEW YORK AUGUST 15TH.

SO FAR THE REACTION TO THIS FILM HAS AMAZED ME. IT WON THE GRAND JURY DRAMATIC PRIZE AT SUNDANCE AND AN INTERNATIONAL FILM CRITICS AWARD AT CANNES. THERE'VE BEEN A NUMBER OF ARTICLES WRITTEN ABOUT IT AND ME IN FILM AND ENTERTAINMENT MAGAZINES. YET, ALTHOUGH THEY'VE GOTTEN SOME CRITICAL ACCLAIM, THE COMICS HAVE BEEN LOSING MONEY YEAR AFTER YEAR. THAT'S DISTURBING BECAUSE I'M A COMIC CREATOR, NOT MOVIE MAKER. I GOT GOOD MONEY FOR THE MOVIE, BUT IT'S PROBABLY A ONE SHOT DEAL. I WAS LOOKING TO COMICS TO HELP SUPPORT ME IN MY OLD AGE. I'M A RETIRED GOVERNMENT FILE CLERK, BUT NOW I DUNNO...

I ADMIT I DIDN'T HAVE MUCH USE FOR COMICS FOR A TIME IN MY TEENS AND EARLY TWENTIES, BUT I, LIKE A LOT OF AMERICANS DIDN'T SEE THEIR POTENTIAL, I COLLECTED 'EM LIKE A MADMAN UNTIL I WAS ABOUT ELEVEN, Y'KNOW THE SUPERHERO KIND WHICH DOMINATED THE MARKET, BUT THEN I GOT TIRED OF 'EM. THEY WERE KID STUFF.

I USED TO TAKE THIS STUFF SO SERIOUSLY, BUT NOW IT'S STARTIN' TO SEEM CORNY AND PREDICTABLE.

THIS STUFF IS SO REALISTIC! I'VE KNOWN KIDS LIKE THE MOFFATS AND THEIR FRIENDS.

AT ABOUT THE SAME AGE I STARTED GETTING ACQUAINTED WITH SOME OF THE BETTER JUVENILE AUTHORS, ESPECIALLY ELEANOR ESTES, WHO WROTE A SERIES OF BOOKS ABOUT A SINGLE-PARENT FAMILY IN "CONNECTICUT, THE MOFFATS." ESTES WAS PROBABLY MY FIRST STRONG LITERARY INFLUENCE.

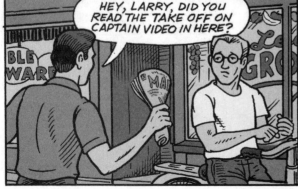

SO FOR A LONG TIME I PRETTY MUCH FORGOT ABOUT COMICS, EXCEPT FOR HARVEY KURTZMAN'S MAD. KURTZMAN'S SATIRE WAS INNOVATIVE, AND PUT HIM IN A CLASS WITH OTHER FAR OUT HUMORISTS LIKE BOB AND RAY, LENNY BRUCE AND JONATHAN WINTERS.

HEY, LARRY, DID YOU READ THE TAKE OFF ON CAPTAIN VIDEO IN HERE?

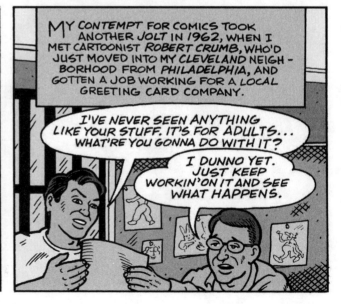

MY CONTEMPT FOR COMICS TOOK ANOTHER JOLT IN 1962, WHEN I MET CARTOONIST ROBERT CRUMB, WHO'D JUST MOVED INTO MY CLEVELAND NEIGHBORHOOD FROM PHILADELPHIA, AND GOTTEN A JOB WORKING FOR A LOCAL GREETING CARD COMPANY.

I'VE NEVER SEEN ANYTHING LIKE YOUR STUFF. IT'S FOR ADULTS... WHAT'RE YOU GONNA DO WITH IT?

I DUNNO YET. JUST KEEP WORKIN' ON IT AND SEE WHAT HAPPENS.

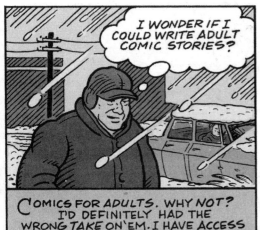

I WONDER IF I COULD WRITE ADULT COMIC STORIES?

COMICS FOR ADULTS. WHY NOT? I'D DEFINITELY HAD THE WRONG TAKE ON 'EM. I HAVE ACCESS TO EVERY WORD THAT SHAKESPEARE USED. AND THERE'S SO MUCH THAT COULD BE DONE IN COMICS THAT HASN'T BEEN DONE. I HAVE A CHANCE TO BE AN INNOVATOR.

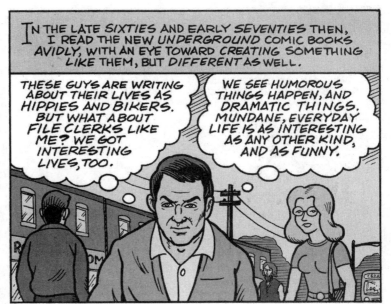

IN THE LATE SIXTIES AND EARLY SEVENTIES THEN, I READ THE NEW UNDERGROUND COMIC BOOKS AVIDLY, WITH AN EYE TOWARD CREATING SOMETHING LIKE THEM, BUT DIFFERENT AS WELL.

THESE GUYS ARE WRITING ABOUT THEIR LIVES AS HIPPIES AND BIKERS. BUT WHAT ABOUT FILE CLERKS LIKE ME? WE GOT INTERESTING LIVES, TOO.

WE SEE HUMOROUS THINGS HAPPEN, AND DRAMATIC THINGS. MUNDANE, EVERYDAY LIFE IS AS INTERESTING AS ANY OTHER KIND, AND AS FUNNY.

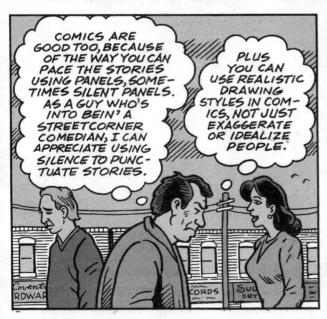

COMICS ARE GOOD TOO, BECAUSE OF THE WAY YOU CAN PACE THE STORIES USING PANELS, SOMETIMES SILENT PANELS. AS A GUY WHO'S INTO BEIN' A STREETCORNER COMEDIAN, I CAN APPRECIATE USING SILENCE TO PUNCTUATE STORIES.

PLUS YOU CAN USE REALISTIC DRAWING STYLES IN COMICS, NOT JUST EXAGGERATE OR IDEALIZE PEOPLE.

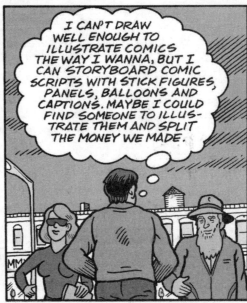

I CAN'T DRAW WELL ENOUGH TO ILLUSTRATE COMICS THE WAY I WANNA, BUT I CAN STORYBOARD COMIC SCRIPTS WITH STICK FIGURES, PANELS, BALLOONS AND CAPTIONS. MAYBE I COULD FIND SOMEONE TO ILLUSTRATE THEM AND SPLIT THE MONEY WE MADE.

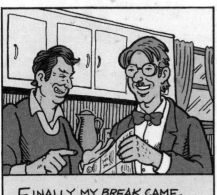

FINALLY MY BREAK CAME. IN 1972 I SHOWED MY SCRIPTS TO CRUMB AND HE LIKED THEM AND ASKED IF HE COULD ILLUSTRATE SOME, SOMETHING HE'S NEVER DONE FOR ANYONE ELSE. IT GAVE ME INSTANT CREDIBILITY.

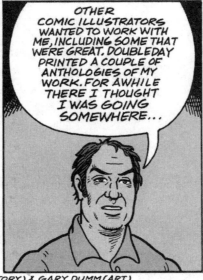

OTHER COMIC ILLUSTRATORS WANTED TO WORK WITH ME, INCLUDING SOME THAT WERE GREAT. DOUBLEDAY PRINTED A COUPLE OF ANTHOLOGIES OF MY WORK. FOR AWHILE THERE I THOUGHT I WAS GOING SOMEWHERE...

YOU NEVER KNOW.

PEKAR
Dumm
Dumm

© COPYRIGHT 2003 BY HARVEY PEKAR (STORY) & GARY DUMM (ART)

SUNDANCE

Story by HARVEY PEKAR
Art by GARY DUMM

LAST JANUARY 19 I FOUND MYSELF, MY WIFE AND KID ON AN AIRPLANE HEADED TOWARD SALT LAKE CITY. FROM THERE I WOULD GO TO PARK CITY, UTAH, WHERE A FILM, "**AMERICAN SPLENDOR**," BASED ON MY COMIC BOOK SERIES, WAS COMPETING FOR A PRIZE IN THE DRAMATIC FEATURE CATEGORY.

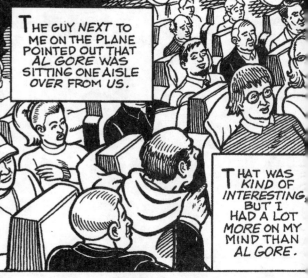

THE GUY NEXT TO ME ON THE PLANE POINTED OUT THAT AL GORE WAS SITTING ONE AISLE OVER FROM US.

THAT WAS KIND OF INTERESTING, BUT I HAD A LOT MORE ON MY MIND THAN AL GORE.

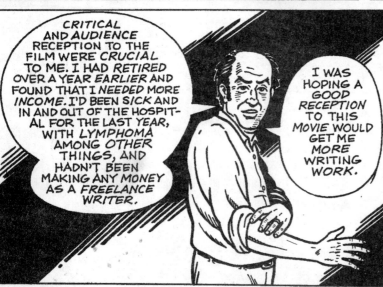

CRITICAL AND AUDIENCE RECEPTION TO THE FILM WERE CRUCIAL TO ME. I HAD RETIRED OVER A YEAR EARLIER AND FOUND THAT I NEEDED MORE INCOME. I'D BEEN SICK AND IN AND OUT OF THE HOSPITAL FOR THE LAST YEAR, WITH LYMPHOMA AMONG OTHER THINGS, AND HADN'T BEEN MAKING ANY MONEY AS A FREELANCE WRITER.

I WAS HOPING A GOOD RECEPTION TO THIS MOVIE WOULD GET ME MORE WRITING WORK.

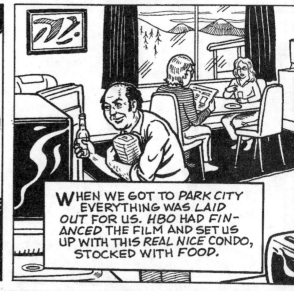

WHEN WE GOT TO PARK CITY EVERYTHING WAS LAID OUT FOR US. HBO HAD FINANCED THE FILM AND SET US UP WITH THIS REAL NICE CONDO, STOCKED WITH FOOD.

THAT NIGHT I GOT TOGETHER WITH HBO FILM EXECUTIVE MAUD NADLER, PRODUCER TED HOPE OF GOOD MACHINE, DIRECTOR/WRITERS BOB PULCINI AND SHARI BERMAN AND PUBLICIST LAURA KIM OF MPRM TO TALK OVER WHAT WE'D BE DOING OVER THE NEXT FEW DAYS. "AMERICAN SPLENDOR" WAS DEBUTING THE NEXT NIGHT AND I STILL HADN'T SEEN A FINAL VERSION OF IT. I WAS NERVOUS.

WELL, I NEEDN'T HAVE WORRIED. AUDIENCE RECEPTION TO THE FILM WAS TERRIFIC. THEY GAVE IT A GREAT HAND AND WERE VERY FRIENDLY AND POSITIVE IN THE Q AND A THAT FOLLOWED.

I REALLY ENJOYED THE MOVIE. WERE YOU WORRIED ABOUT HOW YOU'D BE PERCEIVED BY THE AUDIENCE?

I WANTED YOU TO LIKE IT BUT IT WASN'T THAT IMPORTANT TO ME WHETHER I WAS SEEN AS A NICE GUY OR NOT.

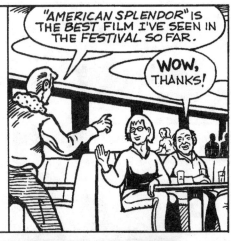

AFTER THE MOVIE A COUPLE OF CRITICS I RESPECTED CAME UP TO ME IN A RESTAURANT TO LET ME KNOW HOW MUCH THEY DUG "AMERICAN SPLENDOR." A "BUZZ" WAS STARTING ABOUT IT.

"AMERICAN SPLENDOR" IS THE BEST FILM I'VE SEEN IN THE FESTIVAL SO FAR.

WOW, THANKS!

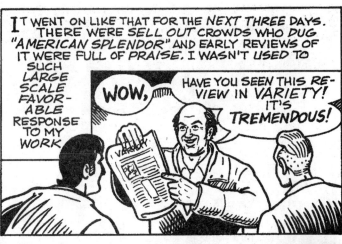

IT WENT ON LIKE THAT FOR THE NEXT THREE DAYS. THERE WERE SELL OUT CROWDS WHO DUG "AMERICAN SPLENDOR" AND EARLY REVIEWS OF IT WERE FULL OF PRAISE. I WASN'T USED TO SUCH LARGE SCALE FAVORABLE RESPONSE TO MY WORK

WOW,

HAVE YOU SEEN THIS REVIEW IN VARIETY! IT'S TREMENDOUS!

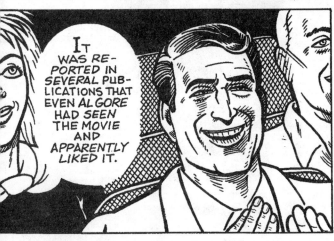

IT WAS REPORTED IN SEVERAL PUBLICATIONS THAT EVEN AL GORE HAD SEEN THE MOVIE AND APPARENTLY LIKED IT.

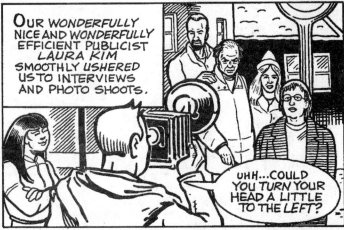

OUR WONDERFULLY NICE AND WONDERFULLY EFFICIENT PUBLICIST LAURA KIM SMOOTHLY USHERED US TO INTERVIEWS AND PHOTO SHOOTS.

UHH...COULD YOU TURN YOUR HEAD A LITTLE TO THE LEFT?

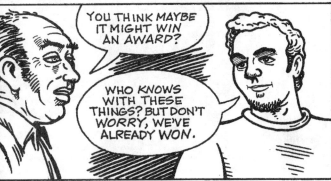

WE LEFT PARK CITY ON THURSDAY, JANUARY 23, KNOWING THAT THE MOVIE WAS WELL REGARDED. I WAS TALKING TO BOB PULCINI ABOUT IT.

YOU THINK MAYBE IT MIGHT WIN AN AWARD?

WHO KNOWS WITH THESE THINGS? BUT DON'T WORRY, WE'VE ALREADY WON.

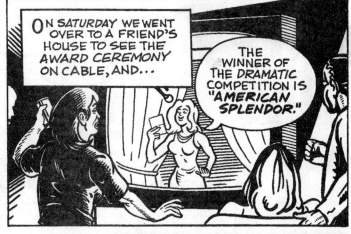

ON SATURDAY WE WENT OVER TO A FRIEND'S HOUSE TO SEE THE AWARD CEREMONY ON CABLE, AND...

THE WINNER OF THE DRAMATIC COMPETITION IS "AMERICAN SPLENDOR."

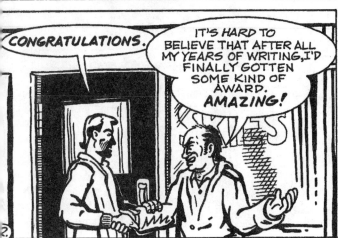

CONGRATULATIONS.

IT'S HARD TO BELIEVE THAT AFTER ALL MY YEARS OF WRITING, I'D FINALLY GOTTEN SOME KIND OF AWARD. AMAZING!

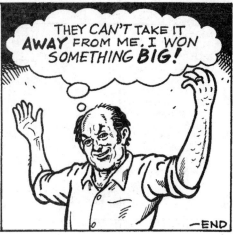

WELL, NOW IT'S A COUPLE OF WEEKS AFTER THE FESTIVAL AND I'VE BEEN BUSY TRYING TO LINE UP WRITING JOBS. I'M STILL VERY APPREHENSIVE ABOUT MY FUTURE, AND MAYBE ALWAYS WILL BE. BUT:

THEY CAN'T TAKE IT AWAY FROM ME. I WON SOMETHING BIG!

—END

MY JOURNEY TO CANNES

Story by Harvey Pekar
Art by Gary Dumm

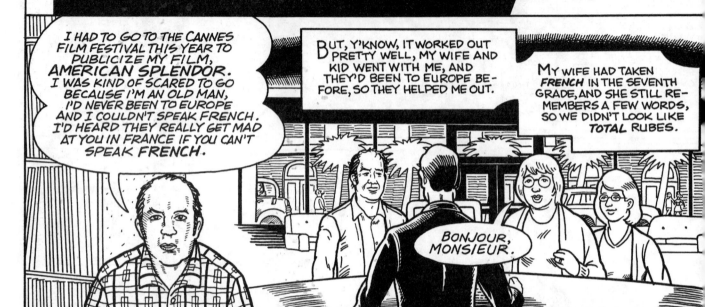

I HAD TO GO TO THE CANNES FILM FESTIVAL THIS YEAR TO PUBLICIZE MY FILM, AMERICAN SPLENDOR. I WAS KIND OF SCARED TO GO BECAUSE I'M AN OLD MAN, I'D NEVER BEEN TO EUROPE AND I COULDN'T SPEAK FRENCH. I'D HEARD THEY REALLY GET MAD AT YOU IN FRANCE IF YOU CAN'T SPEAK FRENCH.

BUT, Y'KNOW, IT WORKED OUT PRETTY WELL, MY WIFE AND KID WENT WITH ME, AND THEY'D BEEN TO EUROPE BEFORE, SO THEY HELPED ME OUT.

MY WIFE HAD TAKEN FRENCH IN THE SEVENTH GRADE, AND SHE STILL REMEMBERS A FEW WORDS, SO WE DIDN'T LOOK LIKE TOTAL RUBES.

BONJOUR, MONSIEUR.

EVERYBODY OVER THERE COULD TALK ENGLISH ANYWAY, MAYBE BECAUSE CANNES IS A RESORT THAT A LOT OF ENGLISHMEN AND AMERICANS GO TO. PLUS I WAS VERY POLITE AND I THINK THEY COULD SENSE MY HEART WAS IN THE RIGHT PLACE, SO THINGS WORKED OUT O.K.

MERCI BEAUCOUP.

I WAS IN GOOD SHAPE CLOTHES-WISE. I HAD BORROWED A TUXEDO FROM A NEIGHBOR THAT WOULD GET ME PAST THE FASHION POLICE.

THE FIRST COUPLE OF DAYS WE DIDN'T HAVE TOO MUCH TO DO SO WE TOURED AROUND GOING TO LOCAL MUSEUMS. A LOT OF FAMOUS PAINTERS WORKED IN OR NEAR CANNES.

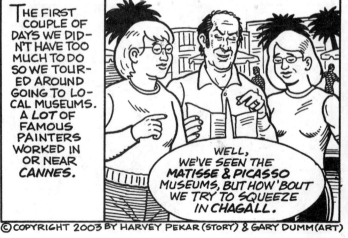

WELL, WE'VE SEEN THE MATISSE & PICASSO MUSEUMS, BUT HOW 'BOUT WE TRY TO SQUEEZE IN CHAGALL.

ACTUALLY IT WAS A GOOD THING I WENT TO THE CHAGALL MUSEUM. I FOUND I'D BEEN UNDERRATING THE GUY.

WOW!

HIS COLORS ARE SO MUCH MORE VIVID THAN IN REPRODUCTIONS I'VE SEEN OF HIS WORK.

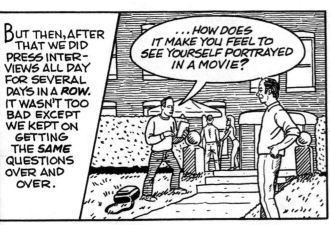

BUT THEN, AFTER THAT WE DID PRESS INTERVIEWS ALL DAY FOR SEVERAL DAYS IN A ROW. IT WASN'T TOO BAD EXCEPT WE KEPT ON GETTING THE SAME QUESTIONS OVER AND OVER.

...HOW DOES IT MAKE YOU FEEL TO SEE YOURSELF PORTRAYED IN A MOVIE?

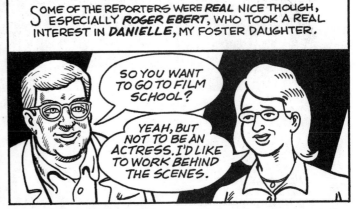

SOME OF THE REPORTERS WERE REAL NICE THOUGH, ESPECIALLY ROGER EBERT, WHO TOOK A REAL INTEREST IN DANIELLE, MY FOSTER DAUGHTER.

SO YOU WANT TO GO TO FILM SCHOOL?

YEAH, BUT NOT TO BE AN ACTRESS. I'D LIKE TO WORK BEHIND THE SCENES.

THE HOTEL WAS PRETTY RITZY, BUT THEIR SERVICE WAS TOP NOTCH, INCLUDING THEIR CLOTHES CLEANING.

WOW! I NEVER THOUGHT THEY'D BE ABLE T'GET THAT WINE STAIN OUT OF DANIELLE'S NEW DRESS BUT THEY DID. MAN, I GOT SO MAD WHEN THAT BIMBO SPILLED IT ON HER.

DANIELLE GOT ANOTHER THRILL WHEN SHE MET ALL THESE "CUTE" HIGH SCHOOL BOYS WHO WERE IN GUS VAN SANT'S MOVIE, "THE ELEPHANT."

BOY, LOOKIT HER. SHE'S IN HER GLORY.

THEY ACTUALLY WERE PRETTY NICE KIDS, THOUGH, AND SAID THEY WERE GOING TO STAY IN TOUCH WITH EACH OTHER.

WHAT'S YOUR E-MAIL ADDRESS? MINE IS...

CANNES WAS SO RITZY, THOUGH. I FELT OUTTA PLACE AND A LITTLE GUILTY GETTIN' ALL THIS RED CARPET TREATMENT, EVEN IF SOMEONE ELSE WAS PICKING UP THE TAB.

MAN! LOOK AT THE PRICES ON THIS MENU!

I'M GLAD I'M NOT PAYIN' THE TAB.

ARTURO OUR DRIVER, GAVE US A SPECIAL TOUR OF NEIGHBORING MONACO BEFORE WE LEFT. HE HAD A CRUSH ON THIS LADY WHO WAS USHERING US AROUND.

DO YOU NOT THINK SHE IS BEAUTIFUL?

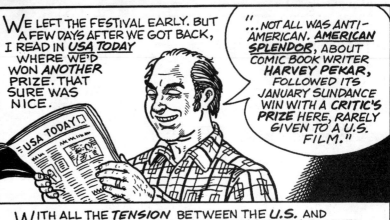

WE LEFT THE FESTIVAL EARLY. BUT A FEW DAYS AFTER WE GOT BACK, I READ IN USA TODAY WHERE WE'D WON ANOTHER PRIZE. THAT SURE WAS NICE.

"...NOT ALL WAS ANTI-AMERICAN. AMERICAN SPLENDOR, ABOUT COMIC BOOK WRITER HARVEY PEKAR, FOLLOWED ITS JANUARY SUNDANCE WIN WITH A CRITIC'S PRIZE HERE, RARELY GIVEN TO A U.S. FILM."

WITH ALL THE TENSION BETWEEN THE U.S. AND FRANCE OVER THE INVASION OF IRAQ, I WAS GLAD TO DO SOMETHING TO HELP CALM THINGS DOWN.

END.

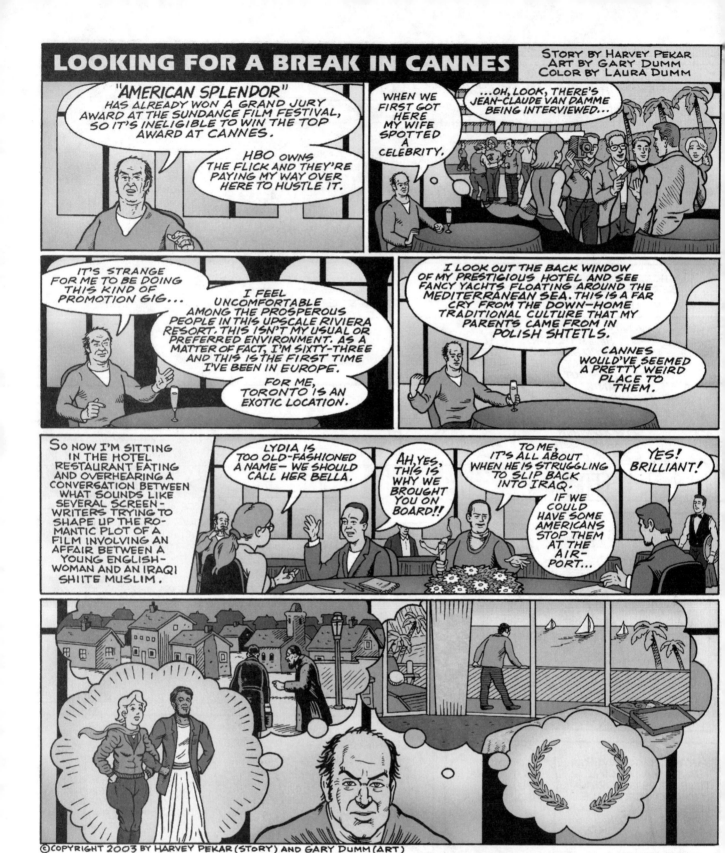

My First Visit To Great Britain
STORY BY HARVEY PEKAR • ART BY GARY DUMM • COLOR BY LAURA DUMM

Harvey Pekar changed the face of comic books with his deadpan observations of everyday life. Exclusively for Empire, he retraces his U.K. publicity tour to promote **American Splendor**, the bittersweet movie of his weird, wonderful life.

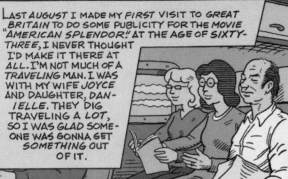

LAST AUGUST I MADE MY *FIRST* VISIT TO GREAT BRITAIN TO DO SOME PUBLICITY FOR THE MOVIE "AMERICAN SPLENDOR." AT THE AGE OF SIXTY-THREE, I NEVER THOUGHT I'D MAKE IT THERE AT ALL. I'M NOT MUCH OF A TRAVELING MAN. I WAS WITH MY WIFE JOYCE AND DAUGHTER, DANIELLE. THEY DIG TRAVELING A LOT, SO I WAS GLAD SOMEONE WAS GONNA GET SOMETHING OUT OF IT.

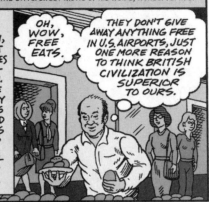

OUR FIRST STOP WAS EDINBURGH, BUT BEFORE THAT WE CHANGED PLANES AT GATWICK AIRPORT IN LONDON. THEY HAD THESE LITTLE LOUNGES BY THE PLANE GATES WHERE YOU COULD HELP YOURSELVES TO PASTRIES AND BEVERAGES. I HADN'T SEEN ANYTHING LIKE THAT IN THE STATES.

OH, WOW, FREE EATS.

THEY DON'T GIVE AWAY ANYTHING FREE IN U.S. AIRPORTS, JUST ONE MORE REASON TO THINK BRITISH CIVILIZATION IS SUPERIOR TO OURS.

THERE WAS A *FILM FESTIVAL* AND A BUNCH OF OTHER FESTIVALS GOING ON IN *EDINBURGH*, AND THE TOWN WAS SWOLLEN TO *TWICE* ITS NUMBER BY TOURISTS. WE WERE MET AT THE *AIRPORT* BY *EMMA PYCROFT* OF *OPTIMUM*, THE FIRM THAT WAS GOING TO BE DISTRIBUTING "AMERICAN SPLENDOR," AND MARK BANKS, A DRIVER AND GUIDE THAT THE *FILM FESTIVAL* HAD ASSIGNED TO ASSIST US.

HOW D'YEH DO?

...HERE, LET ME GI' YOU A HAND WITH YOUR LUGGAGE.

BOTH OF THEM WERE *EXCELLENT* COMPANY, FRIENDLY AND QUITE HELPFUL TO US DURING OUR STAY, MARK ESPECIALLY, SINCE HE WAS AN *EDINBURGH* NATIVE AND HAD A GOOD KNOWLEDGE OF THE CITY'S *HISTORY*.

NOW IF YOU'LL LOOK AT THE TOP A' THAT CLIFF, THAT'S THE OLDER PART A' THE CITY.

EDINBURGH REALLY HAD IT GOIN' ON THAT WEEK. THE STREETS WERE THRONGED WITH TOURISTS, A FEW DRUNK, BUT EVERYONE CHEERFUL. IT'S A NICE, COMPACT CITY, EASY TO GET AROUND IN AND, THOUGH OLD, WELL KEPT UP.

ONE OF THE FIRST THINGS EMMA DID WAS TO SHOW US AN EXCELLENT REVIEW OF "AMERICAN SPLENDOR" IN THE GUARDIAN. THAT CERTAINLY RAISED MY OPINION OF THE *BRITISH POPULATION* QUICKLY.

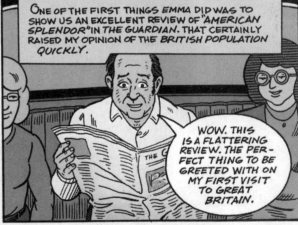

WOW. THIS IS A FLATTERING REVIEW. THE PERFECT THING TO BE GREETED WITH ON MY FIRST VISIT TO GREAT BRITAIN.

OVER HERE YE'LL SEE A CABINET FILLED WITH SNACKS AN' BEVERAGES.

WE CHECKED IN AT THE HOTEL, WHERE I SAW MY FIRST SCOTSMAN DRESSED IN KILTS. HE SHOWED US TO OUR ROOM. I GUESS THE GENERAL *MALE* POPULATION OF *EDINBURGH* DOESN'T HAVE A GREAT DEAL OF USE FOR KILTS AS EVERYDAY APPAREL.

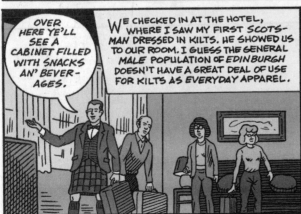

SO THEN JOYCE AND DANIELLE TOOK A WALK TO CHECK OUT EDINBURGH AND DO SOME SHOPPING AND MARK DROVE ME AROUND TO DO SOME BOOK SHOPPING.

'AY, MARK, 'AY HERE'S LEWIS GRASSIC GIBBON'S FIRST NOVEL, "STAINED RADIANCE," I REALLY LIKE THAT GUY, Y'KNOW HE'S ONE OF THE TOP SCOTTISH WRITERS OF TH' 20TH CENTURY.

THE *NEXT* DAY WE WENT OUT TO THE AIRPORT T'MEET *PAUL GIAMATTI,* WHO PLAYED ME IN THE MOVIE.

'AY WHAT'S 'AT "FREE BUDDY" T-SHIRT YER WEARIN'? IS 'AT THAT PROVIDENCE MAYOR THAT WAS HEAD OF THE MAFIA DOWN THERE, AN' THEN THEY BUSTED 'IM FOR SOMETHIN'? IS HE STILL IN JAIL?

YEAH, HE'S KIND OF A FOLK HERO - T'SOME PEOPLE, ANYWAY.

So, Y'KNOW, *PAUL'S* A BIG BOOK COLLECTOR, SO WE TOOK 'IM OVER T' THIS BOOK STORE WHERE I'D "GOTTEN STAINED RADIANCE" AND HE SCORED.

WHOA, THE COMPLETE WORKS OF *JAMES HOGG* IN TWO VOLUMES FOR 25 POUNDS. *SIR WALTER SCOTT* LIKED HIS WORK. HE STARTED OUT AS A FARMER. HE WROTE ALL KINDS OF INTERESTING STUFF.

THAT NIGHT *PAUL* GOT TO TALKING WITH *ERIN,* WHO WORKED WITH *EMMA,* AND *DANIELLE* ABOUT *KILTS.*

YEAH, I THINK THOSE KILTS ARE PRETTY COOL, MAN. I C'LD SEE MYSELF WEARIN' ONE. DEF'NITELY.

So THE NEXT MORNING *ERIN* AND *DANIELLE* WENT TO THE KILT SHOP TO RENT *PAUL* A KILT WITHOUT HIM *KNOWING* ABOUT IT.

HERE, LET ME GI' YEH A LITTLE INFORMATION ABOUT HOW HE'S SUPPOSED T'GET IT ON HIMSELF.

HE WAS PRETTY SURPRISED WHEN *DANIELLE* AND *ERIN* BROUGHT TH' KILT OVER TO HIM, BUT HE PUT IT ON AND *WORE* IT THAT DAY.

WHAT D'YA THINK, DO I LOOK OKAY?

YEAH, *PAUL,* Y'LOOK LIKE A *TRUE SCOTSMAN.*

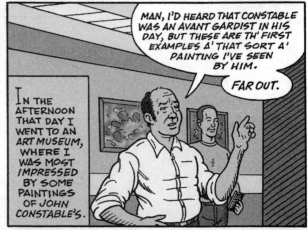

MAN, I'D HEARD THAT CONSTABLE WAS AN AVANT GARDIST IN HIS DAY, BUT THESE ARE TH' FIRST EXAMPLES Δ' THAT SORT Δ' PAINTING I'VE SEEN BY HIM.

FAR OUT.

IN THE AFTERNOON THAT DAY I WENT TO AN ART MUSEUM, WHERE I WAS MOST IMPRESSED BY SOME PAINTINGS OF *JOHN CONSTABLE'S.*

ON THE NEXT DAY, AND OUR *LAST* IN *SCOTLAND,* WE WENT TO AN AWARDS CEREMONY AND *PAUL* WAS *STILL* WEARING HIS KILTS.

GOOD MAN! DON'T MIND THOSE PEOPLE WHO ARE LOOKIN' AT YOU FUNNY ON ACCOUNTA THOSE KILTS. TOO MANY PEOPLE DRESS THE SAME NOWADAYS. YER SHOWIN' SOME STYLISTIC INDIVIDUALITY.

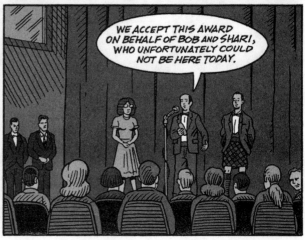

WE ACCEPT THIS AWARD ON BEHALF OF BOB AND SHARI, WHO UNFORTUNATELY COULD NOT BE HERE TODAY.

THEN WE WENT TA LONDON TO DO SOME MORE PUBLICITY WORK ON BEHALF OF "AMERICAN SPLENDOR."

WHEW. THIS IS A BIG ASS CITY LIKE NEW YORK. MAYBE EASIER TO GET A-ROUND IN IT THOUGH.

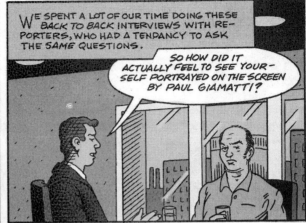

WE SPENT A LOT OF OUR TIME DOING THESE BACK TO BACK INTERVIEWS WITH RE-PORTERS, WHO HAD A TENDANCY TO ASK THE SAME QUESTIONS.

SO HOW DID IT ACTUALLY FEEL TO SEE YOUR-SELF PORTRAYED ON THE SCREEN BY PAUL GIAMATTI?

OTHER THAN THAT WE DID THE USUAL TOUR-ISTY THINGS. WE SAW A COUPLE OF SHOWS THAT'D BEEN AROUND FOR AWHILE BECAUSE TICKETS WEREN'T A-VAILABLE FOR MORE RECENT ONES. MAYBE SEEING "MY FAIR LADY" AND "CHICAGO" WERE A KICK FOR DANIELLE. MY WIFE JOYCE LIKED 'EM OKAY. I GUESS THEY'RE REGARDED AS CLASSICS.

THE RAIN IN SPAIN FELL MAINLY ON THE PLAIN...

WE DID CATCH THIS ONE NEW BOLLYWOOD MUSICAL "BOMBAY DREAMS," THAT HAD SOME GOOD MUSIC AND A PLOT THAT WAS SO CORNY IT WAS KINDA HIP.

SHAKA LAKA, BABY.

WE WENT TO HENRY THE EIGHTH'S CASTLE. THEY HAD THESE ACTORS DRESSED UP LIKE THEY HAD IN HIS TIME AND DOING BITS THAT WERE SUPPOSED TO BE REMINISCENT OF THE PERIOD. SOMETIMES THEY GOT IN YOUR FACE.

OH, SIR, I BESEECH YOU...

MAN, TAKE IT EASY, WILLYA?

THEN WE WENT TO THE BRITISH MUSEUM.

MAN, THESE ENGLISHMEN WERE REALLY INTA STEALIN' STUFF OFFA POOR COUNTRIES.

WE WOUND UP OUR DAYS IN ENGLAND IN CAMBRIDGE WITH A FRIEND. WE HIKED ALONG THE RIVER CAM, WHILE ALL KINDSA PEOPLE WERE HAV-ING TROUBLE PUNTING ON IT.

THUD!

SO THEN WE CAME HOME. I CAME HOME A COUPLE DAYS EARL-IER THAN MY WIFE & KID BECAUSE I HADDA DO THE HOWARD STERN SHOW IN NEW YORK. IT WAS FINE, THOUGH.

WHAT IS IT ABOUT THAT DAVID LETTERMAN? HE'S ALWAYS JUDGING PEOPLE.

END-

MY POST COLLECTING YEARS

STORY by HARVEY PEKAR

ART by GARY DUMM

COLOR by LAURA DUMM

THIS IS MY JAPANESE DEBUT.

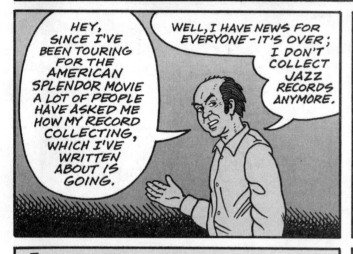

HEY, SINCE I'VE BEEN TOURING FOR THE AMERICAN SPLENDOR MOVIE A LOT OF PEOPLE HAVE ASKED ME HOW MY RECORD COLLECTING, WHICH I'VE WRITTEN ABOUT IS GOING.

WELL, I HAVE NEWS FOR EVERYONE – IT'S OVER; I DON'T COLLECT JAZZ RECORDS ANYMORE.

THAT MAY SURPRISE SOME OF YOU, BUT I GOT TO BE SUCH A FANATIC COLLECTOR OF RECORDS AND BOOKS THAT FINALLY SOMETHING IN ME SNAPPED. I'VE NEVER THOUGHT I COULD OVERCOME MY OBSESSIVE COLLECTING, BUT IT LOOKS LIKE I HAVE. IT'S JUST GOTTEN TOO MUCH OUT OF HAND FOR EVEN A COMPULSIVE NUT LIKE ME TO HANDLE.

IT'S KIND OF FUNNY, BECAUSE A WHOLE LOT OF MY RECORDS WOUND UP IN JAPAN WELL BEFORE I DID, MY FIRST VISIT HERE BEING IN MAY, 2004.

DURING THE FIRST PERIOD OF MY COLLECTING – FROM 1956 TO 1975 I TRIED TO GET JUST ABOUT EVERY JAZZ LP THAT WAS EVER CUT. I HAD A FRIEND IN CALIFORNIA WHO WAS A RECORD DEALER. I USED TO TRADE HIM FIRST EDITION AMERICAN JAZZ LPs FOR JAPANESE REISSUES OF THE SAME RECORDS PLUS OTHER RECORDS OR CASH. (I DIDN'T CARE IF A RECORD WAS A FIRST EDITION OR NOT AS LONG AS IT SOUNDED GOOD.)

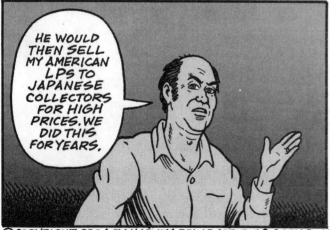

HE WOULD THEN SELL MY AMERICAN LPs TO JAPANESE COLLECTORS FOR HIGH PRICES. WE DID THIS FOR YEARS.

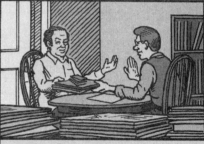

I STARTED GETTING COMIC BOOK STORIES PUBLISHED IN 1972. MY STORIES GOT LONGER AND MORE AMBITIOUS AS TIME WENT ON, WHILE THE ACTUAL SALES OF ALTERNATIVE OR UNDERGROUND COMICS SHRANK. SO I WAS HAVING TROUBLE GETTING MY COMICS STORIES PUBLISHED. THAT WAS ESPECIALLY UNFORTUNATE BECAUSE THEY GOT EXCELLENT READER REACTION, AND THAT IMPROVED MY MORALE A GREAT DEAL.

HEY, HARVEY, I REALLY LIKE YOUR STORY HERE.

SO WHAT I DID IN 1975 WAS TO DEEMPHASIZE MY INTEREST IN WRITING JAZZ. I'VE BEEN A JAZZ CRITIC SINCE 1959, BUT NOW WOULD CONCENTRATE ON WRITING *ENTIRE* COMICS WHICH I WOULD *PUBLISH* MYSELF WITH THE MONEY I SAVED BY *NOT* COLLECTING RECORDS.

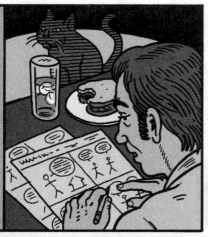

MY FIRST COMIC, *AMERICAN SPLENDOR #1*, RECEIVED VERY FAVORABLE *REVIEWS*, AND FOR YEARS AFTER THAT I CONCENTRATED ON COMICS *INSTEAD* OF JAZZ. AFTER ALL, IT'S BETTER TO BE AN *ARTIST* THAN A *CRITIC*.

BUT IN *1980* I DECIDED TO STUDY *PROSE FICTION* WRITING OF THE PAST SEVERAL CENTURIES VERY *CLOSELY*, AND BEGINNING THEN BOUGHT *THOUSANDS* OF *USED* BOOKS. THESE WEREN'T *EXPENSIVE*, BUT THEY TOOK UP A *GREAT DEAL* OF SPACE.

FINALLY, IN THE LATE 1980s, I STARTED WRITING ABOUT JAZZ AGAIN. SOME AVANT GARDE JAZZMEN HAD EMERGED WHO I FELT STRONGLY ABOUT. SO I STARTED GETTING *THOUSANDS* OF CDS TO REVIEW FROM *RECORD* COMPANIES.

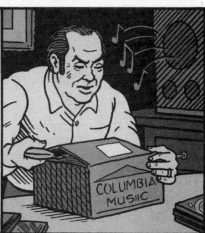

COLUMBIA MUSIC

AT FIRST IT WAS *GREAT* GETTING ALL THAT *FREE* MUSIC, BUT GRADUALLY I RAN OUT OF SPACE FOR ALL MY *LPS*, *BOOKS* AND *CDS*. I HAD *NO PLACE* TO FILE THEM ANYMORE, SO I PUT THEM IN BOXES TO PILE UP IN MY *BASEMENT*.

THEN I *COULDN'T* FIND ANYTHING ANYMORE. I COULD LOOK FOR A *BOOK*, *LP* OR *CD* FOR DAYS AND *NOT* LOCATE IT.

WHAT WAS THE *SENSE* OF COLLECTING THINGS I COULDN'T FIND? MY HOUSE WAS SO CLUTTERED IT REALLY UPSET MY *WIFE*. AT THAT POINT COLLECTING DIDN'T SEEM TO *MATTER* TO ME. I GAVE IT UP.

WHERE'S ALL THIS STUFF GOING TO GO?

SO I GOT *RID* OF AS MANY OF THE LPS AND CDS AS I COULD TO DEALERS. WHO KNOWS HOW MANY WOUND UP IN JAPAN? ANYWAY, NOW I'M FINALLY PAYING A VISIT TO THE COUNTRY WHERE SO MANY OF MY RECORDS HAVE BEEN FOR SO LONG.

IRONIC ISN'T IT?

2

THE *NEW* DVD

STORY by Harvey Pekar
ART by Gary Dumm
COLOR by Laura Dumm

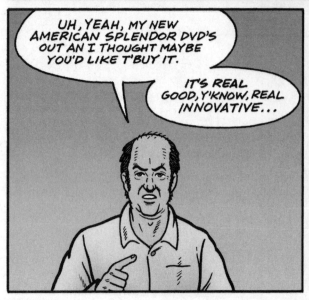

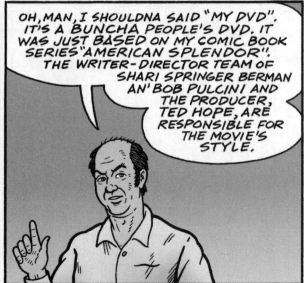

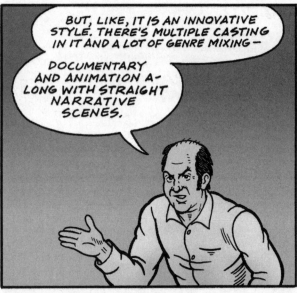

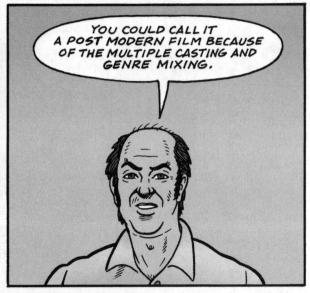

SELLING OUT

STORY BY HARVEY PEKAR

ART BY GARY DUMM

HELLO, MY MIND'S EYE RECORDS.

HEY, CHARLES, I'M JUST CALLIN' T' VERIFY THAT YOU'LL BE OVER AT SIX.

I SURE WILL.

O.K., I'LL SEE YA THEN.

we buy VINYL

SIX O'CLOCK

I GOT SO MUCH STUFF T' CHECK OUT THAT IT'S GONNA TAKE YA A FEW TRIPS. WHYN'T YA START WITH THE POP L.P.'S ON THAT WALL.

FINE.

AN HOUR LATER

HOLY COW, ARE YOU INTERESTED IN BUYIN' ALL THE STUFF IN THOSE STACKS?

I SURE AM. IS THERE A PROBLEM?

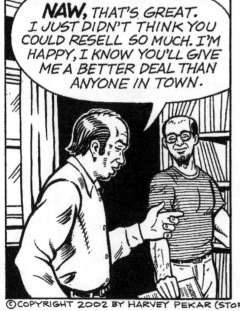

NAW, THAT'S GREAT. I JUST DIDN'T THINK YOU COULD RESELL SO MUCH. I'M HAPPY, I KNOW YOU'LL GIVE ME A BETTER DEAL THAN ANYONE IN TOWN.

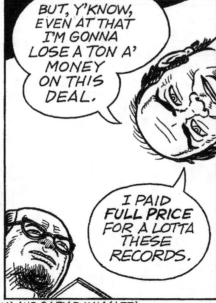

BUT, Y'KNOW, EVEN AT THAT I'M GONNA LOSE A TON A' MONEY ON THIS DEAL.

I PAID FULL PRICE FOR A LOTTA THESE RECORDS.

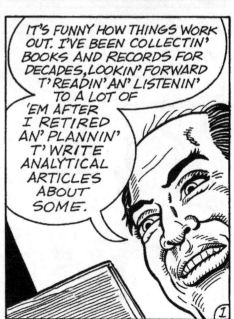

IT'S FUNNY HOW THINGS WORK OUT. I'VE BEEN COLLECTIN' BOOKS AND RECORDS FOR DECADES, LOOKIN' FORWARD T' READIN' AN' LISTENIN' TO A LOT OF 'EM AFTER I RETIRED AN' PLANNIN' T' WRITE ANALYTICAL ARTICLES ABOUT SOME.

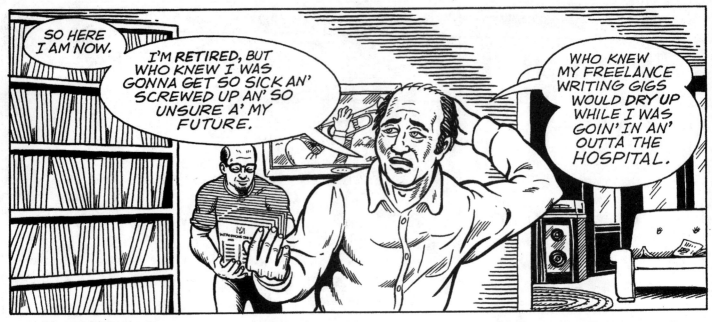

SO HERE I AM NOW.

I'M RETIRED, BUT WHO KNEW I WAS GONNA GET SO SICK AN' SCREWED UP AN' SO UNSURE A' MY FUTURE.

WHO KNEW MY FREELANCE WRITING GIGS WOULD DRY UP WHILE I WAS GOIN' IN AN' OUTTA THE HOSPITAL.

MAYBE I'M BEIN' PREMATURE. MAYBE THAT MOVIE THEY MADE BASED ON MY COMICS WILL GO OVER REAL GOOD AN' GENERATE OTHER WRITING JOBS.

NEVER MIND THE BOLLOCKS HERE'S THE

THE PEOPLE THAT'VE SEEN EARLY VERSIONS OF IT SO FAR HAVE BEEN VERY FAVORABLY IMPRESSED.

THAT'S GREAT!

YEAH, BUT I SURE CAN'T COUNT ON IT.

NOT WITH A WIFE AN' FOURTEEN-YEAR-OLD KID T' SUPPORT.

LOOKIT THIS STUFF THAT'S GONNA BE GOIN' OUT TH' DOOR —

THE WHO THE BEATLES JIMI HENDRIX

B.B. KING CHUCK BERRY BO DIDDLEY THE YARDBIRDS

ELVIS PRESLEY

JAMES BROWN

ARETHA FRANKLIN

QUITE A COLLECTION.

MOTHER

are you experienced

IF YOU'RE BUYIN' I'M SELLIN'.

END.

SLEEP

STORY BY HARVEY PEKAR · ART BY GARY DUMM

IN HIS AUTOBIOGRAPHICAL NOVEL "DOWN AND OUT IN PARIS AND LONDON" GEORGE ORWELL DISCUSSED HIS DAYS AS A DISHWASHER IN PARIS HOTELS AND RESTAURANTS AND MADE WHAT I'VE ALWAYS THOUGHT WAS A BRILLIANTLY PERCEPTIVE COMMENT ABOUT SLEEP:

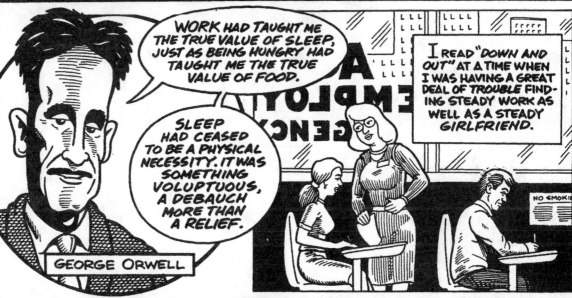

WORK HAD TAUGHT ME THE TRUE VALUE OF SLEEP, JUST AS BEING HUNGRY HAD TAUGHT ME THE TRUE VALUE OF FOOD.

SLEEP HAD CEASED TO BE A PHYSICAL NECESSITY. IT WAS SOMETHING VOLUPTUOUS, A DEBAUCH MORE THAN A RELIEF.

GEORGE ORWELL

I READ "DOWN AND OUT" AT A TIME WHEN I WAS HAVING A GREAT DEAL OF TROUBLE FINDING STEADY WORK AS WELL AS A STEADY GIRLFRIEND.

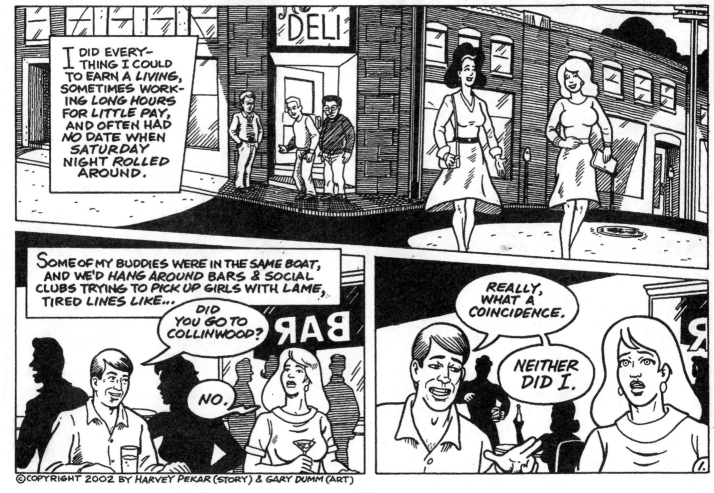

I DID EVERYTHING I COULD TO EARN A LIVING, SOMETIMES WORKING LONG HOURS FOR LITTLE PAY, AND OFTEN HAD NO DATE WHEN SATURDAY NIGHT ROLLED AROUND.

SOME OF MY BUDDIES WERE IN THE SAME BOAT, AND WE'D HANG AROUND BARS & SOCIAL CLUBS TRYING TO PICK UP GIRLS WITH LAME, TIRED LINES LIKE...

DID YOU GO TO COLLINWOOD?

NO.

REALLY, WHAT A COINCIDENCE.

NEITHER DID I.

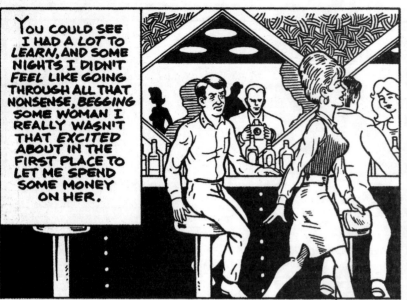

YOU COULD SEE I HAD A LOT TO LEARN, AND SOME NIGHTS I DIDN'T FEEL LIKE GOING THROUGH ALL THAT NONSENSE, BEGGING SOME WOMAN I REALLY WASN'T THAT EXCITED ABOUT IN THE FIRST PLACE TO LET ME SPEND SOME MONEY ON HER.

IT WAS ESPECIALLY DIFFICULT GOING THROUGH THOSE DISCOURAGING SATURDAY NIGHT RITUALS IN THE DEAD OF WINTER.

BAR

THE PLACES I LIVED IN WERE AT LEAST WARM, SO IF A BLIZZARD WAS RAGING I'D THINK, "AH, TO HELL WITH IT!", EAT A GOOD SUPPER, LISTEN TO RADIO OR WATCH TV AND TURN IN EARLY.

BLAH, BLAH!... HA, HA, HA, HAH!

THEN I'D GET GOOD AND COZY UNDER MY BLANKET, RELAX AND LET MY MIND ROAM, SOMETIMES YOU MAY BE A LITTLE TENSE, BUT AS YOU LIE THERE DROWSINESS WILL TAKE THE EDGE OFF YOUR MOOD AND EVERYTHING FEELS PLEASANT. YOU CAN DO ANYTHING YOU WANT TO AND NOT GET ARRESTED.

2

IF YOU AREN'T DOING THAT HOT IN THE REAL WORLD, YOU CAN ALWAYS HAVE AN ORWELLIAN "DEBAUCH" IN YOUR SLEEP.

THE MAG

DREAMS, DAY OR NIGHT, ARE WHAT KEEP US GOING.

WE NEED GOALS, AND IT DOESN'T HURT TO SOMETIMES IMAGINE WE'VE ATTAINED THEM. AND DOING SO DOESN'T COST A THING.

END

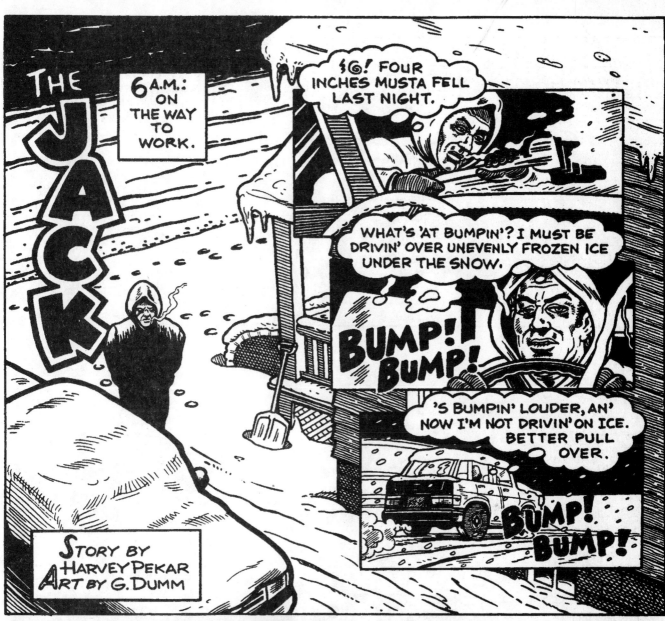

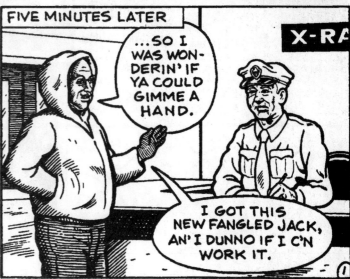

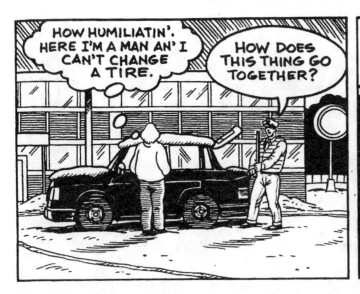

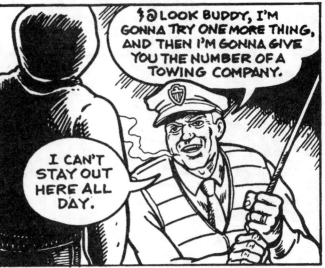

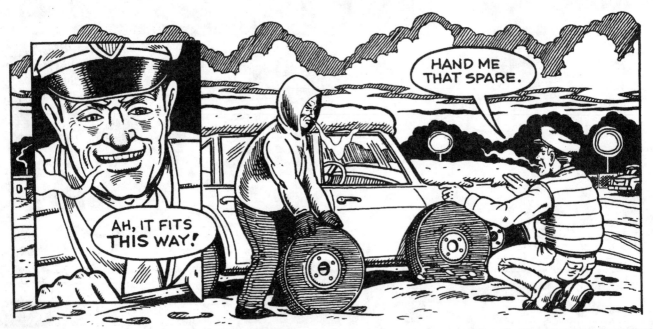

KEYS

STORY BY HARVEY PEKAR · ART BY GARY DUMM

LOOK, I'LL RENEW THE "HISTORY OF WESTERN ART" SET AND YOU LOOK FOR MORE VIDEOS, OKAY?

OKAY.

PUBLIC LIBRARY

UH, CAN I RENEW THIS FOUR TAPE SET?

HAVE YOU RENEWED THEM BEFORE?

THAT WAS QUICK.

WHAT YOU GOT?

HMM. WHILE THE CAT'S AWAY. IT GOT TWO THUMBS UP FROM SISKEL AND EBERT, AND IT FEATURES "THE REMARKABLE RENEE LECALM AS A CAT SITTER."

MRS. BROWN. JUDI DENCH PLAYING QUEEN VICTORIA. YEAH, SHE'S ALWAYS GOOD.

HOW'S THIS "BIG DEAL ON MADONNA STREET?"

1

OH, THAT'S **GREAT**. IT'S GOT VITTORIO GASSMAN AN' MARCELLO MASTROIANNI IN IT...

...IT'S ONE OF THE BEST COMEDIES I'VE EVER SEEN.

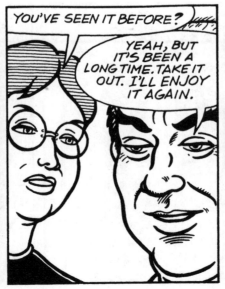

YOU'VE SEEN IT BEFORE?

YEAH, BUT IT'S BEEN A LONG TIME. TAKE IT OUT. I'LL ENJOY IT AGAIN.

AT HOME...

WAIT A MINUTE, WHERE'S MY **KEY RING**?

THEY'RE NOT IN MY POCKETS, **OH, NO!** I'VE NEVER LOST MY KEYS. THIS CAN'T BE HAPPENING! THE HASSLE OF REPLACIN' 'EM, ON TOP OF EVERYTHING ELSE THAT'S GONE **WRONG!**

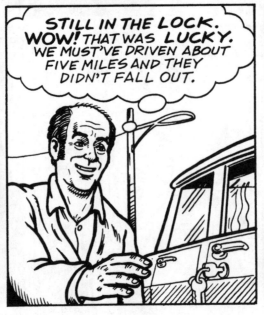

STILL IN THE **LOCK**. **WOW!** THAT WAS **LUCKY**. WE MUST'VE DRIVEN ABOUT FIVE MILES AND THEY DIDN'T FALL OUT.

WHEW!

END

DAVID & ME: MY PROTEST ON THE LETTERMAN SHOW

STORY BY HARVEY PEKAR
ART BY GARY DUMM

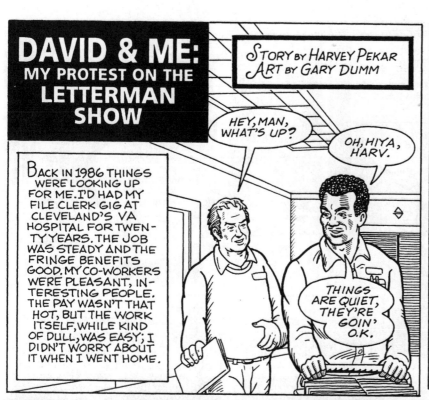

HEY, MAN, WHAT'S UP?

OH, HIYA, HARV.

BACK IN 1986 THINGS WERE LOOKING UP FOR ME. I'D HAD MY FILE CLERK GIG AT CLEVELAND'S VA HOSPITAL FOR TWENTY YEARS. THE JOB WAS STEADY AND THE FRINGE BENEFITS GOOD. MY CO-WORKERS WERE PLEASANT, INTERESTING PEOPLE. THE PAY WASN'T THAT HOT, BUT THE WORK ITSELF, WHILE KIND OF DULL, WAS EASY; I DIDN'T WORRY ABOUT IT WHEN I WENT HOME.

THINGS ARE QUIET, THEY'RE GOIN' O.K.

PLUS I WAS WRITING ABOUT MY QUOTIDIAN EXPERIENCES IN THE COMIC BOOK I'D PUBLISHED SINCE 1976, "AMERICAN SPLENDOR." SALES LEFT SOMETHING TO BE DESIRED, BUT CRITICAL REACTION TO IT WAS QUITE FAVORABLE, FAVORABLE ENOUGH FOR ME TO GET A CALL ONE DAY TO APPEAR ON DAVID LETTERMAN'S SHOW.

THINK YOU'LL BE AVAILABLE IN THE MIDDLE OF OCTOBER?

SURE, THAT'S NOT A PROBLEM.

SO THIS WAS A GOOD THING. LETTERMAN HAD A RELATIVELY HIP AUDIENCE BACK THEN.

MAYBE MY APPEARANCE WOULD RESULT IN INCREASED "AMERICAN SPLENDOR" SALES. IN ANY EVENT IT WAS A FREE TRIP TO NEW YORK AND SOME EXTRA SPENDING CASH.

I'D NEVER APPEARED ON NATIONAL T.V. BEFORE, BUT I WAS A VETERAN STREET CORNER COMEDIAN AND FIGURED I COULD HOLD MY OWN DURING THE REPARTEE.

REALLY, THE WHOLE THING LOOKED LIKE A NO-LOSE SITUATION.

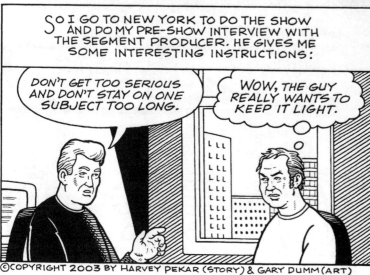

SO I GO TO NEW YORK TO DO THE SHOW AND DO MY PRE-SHOW INTERVIEW WITH THE SEGMENT PRODUCER. HE GIVES ME SOME INTERESTING INSTRUCTIONS:

DON'T GET TOO SERIOUS AND DON'T STAY ON ONE SUBJECT TOO LONG.

WOW, THE GUY REALLY WANTS TO KEEP IT LIGHT.

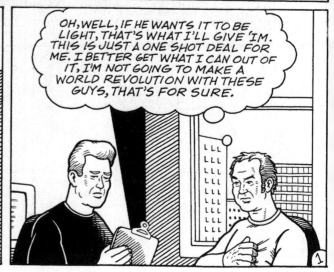

OH, WELL, IF HE WANTS IT TO BE LIGHT, THAT'S WHAT I'LL GIVE 'IM. THIS IS JUST A ONE SHOT DEAL FOR ME. I BETTER GET WHAT I CAN OUT OF IT, I'M NOT GOING TO MAKE A WORLD REVOLUTION WITH THESE GUYS, THAT'S FOR SURE.

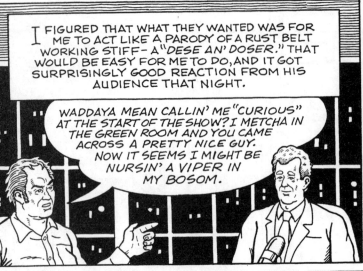

I FIGURED THAT WHAT THEY WANTED WAS FOR ME TO ACT LIKE A PARODY OF A RUST BELT WORKING STIFF— A "DESE AN' DOSER." THAT WOULD BE EASY FOR ME TO DO, AND IT GOT SURPRISINGLY GOOD REACTION FROM HIS AUDIENCE THAT NIGHT.

WADDAYA MEAN CALLIN' ME "CURIOUS" AT THE START OF THE SHOW? I METCHA IN THE GREEN ROOM AND YOU CAME ACROSS A PRETTY NICE GUY. NOW IT SEEMS I MIGHT BE NURSIN' A VIPER IN MY BOSOM.

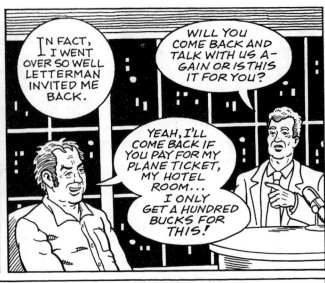

IN FACT, I WENT OVER SO WELL LETTERMAN INVITED ME BACK.

WILL YOU COME BACK AND TALK WITH US A-GAIN OR IS THIS IT FOR YOU?

YEAH, I'LL COME BACK IF YOU PAY FOR MY PLANE TICKET, MY HOTEL ROOM... I ONLY GET A HUNDRED BUCKS FOR THIS!

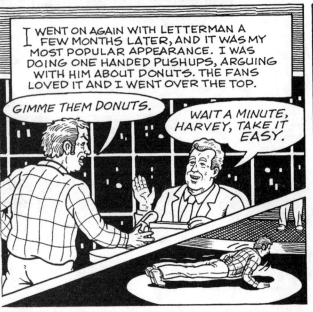

I WENT ON AGAIN WITH LETTERMAN A FEW MONTHS LATER, AND IT WAS MY MOST POPULAR APPEARANCE. I WAS DOING ONE HANDED PUSHUPS, ARGUING WITH HIM ABOUT DONUTS. THE FANS LOVED IT AND I WENT OVER THE TOP.

GIMME THEM DONUTS.

WAIT A MINUTE, HARVEY, TAKE IT EASY.

BUT WHERE COULD I GO FROM THERE? I COULDN'T ACT ANY CRAZIER AND I WAS TIRED OF DOING THE SELF-PARODY SHTICK. I AGREED WITH LETTERMAN'S PEOPLE THAT I SHOULD KEEP ON ACTIN' FUNNY, BUT I WANTED TO GET INTO MORE SUBSTANTIAL HUMOR. I STARTED LOOKING AROUND FOR DIFFERENT TOPICS AND I FOUND SOME INTRIGUING STUFF IN THE LIBRARY.

WOW, GENERAL ELECTRIC BOUGHT NBC A FEW MONTHS AGO. THAT'S NOT RIGHT. GE IS ONE OF THE MOST POWER-FUL, CORRUPT CORPORATIONS ANYWHERE. THEY'RE A BIG WEAPONS CONTRACTOR. NOW THAT THEY GOT CON-TROL OF NBC NEWS THEY CAN PUSH THEIR POLITICAL, MILITARY AGENDA AND MOST PEOPLE WON'T SEE THE CONFLICT OF INTER-EST INVOLVED.

LETTERMAN'S ALWAYS MAKIN' CRACKS ABOUT GE, BUT IT'S ABOUT RELATIVELY MINOR STUFF, LIKE LIGHT BULBS. HE PROBABLY ISN'T AWARE OF ALL THE REALLY DANGER-OUS STUFF THEY'RE INTO. I WONDER IF HE'D BE WILLING TO DISCUSS IT WITH ME ON HIS SHOW?

I BROACHED THE SUBJECT JUST BEFORE MY NEXT APPEARANCE, BUT DAVID'S PEOPLE SEEMED AFRAID TO GET INTO ANYTHING HEAVY ABOUT GE, EVEN IF I WAS FUNNY ABOUT IT TOO. NEVERTHELESS I WAS INSISTANT.

LOOK, I WANNA TALK ABOUT GE AND I HAVE NOTHING TO LOSE BY DOING SO.

I MIGHT BE POPULAR ON THIS SHOW BUT MY COMIC BOOK SALES ARE AS BAD AS EVER.

I WON'T LOSE ANY MONEY IF YOU BAN ME FROM THE SHOW.

THEY TRIED TO USE A PLOY TO KEEP ME FROM TALKING ABOUT GE, BUT I WASN'T BUYING IT.

LOOK, HARVEY, YOU'LL BE ABLE TO TALK ABOUT GE. HERE'S A LIST OF TEN SUBJECTS YOU AND DAVE DISCUSS TONIGHT. GE'S NUMBER SEVEN ON THE LIST.

NUMBER SEVEN? WE'LL BE LUCKY TO GET T' NUMBER FIVE! IF HE DOESN'T BRING UP GE, THOUGH, I WILL. I'LL FORCE THE ISSUE.

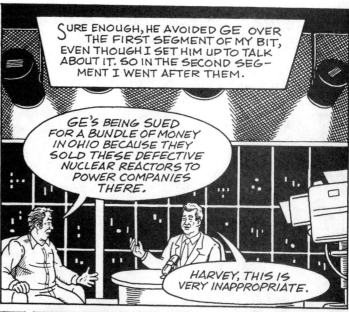

SURE ENOUGH, HE AVOIDED GE OVER THE FIRST SEGMENT OF MY BIT, EVEN THOUGH I SET HIM UP TO TALK ABOUT IT. SO IN THE SECOND SEGMENT I WENT AFTER THEM.

GE'S BEING SUED FOR A BUNDLE OF MONEY IN OHIO BECAUSE THEY SOLD THESE DEFECTIVE NUCLEAR REACTORS TO POWER COMPANIES THERE.

HARVEY, THIS IS VERY INAPPROPRIATE.

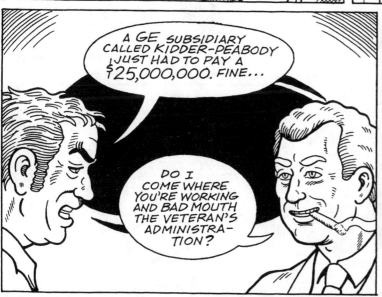

A GE SUBSIDIARY CALLED KIDDER-PEABODY JUST HAD TO PAY A $25,000,000. FINE...

DO I COME WHERE YOU'RE WORKING AND BAD MOUTH THE VETERAN'S ADMINISTRATION?

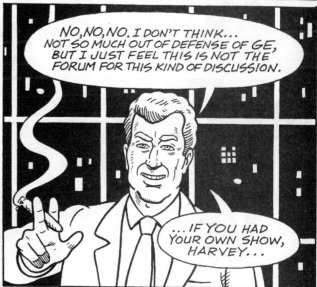

NO, NO, NO. I DON'T THINK... NOT SO MUCH OUT OF DEFENSE OF GE, BUT I JUST FEEL THIS IS NOT THE FORUM FOR THIS KIND OF DISCUSSION.

...IF YOU HAD YOUR OWN SHOW, HARVEY...

YOU'RE A GUEST IN MY HOUSE. YOU SHOW UP, YOU SNEEZE IN THE HORS D'OUVRES.

THIS AIN'T YOUR HOUSE.

WHERE'S THE MAILBOX; WHERE ARE THE HORS D'OUVRES?

AND THE SEGMENT WOUND UP IN CHAOS.

3

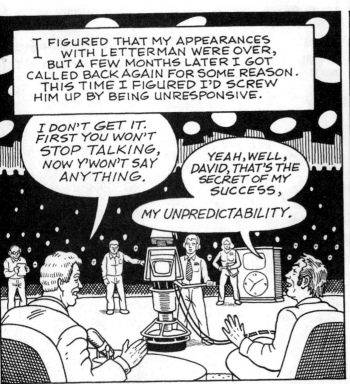

I FIGURED THAT MY APPEARANCES WITH LETTERMAN WERE OVER, BUT A FEW MONTHS LATER I GOT CALLED BACK AGAIN FOR SOME REASON. THIS TIME I FIGURED I'D SCREW HIM UP BY BEING UNRESPONSIVE.

I DON'T GET IT. FIRST YOU WON'T STOP TALKING, NOW Y'WON'T SAY ANYTHING.

YEAH, WELL, DAVID, THAT'S THE SECRET OF MY SUCCESS, MY UNPREDICTABILITY.

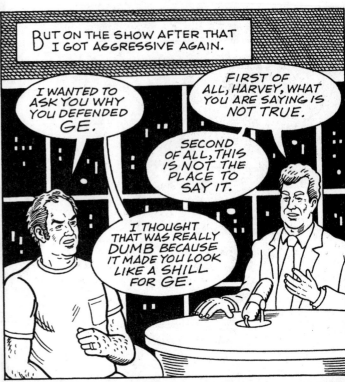

BUT ON THE SHOW AFTER THAT I GOT AGGRESSIVE AGAIN.

I WANTED TO ASK YOU WHY YOU DEFENDED GE.

FIRST OF ALL, HARVEY, WHAT YOU ARE SAYING IS NOT TRUE.

SECOND OF ALL, THIS IS NOT THE PLACE TO SAY IT.

I THOUGHT THAT WAS REALLY DUMB BECAUSE IT MADE YOU LOOK LIKE A SHILL FOR GE.

BELIEVE IT OR NOT, I GOT INVITED BACK AND APPEARED ON A COUPLE OF LETTERMAN SHOWS IN THE 1990s.

NOTHING CONTROVERSIAL HAPPENED ON THEM, BUT HE FINALLY STOPPED ASKING ME BACK, BECAUSE, I THINK, HIS AUDIENCE DIDN'T UNDERSTAND WHERE I WAS COMING FROM.

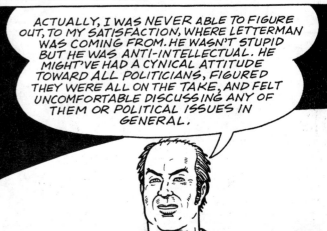

ACTUALLY, I WAS NEVER ABLE TO FIGURE OUT, TO MY SATISFACTION, WHERE LETTERMAN WAS COMING FROM. HE WASN'T STUPID BUT HE WAS ANTI-INTELLECTUAL. HE MIGHT'VE HAD A CYNICAL ATTITUDE TOWARD ALL POLITICIANS, FIGURED THEY WERE ALL ON THE TAKE, AND FELT UNCOMFORTABLE DISCUSSING ANY OF THEM OR POLITICAL ISSUES IN GENERAL.

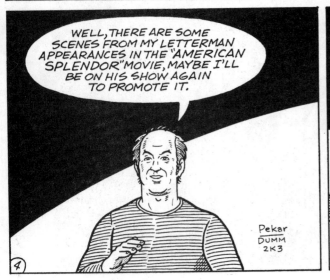

WELL, THERE ARE SOME SCENES FROM MY LETTERMAN APPEARANCES IN THE "AMERICAN SPLENDOR" MOVIE, MAYBE I'LL BE ON HIS SHOW AGAIN TO PROMOTE IT.

Pekar
DUMM
2K3

4

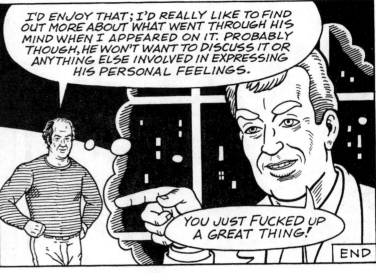

I'D ENJOY THAT; I'D REALLY LIKE TO FIND OUT MORE ABOUT WHAT WENT THROUGH HIS MIND WHEN I APPEARED ON IT. PROBABLY THOUGH, HE WON'T WANT TO DISCUSS IT OR ANYTHING ELSE INVOLVED IN EXPRESSING HIS PERSONAL FEELINGS.

YOU JUST FUCKED UP A GREAT THING!

END

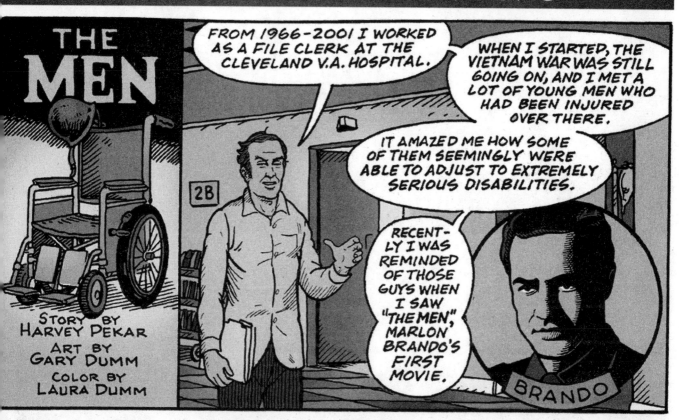

THE MEN

Story by
Harvey Pekar
Art by
Gary Dumm
Color by
Laura Dumm

FROM 1966-2001 I WORKED AS A FILE CLERK AT THE CLEVELAND V.A. HOSPITAL.

WHEN I STARTED, THE VIETNAM WAR WAS STILL GOING ON, AND I MET A LOT OF YOUNG MEN WHO HAD BEEN INJURED OVER THERE.

IT AMAZED ME HOW SOME OF THEM SEEMINGLY WERE ABLE TO ADJUST TO EXTREMELY SERIOUS DISABILITIES.

RECENTLY I WAS REMINDED OF THOSE GUYS WHEN I SAW "THE MEN," MARLON BRANDO'S FIRST MOVIE.

BRANDO

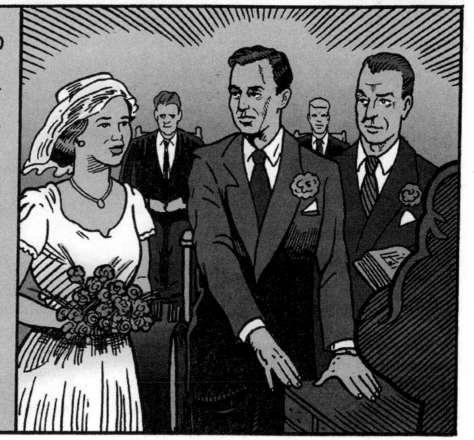

BRANDO PLAYS A WAR VETERAN, LT. KEN (BUD) WILOCEK, WHO'S BEEN PARALYZED FROM THE WAIST DOWN. HE'S ENGAGED TO MARRY ELLEN (TERESA WRIGHT), BUT WHEN HE COMES BACK AND IS IN THE V.A. HOSPITAL FOR TREATMENT HE AVOIDS HER, BECAUSE HE'S ASHAMED OF HIMSELF. THERE'S THE ISSUE OF BEING IMMOBILE AND THERE'S THE SEXUAL ISSUE THAT HE'S CONCERNED WITH. SHE TRACKS HIM DOWN AND THEY DO GET MARRIED. USING EXERCISE AND LEG BRACES HE'S ABLE TO STAND DURING THE CEREMONY.

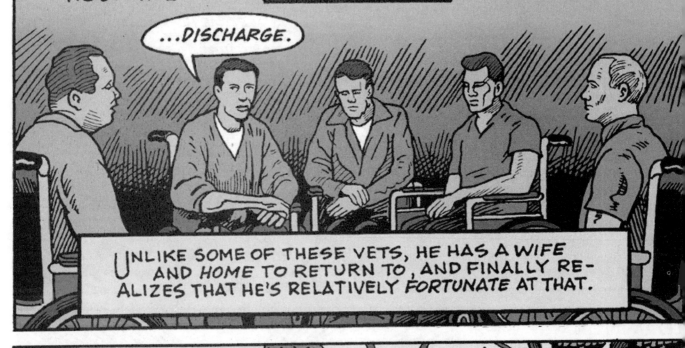

BUT THEY *DON'T* LIVE HAPPILY EVER AFTER. DE-PRESSED AGAIN, *BRANDO* GOES BACK INTO THE HOSPITAL.

HE GOES A.W.O.L. FROM THERE, GETS *DRUNK* AND SMASHES UP HIS SPECIALLY EQUIPPED CAR.

BECAUSE OF THIS, *WILOCEK* IS VOTED OUT OF THE HOS-PITAL BY THE PARALYZED VETS BOARD AND RETURNS TO *ELLEN.*

...DISCHARGE.

UNLIKE SOME OF THESE VETS, HE HAS A *WIFE* AND *HOME* TO RETURN TO, AND FINALLY RE-ALIZES THAT HE'S RELATIVELY *FORTUNATE* AT THAT.

THE MEN, THOUGH NOT A WELL-KNOWN MOVIE, RANKS AMONG *BRANDO'S* BEST. IT HAS A *FINE* CAST, FEATURING *EVERETT SLOANE* AS HIS DOC-TOR, AND *JACK WEBB* AS HIS PARALYZED BUDDY. *BRANDO* HIMSELF GIVES A VERY AF-FECTING, SOMETIMES LOW-KEY PERFORMANCE. HE MAY BE MORE OF AN *ENSEMBLE* PLAY-ER HERE THAN IN OTHER MOV-IES, WHERE HE SOMETIMES ACTS IN A MORE *ECCENTRIC* MANNER. I CAN *EMPATHIZE* WITH GUYS GETTING *STUCK* IN THE HOS-PITAL OR *SICK* FOR LONG PERIODS OF TIME. IN *1990-1991* AND AGAIN IN *2002* I HAD CANCER. YOU BETTER *BELIEVE "THE MEN"* HAS EVEN MORE *RESONANCE* FOR ME AFTER THAT.

Everett Sloane

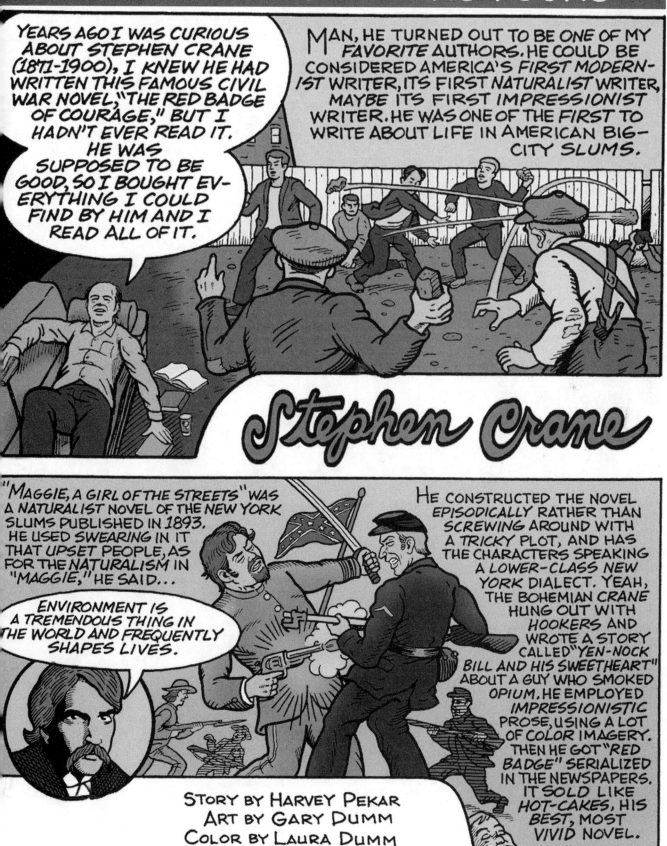

YEARS AGO I WAS CURIOUS ABOUT STEPHEN CRANE (1871-1900), I KNEW HE HAD WRITTEN THIS FAMOUS CIVIL WAR NOVEL, "THE RED BADGE OF COURAGE," BUT I HADN'T EVER READ IT. HE WAS SUPPOSED TO BE GOOD, SO I BOUGHT EVERYTHING I COULD FIND BY HIM AND I READ ALL OF IT.

MAN, HE TURNED OUT TO BE ONE OF MY FAVORITE AUTHORS. HE COULD BE CONSIDERED AMERICA'S FIRST MODERNIST WRITER, ITS FIRST NATURALIST WRITER, MAYBE ITS FIRST IMPRESSIONIST WRITER. HE WAS ONE OF THE FIRST TO WRITE ABOUT LIFE IN AMERICAN BIG-CITY SLUMS.

Stephen Crane

"MAGGIE, A GIRL OF THE STREETS" WAS A NATURALIST NOVEL OF THE NEW YORK SLUMS PUBLISHED IN 1893. HE USED SWEARING IN IT THAT UPSET PEOPLE, AS FOR THE NATURALISM IN "MAGGIE," HE SAID...

ENVIRONMENT IS A TREMENDOUS THING IN THE WORLD AND FREQUENTLY SHAPES LIVES.

HE CONSTRUCTED THE NOVEL EPISODICALLY RATHER THAN SCREWING AROUND WITH A TRICKY PLOT, AND HAS THE CHARACTERS SPEAKING A LOWER-CLASS NEW YORK DIALECT. YEAH, THE BOHEMIAN CRANE HUNG OUT WITH HOOKERS AND WROTE A STORY CALLED "YEN-NOCK BILL AND HIS SWEETHEART" ABOUT A GUY WHO SMOKED OPIUM. HE EMPLOYED IMPRESSIONISTIC PROSE, USING A LOT OF COLOR IMAGERY. THEN HE GOT "RED BADGE" SERIALIZED IN THE NEWSPAPERS. IT SOLD LIKE HOT-CAKES, HIS BEST, MOST VIVID NOVEL.

STORY BY HARVEY PEKAR
ART BY GARY DUMM
COLOR BY LAURA DUMM

AND HE WAS AN EVEN *BETTER* SHORT STORY WRITER. HIS PROSE WAS ECONOMICAL. HE GOT RIGHT TO THE *POINT.* SOME OF THE STORIES WERE SUSPENSE-FILLED, SUCH AS "THE OPEN BOAT" AND "THE BLUE HOTEL." BUT HE ALSO COULD PRODUCE EXCELLENT *HUMOROUS* STORIES, SOMETHING HE HASN'T BEEN GIVEN ENOUGH CREDIT FOR, LIKE "THE BRIDE COMES TO YELLOW SKY."

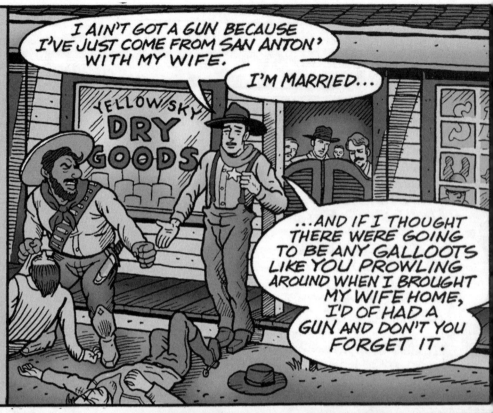

I AIN'T GOT A GUN BECAUSE I'VE JUST COME FROM SAN ANTON' WITH MY WIFE.

I'M MARRIED...

...AND IF I THOUGHT THERE WERE GOING TO BE ANY GALLOOTS LIKE YOU PROWLING AROUND WHEN I BROUGHT MY WIFE HOME, I'D OF HAD A GUN AND DON'T YOU FORGET IT.

CRANE WASN'T AS WELL KNOWN FOR HIS POEMS. BUT HIS TWO VOLUMES OF *POETRY* SHOW HE WAS INFLUENCED BY THE EARLY *FREE VERSE* OF EMILY *DICKINSON.* BEYOND HIS *AESTHETIC* ACHIEVEMENTS, HE DESERVES CREDIT FOR REPEATEDLY BRINGING TO PUBLIC ATTENTION THE *PLIGHT* OF THE *POOR* IN "MAGGIE" AND "GEORGE'S MOTHER."

HE ONCE CRITICISED TEDDY ROOSEVELT, THEN NEW YORK POLICE COMMISSIONER, OBJECTING TO THE ROUGH HANDLING OF PROSTITUTES BY THE POLICE. RARELY, I THINK, WERE ARTISTIC ABILITIES AND HUMANITARIANISM COMBINED WITH SUCH BENEFICIAL RESULTS.

114

THE BICYCLE THIEF

Story by Harvey Pekar
Art by Gary Dumm

"THE BICYCLE THIEF" TAKES PLACE IN ROME, JUST AFTER THE SECOND WORLD WAR WHEN TIMES WERE REALLY TOUGH AND UNEMPLOYMENT WAS VERY HIGH. IT'S ABOUT A GUY WHO GETS A JOB THAT DEPENDS ON HIM HAVING A BICYCLE, BUT SOMEONE STEALS HIS BICYCLE, SO FOR THE REST OF THE MOVIE THE GUY AND HIS LITTLE SON GO ALL OVER ROME LOOKING FOR THE BIKE,

I WAS ABOUT TWENTY WHEN I SAW "THE BICYCLE THIEF" AND REALLY AT LOOSE ENDS. THINGS WERE NOT ALL THAT GREAT ECONOMICALLY IN CLEVELAND, MY HOME TOWN, EITHER. IT WAS TOUGH FINDING ANY KIND OF JOB, LET ALONE A GOOD ONE, AND I DIDN'T KNOW WHAT I WANTED TO DO ANYWAY.

SO NATURALLY I IDENTIFIED WITH THE GUY IN "THE BICYCLE THIEF." I SUFFERED WITH HIM, WAS MOVED ALMOST TO TERROR BY HIS PLIGHT. THE FILM WAS SO REALISTICALLY DONE. THAT'S PARTLY WHY IT AFFECTED ME SO STRONGLY. THERE WASN'T ANY OF THE CORNINESS IN IT THAT I TOOK FOR GRANTED IN HOLLYWOOD MOVIES. I WASN'T USED TO FILMS LIKE THIS.

AT THE END THE GUY, OUT OF DESPERATION, TRIES TO STEAL A BIKE HIMSELF, AND IS CAUGHT BY A CROWD. THE BIKE OWNER SETS HIM FREE, BUT HIS SON HAS WITNESSED HIS HUMILIATION. THAT MOVIE WAS A WAKE UP CALL FOR ME.

THE ENDING WAS REAL SAD, BUT IT COULD'VE BEEN WORSE. HE COULD'VE BEEN JAILED. YEAH, BUT I COULD SEE THE BIKE OWNER TAKING PITY ON HIM. THAT COULD VERY EASILY HAVE HAPPENED IN REAL LIFE.

WHY DON'T THEY MAKE MORE MOVIES LIKE THIS?

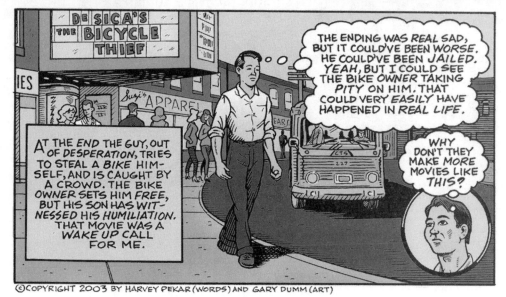

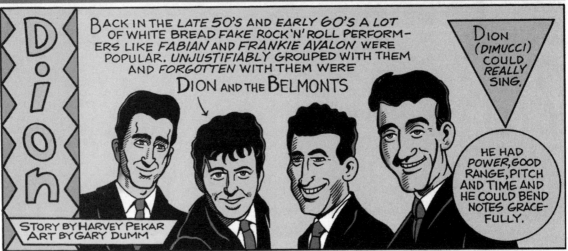

Dion

Back in the *late 50's* and *early 60's* a lot of white bread *fake rock 'n' roll* performers like *Fabian* and *Frankie Avalon* were popular. *Unjustifiably* grouped with them and *forgotten* with them were

Dion and the Belmonts

Story by Harvey Pekar
Art by Gary Dumm

Dion (Dimucci) could *really* sing.

He had *power, good range, pitch and time* and he could bend notes gracefully.

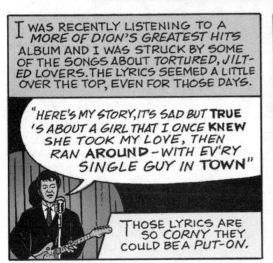

I was recently listening to a *more of Dion's greatest hits* album and I was struck by some of the songs about *tortured, jilted* lovers. The lyrics seemed a little over the top, even for those days.

"Here's my story, it's sad but **TRUE**
's about a girl that I once **KNEW**
she took my love, then
ran **AROUND** — with ev'ry
single guy in **TOWN**"

Those lyrics are so corny they could be a *put-on*.

And what about *"Little Diane"* with its *quasi-flamenco* introduction

"Diane, down
deep inside I **CRY**
Diane, without your love I **DIE**
Diane, you know you drive me **WILD**
Diane, you're such a
little evil **CHILD**"

Which was followed by a *kazoo* solo and—

"I wanna pack and leave
and slap your **FACE**
girls like you are a **DISGRACE**
but way down deep inside
I **CRY** without you
little Diane I **DIE**"

My *fourteen year old* foster daughter heard the *kazoo* and started *laughing*

Which got me to thinking — were *Dion and the Belmonts*, their song writers and producers *subtle satirists*? I mean, a *kazoo*. C'mon... If they were then they *deserve* even more credit than I gave them.

I thought about trying to locate people that could tell me if *Dion* and his cohorts were *secretly* laughing at their audience—for the purposes of *this* piece, but I dunno.

Maybe it's best left a *mystery*.

GEORGE ADE

STORY BY HARVEY PEKAR

ART BY GARY DUMM

GEORGE ADE WAS ONE OF THE *BEST* AMERICAN REALIST WRITERS AROUND THE TURN OF THE CENTURY.

HE WAS *REAL* POPULAR, TOO, FOR AWHILE, WITH HIS *"FABLES IN SLANG"* IN WHICH HE WROTE IN VARIOUS AMERICAN *DIALECTS* AND ADDED HUMOROUS *MORALS* AT THE ENDS OF HIS STORIES. HE HAD A *GREAT EAR* FOR LANGUAGE.

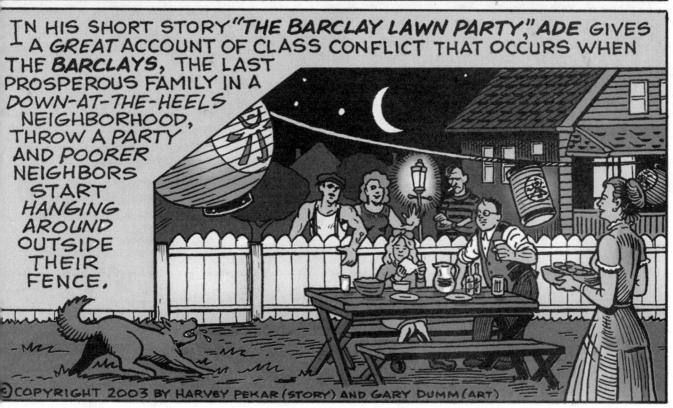

IN HIS SHORT STORY *"THE BARCLAY LAWN PARTY,"* ADE GIVES A *GREAT* ACCOUNT OF CLASS CONFLICT THAT OCCURS WHEN THE *BARCLAYS*, THE LAST PROSPEROUS FAMILY IN A DOWN-AT-THE-HEELS NEIGHBORHOOD, THROW A *PARTY* AND *POORER* NEIGHBORS START HANGING AROUND OUTSIDE THEIR FENCE.

ADE WAS AMONG THE *FIRST* AUTHORS TO CONCENTRATE ON THE *MUNDANE* DETAILS OF THE *EVERYDAY* LIVES OF *POOR* AND WORKING CLASS AMERICANS. HE WROTE ABOUT POOR WHITES IN *"ARTIE"* AND EVEN *POOR* BLACKS IN *"PINK MARSH."* IT WAS VERY *UNUSUAL* AT THAT TIME FOR WHITE WRITERS TO PAY ATTENTION TO BLACKS LIKE *PINK MARSH,* WHO SHINED SHOES IN A BARBER SHOP.

ADE LIVED A LONG TIME THOUGH, AND AFTER THE *BRILLIANT* FIRST FIFTEEN YEARS OF HIS CAREER HE *DECLINED.* FOR DECADES AFTER THAT HIS WRITING GOT *CORNIER* AND MORE *REPETITIVE,* 'TIL PEOPLE *FORGOT* ABOUT HIS *GOOD STUFF.*

I DOUBT IF THERE'LL BE A *REVIVAL* OF *INTEREST* IN HIS WORK IN THE *FORESEEABLE* FUTURE.

BUT, REMEMBER, YOU HEARD ABOUT IT *HERE.*

Color by Laura Dumm

118

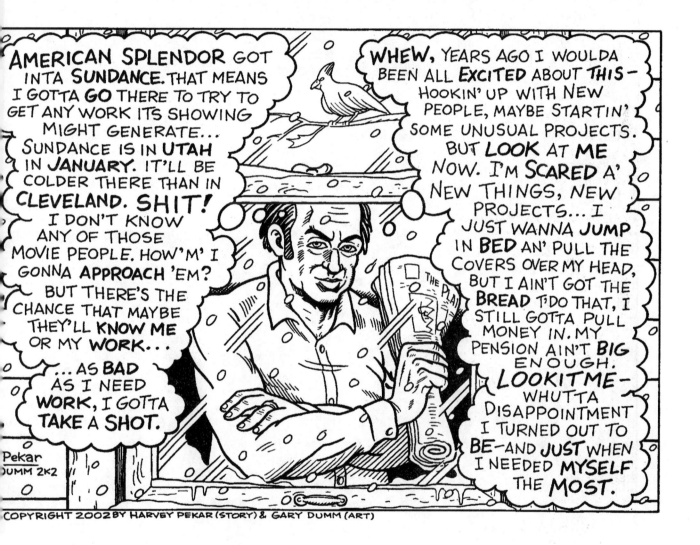

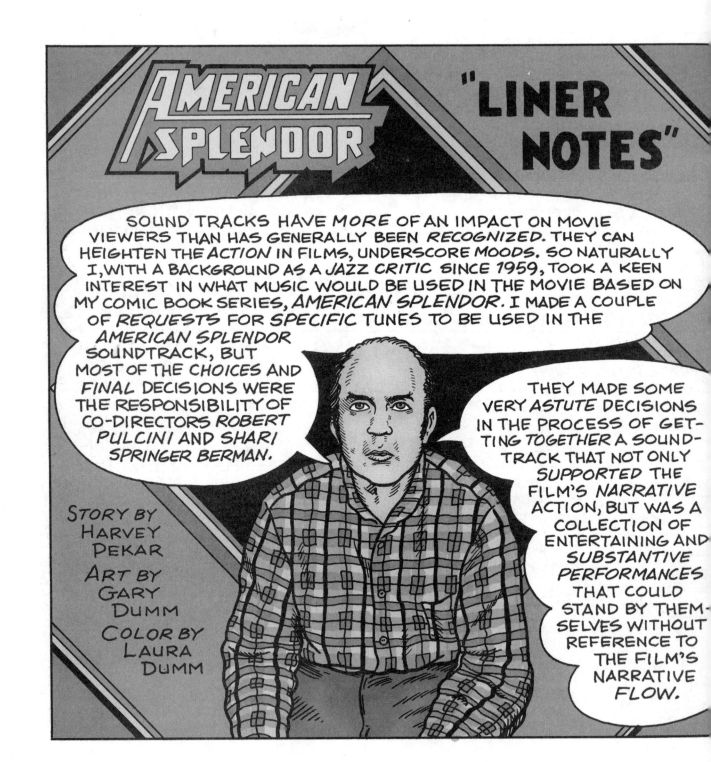

AMERICAN SPLENDOR

"LINER NOTES"

SOUND TRACKS HAVE *MORE* OF AN IMPACT ON MOVIE VIEWERS THAN HAS GENERALLY BEEN *RECOGNIZED.* THEY CAN HEIGHTEN THE *ACTION* IN FILMS, UNDERSCORE MOODS. SO NATURALLY I, WITH A BACKGROUND AS A *JAZZ CRITIC* SINCE 1959, TOOK A KEEN INTEREST IN WHAT MUSIC WOULD BE USED IN THE MOVIE BASED ON MY COMIC BOOK SERIES, *AMERICAN SPLENDOR.* I MADE A COUPLE OF *REQUESTS* FOR *SPECIFIC* TUNES TO BE USED IN THE *AMERICAN SPLENDOR* SOUNDTRACK, BUT MOST OF THE *CHOICES* AND *FINAL* DECISIONS WERE THE RESPONSIBILITY OF CO-DIRECTORS *ROBERT PULCINI* AND *SHARI SPRINGER BERMAN.*

THEY MADE SOME VERY *ASTUTE* DECISIONS IN THE PROCESS OF GETTING *TOGETHER* A SOUNDTRACK THAT NOT ONLY *SUPPORTED* THE FILM'S *NARRATIVE* ACTION, BUT WAS A COLLECTION OF ENTERTAINING AND *SUBSTANTIVE PERFORMANCES* THAT COULD STAND BY THEMSELVES WITHOUT REFERENCE TO THE FILM'S NARRATIVE FLOW.

STORY BY
HARVEY PEKAR

ART BY
GARY DUMM

COLOR BY
LAURA DUMM

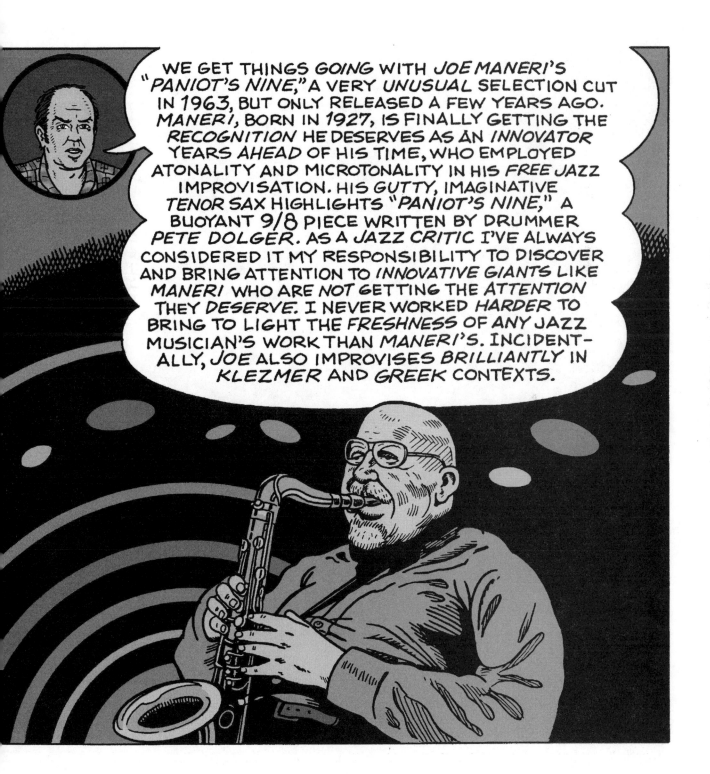

WE GET THINGS *GOING* WITH *JOE MANERI'S* "*PANIOT'S NINE,*" A VERY *UNUSUAL* SELECTION CUT IN 1963, BUT ONLY RELEASED A FEW YEARS AGO. *MANERI,* BORN IN *1927,* IS FINALLY GETTING THE *RECOGNITION* HE DESERVES AS AN *INNOVATOR* YEARS *AHEAD* OF HIS TIME, WHO EMPLOYED ATONALITY AND MICROTONALITY IN HIS *FREE JAZZ* IMPROVISATION. HIS *GUTTY,* IMAGINATIVE *TENOR* SAX HIGHLIGHTS "*PANIOT'S NINE,*" A *BUOYANT* 9/8 PIECE WRITTEN BY DRUMMER *PETE DOLGER.* AS A *JAZZ CRITIC* I'VE ALWAYS CONSIDERED IT MY RESPONSIBILITY TO DISCOVER AND BRING ATTENTION TO *INNOVATIVE GIANTS* LIKE *MANERI* WHO ARE *NOT* GETTING THE *ATTENTION* THEY *DESERVE.* I NEVER WORKED *HARDER* TO BRING TO LIGHT THE *FRESHNESS* OF ANY JAZZ MUSICIAN'S WORK THAN *MANERI'S.* INCIDENT-ALLY, *JOE* ALSO IMPROVISES *BRILLIANTLY* IN *KLEZMER* AND *GREEK* CONTEXTS.

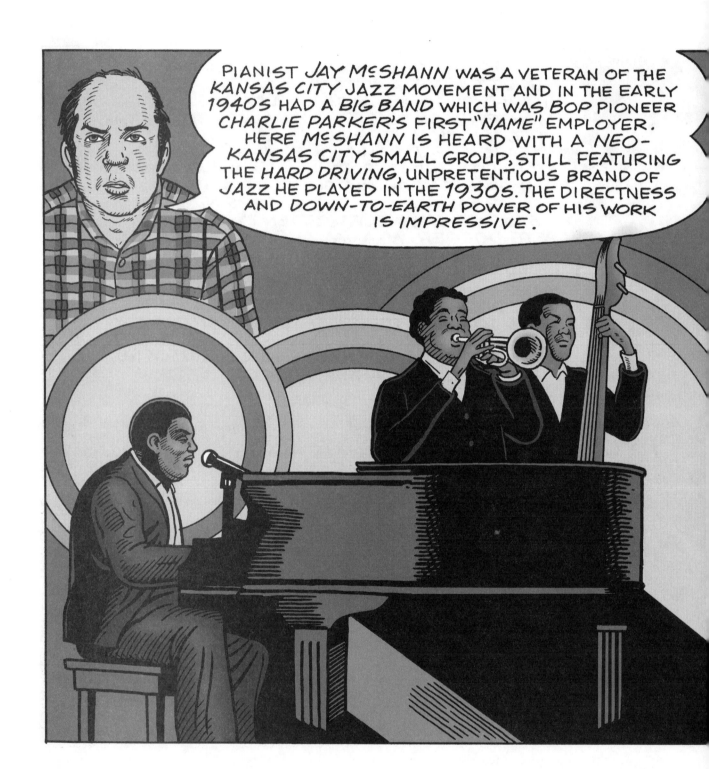

PIANIST *JAY McSHANN* WAS A VETERAN OF THE *KANSAS CITY* JAZZ MOVEMENT AND IN THE EARLY *1940S* HAD A *BIG BAND* WHICH WAS *BOP* PIONEER *CHARLIE PARKER'S* FIRST "*NAME*" EMPLOYER. HERE *McSHANN* IS HEARD WITH A *NEO-KANSAS CITY* SMALL GROUP, STILL FEATURING THE *HARD DRIVING*, UNPRETENTIOUS BRAND OF *JAZZ* HE PLAYED IN THE *1930S.* THE DIRECTNESS AND *DOWN-TO-EARTH* POWER OF HIS WORK IS *IMPRESSIVE.*

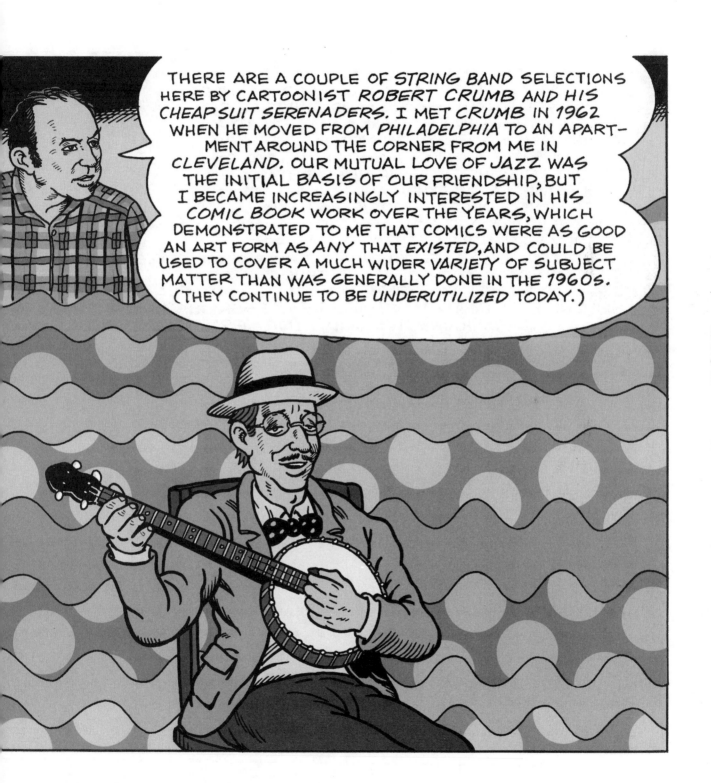

THERE ARE A COUPLE OF *STRING BAND* SELECTIONS HERE BY CARTOONIST *ROBERT CRUMB* AND HIS *CHEAP SUIT SERENADERS.* I MET *CRUMB* IN *1962* WHEN HE MOVED FROM *PHILADELPHIA* TO AN APARTMENT AROUND THE CORNER FROM ME IN *CLEVELAND.* OUR MUTUAL LOVE OF *JAZZ* WAS THE INITIAL BASIS OF OUR FRIENDSHIP, BUT I BECAME INCREASINGLY INTERESTED IN HIS *COMIC BOOK* WORK OVER THE YEARS, WHICH DEMONSTRATED TO ME THAT COMICS WERE AS GOOD AN ART FORM AS ANY THAT *EXISTED,* AND COULD BE USED TO COVER A MUCH WIDER *VARIETY* OF SUBJECT MATTER THAN WAS GENERALLY DONE IN THE *1960s.* (THEY CONTINUE TO BE *UNDERUTILIZED* TODAY.)

ANYWAY, CRUMB WAS A PASSIONATE, THOUGH SELECTIVE COLLECTOR OF VARIOUS EARLY GENRES OF POP, COUNTRY, BLUES, JAZZ AND ETHNIC 78 RPM RECORDINGS WHEN I MET HIM, AND IT GOT TO A POINT, AROUND 1970, WHEN MERELY LISTENING TO MUSIC WAS NOT ENOUGH, HE WANTED TO PLAY IT. SO HE GOT SOME RUDIMENTARY BANJO CHOPS TOGETHER AND FORMED A TRIO WITH MANDOLINIST AL DODGE AND NATIONAL STEEL GUITARIST BOB ARMSTRONG, AND THEY WEREN'T HALF BAD. THEY WERE TRADITIONALISTS, FAITHFUL TO THE ORIGINAL STYLES THEY EMULATED, AND SOLID, TASTEFUL PERFORMERS AS WELL. I TAKE MY HAT OFF TO CRUMB FOR GETTING INTO PLAYING MUSIC AT A RELATIVELY ADVANCED AGE. HE WAS SERIOUS ABOUT IT, TOO, AS "CHASIN' RAINBOWS" AND "HULA MEDLEY" ILLUSTRATE.

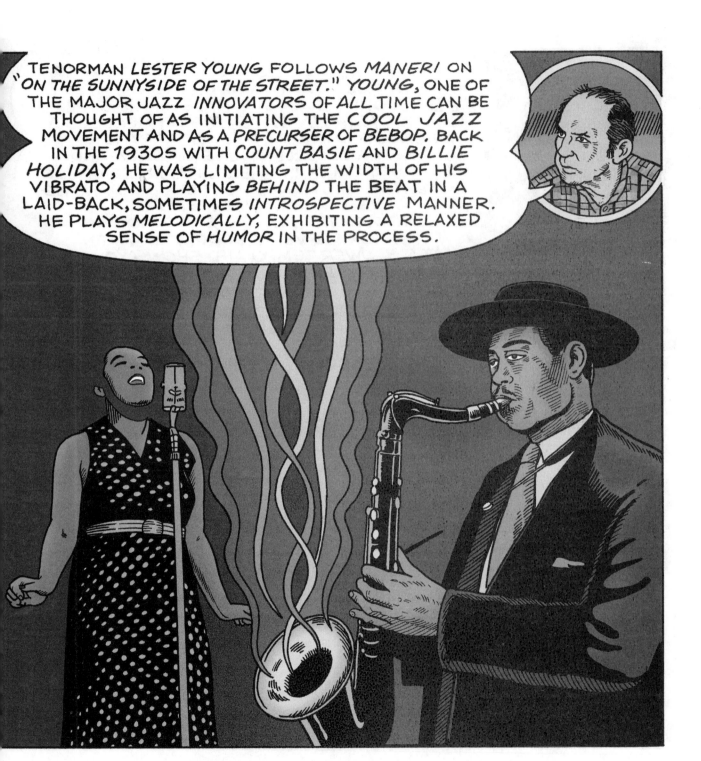

TENORMAN *LESTER YOUNG* FOLLOWS *MANERI* ON "*ON THE SUNNYSIDE OF THE STREET.*" *YOUNG,* ONE OF THE MAJOR JAZZ *INNOVATORS* OF ALL TIME CAN BE THOUGHT OF AS INITIATING THE *COOL JAZZ* MOVEMENT AND AS A *PRECURSER* OF *BEBOP.* BACK IN THE 1930s WITH *COUNT BASIE* AND *BILLIE HOLIDAY,* HE WAS LIMITING THE WIDTH OF HIS *VIBRATO* AND PLAYING *BEHIND* THE BEAT IN A LAID-BACK, SOMETIMES *INTROSPECTIVE* MANNER. HE PLAYS *MELODICALLY,* EXHIBITING A RELAXED SENSE OF *HUMOR* IN THE PROCESS.

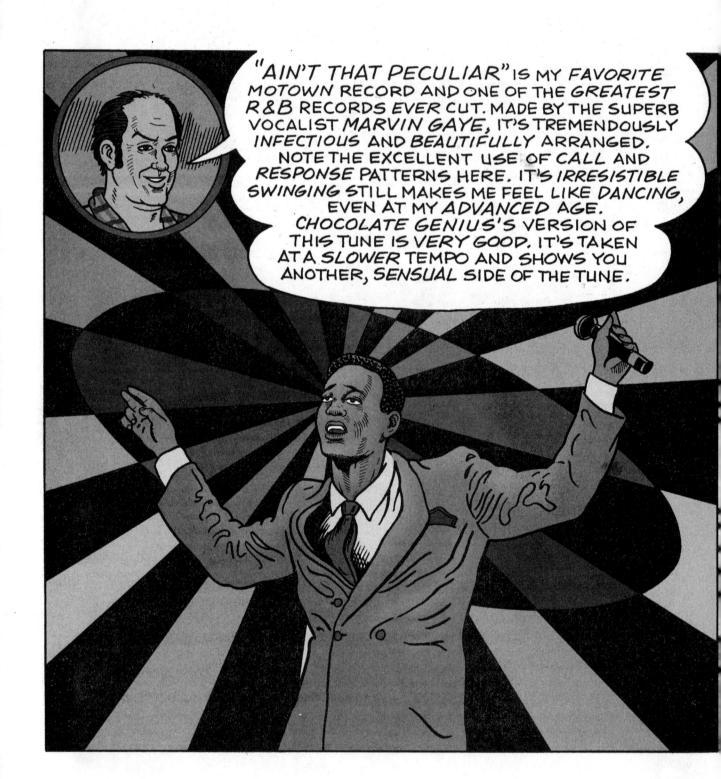

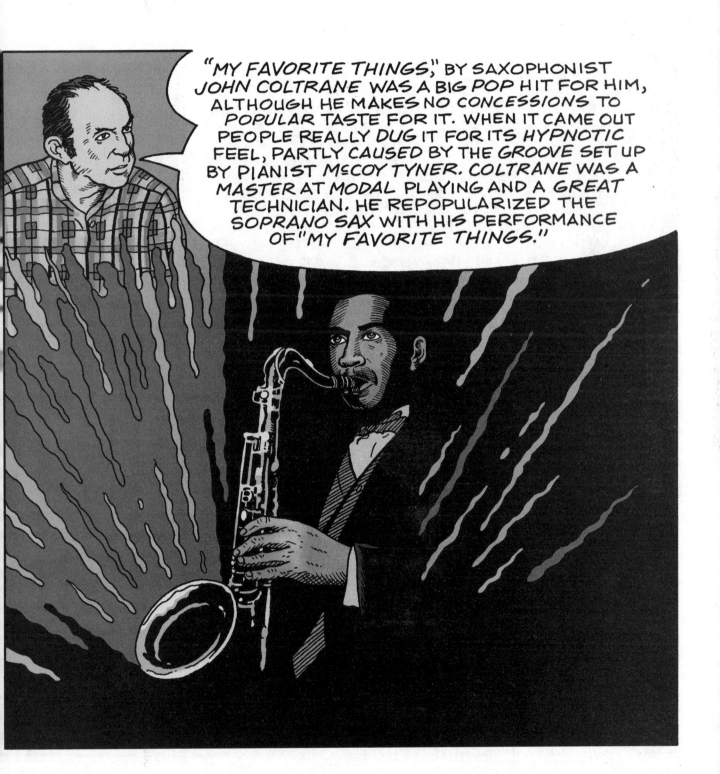

"MY FAVORITE THINGS," BY SAXOPHONIST JOHN COLTRANE WAS A BIG POP HIT FOR HIM, ALTHOUGH HE MAKES NO CONCESSIONS TO POPULAR TASTE FOR IT. WHEN IT CAME OUT PEOPLE REALLY DUG IT FOR ITS HYPNOTIC FEEL, PARTLY CAUSED BY THE GROOVE SET UP BY PIANIST McCOY TYNER. COLTRANE WAS A MASTER AT MODAL PLAYING AND A GREAT TECHNICIAN. HE REPOPULARIZED THE SOPRANO SAX WITH HIS PERFORMANCE OF "MY FAVORITE THINGS."

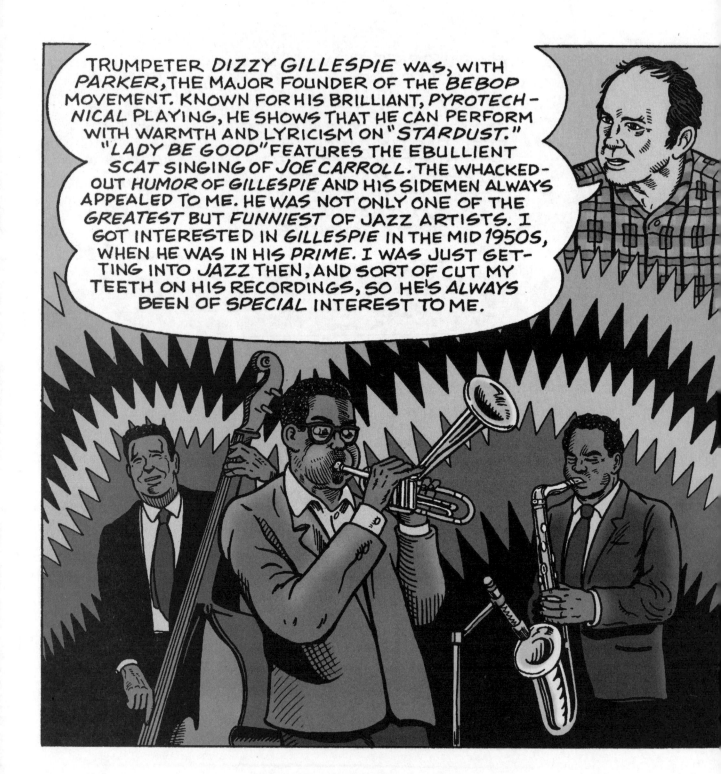

TRUMPETER *DIZZY GILLESPIE* WAS, WITH *PARKER*, THE MAJOR FOUNDER OF THE *BEBOP* MOVEMENT. KNOWN FOR HIS BRILLIANT, *PYROTECHNICAL* PLAYING, HE SHOWS THAT HE CAN PERFORM WITH WARMTH AND LYRICISM ON "*STARDUST.*" "*LADY BE GOOD*" FEATURES THE EBULLIENT SCAT SINGING OF *JOE CARROLL.* THE WHACKED-OUT *HUMOR* OF *GILLESPIE* AND HIS SIDEMEN ALWAYS APPEALED TO ME. HE WAS NOT ONLY ONE OF THE *GREATEST* BUT *FUNNIEST* OF JAZZ ARTISTS. I GOT INTERESTED IN *GILLESPIE* IN THE MID 1950S, WHEN HE WAS IN HIS *PRIME.* I WAS JUST GETTING INTO *JAZZ* THEN, AND SORT OF CUT MY TEETH ON HIS RECORDINGS, SO HE'S *ALWAYS* BEEN OF *SPECIAL* INTEREST TO ME.

MARK SUOZZO'S ORIGINAL MUSIC FOR THE FILM WAS EDITED BY HIM INTO WHAT MIGHT BE CALLED A *SUITE*, CONTAINING SOME OTHER *SMALLER* SUITES. IT'S MOSTLY PRETTY, MELANCHOLY MUSIC, WHICH REFLECTS *HARVEY'S* MOODS. ORCHESTRATION ON THEM VARIES QUITE A BIT TIMBRALLY, PARTLY BECAUSE THE CHARTS ARE PLAYED BY GROUPS OF VARYING *SIZE* AND MAKE UP. I FOUND "*LONGING SUITE*" TO BE PARTICULARLY *HAUNTING*, WITH SENSITIVE PLAYING BY TENORMAN *BOB MALACH*. THE BRIGHT VIBES SOUND OF *JIM SAPORITO* IS USED EFFECTIVELY IN *SUOZZO'S* SCORE TO CONTRAST WITH THE DARKER, MORE SOMBRE ENSEMBLE COLORS. THERE ARE SOME UPBEAT MOMENTS IN THE SCORE AS WELL, AS "*SCHTICK FIGURES*" AND THE *COUNT BASIEISH* "*CHECKOUT DREAMS*" INDICATE. ALL IN ALL *SUOZZO'S* WORK DOES WHAT A LOT OF GOOD FILM MUSIC IS SUPPOSED TO DO, *SUPPORT* THE ON SCREEN *ACTION* WITHOUT DRAWING UNDUE *ATTENTION* TO ITSELF.

B.B. KING

Story by HARVEY PEKAR
Art by GARY DUMM

RILEY B. KING WAS BORN IN INDIANOLA, MISSISSIPPI IN 1925. HE WAS A COUSIN OF EARLY BLUES GREAT BUKKA WHITE, AND GREW UP TO BE B.B. KING, THE MOST INFLUENTIAL BLUES ARTIST OF THE PAST FIFTY YEARS.

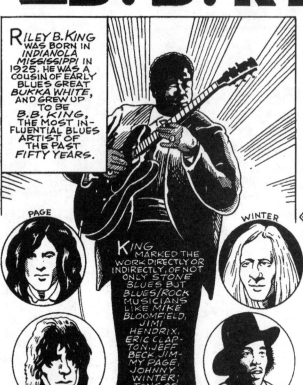

PAGE

WINTER

KING MARKED THE WORK DIRECTLY OR INDIRECTLY, OF NOT ONLY STONE BLUES BUT BLUES/ROCK MUSICIANS LIKE MIKE BLOOMFIELD, JIMI HENDRIX, ERIC CLAPTON, JEFF BECK, JIMMY PAGE, JOHNNY WINTER; TONS OF GUYS.

BECK

HENDRIX

AS A YOUNG GUY B.B. WAS A FARM WORKER. HE PICKED UP A GUITAR AND LISTENED TO EVERYONE HE COULD, INCLUDING JAZZ MUSICIANS LIKE CHARLIE CHRISTIAN & DJANGO REINHARDT...

NOW I COULD ALSO EXTRACT FROM MANY PEOPLE...SO THAT IS HOW I COULD EASILY INCORPORATE CHARLIE CHRISTIAN & DJANGO REINHARDT IN MY PLAYING.

BUT OF COURSE B.B. IS BASICALLY A BLUES SINGER/GUITARIST, AND THE GUYS THAT SEEM TO HAVE HAD THE MOST IMPACT ON HIM ARE BLIND LEMON JEFFERSON, LONNIE JOHNSON AND T-BONE WALKER.

LONNIE JOHNSON WAS MY MAIN MAN. HE AND BLIND LEMON. PERSONALLY, I CALL T-BONE WALKER THE BOSS OF BLUES GUITAR... ...LIKE WHEN I HEARD T-BONE PLAY THE ELECTRIC GUITAR, I JUST HAD TO HAVE ONE.

KING GOT HIS START IN MEMPHIS PLAYING WITH SONNY BOY WILLIAMSON IN 1947.

IN 1949 HE BECAME A RADIO DEEJAY, THE BEALE STREET BLUES BOY, WHICH WAS LATER SHORTENED TO B.B.

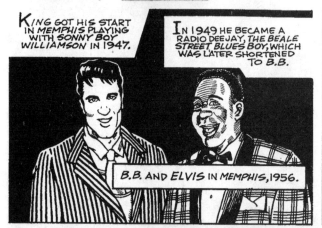

B.B. AND ELVIS IN MEMPHIS, 1956.

HE STARTED RECORDING IN 1949, AND BY 1951 HAD AN R&B HIT, "THREE O'CLOCK BLUES." HE NEVER LOOKED BACK AND BY THE MID 1950'S WAS AN ESTABLISHED STAR IN HIS GENRE. IN THE 1960'S ROCK FANS DISCOVERED HIM & HE BECAME A CROSS-GENRE SUPER STAR.

19 69

KING'S A FORCEFUL URGENT SINGER, BUT EVEN MORE WELL KNOWN FOR HIS GUITAR WORK, WHICH IS ECONOMICAL BUT HAS GREAT PRESENCE. HE MAKES HIS NOTES COUNT.

EVER HEAR OF A TRUMPET PLAYER CALLED BOBBY HACKETT OR AN ALTO SAXOPHONIST CALLED JOHNNY HODGES? THOSE PEOPLE, WHEN THEY PLAYED JUST ONE NOTE, THEY SEEMED TO LIVE IT. THAT'S THE WAY I LIKE TO PLAY.

ANOTHER OF KING'S CONSIDERABLE ACHIEVEMENTS IS THAT HE'S SO WELL-LIKED. CHECK OUT WHAT BONNIE RAITT SAYS ABOUT HIM:

WITHOUT A DOUBT B.B. KING HAS INFLUENCED MORE ROCK AND BLUES MUSICIANS THAN ANYONE ELSE IN HISTORY...

...THERE IS SIMPLY NO ONE ELSE WITH MORE RAW PASSION OR ELOQUENCE...

...HE'S ALSO THE KINDEST AND MOST GENEROUS PERSON TO OTHER MUSICIANS I KNOW...THERE ARE REASONS WHY HE'S...LOVED... IT'S THE DIGNITY AND HEART HE BRINGS TO HIS LIFE AS WELL AS HIS MUSIC.

CLIFTON CHENIER

I READ IN A BOOK ONCE THAT CLIFTON CHENIER WAS BUSTING UP CLODS OF BLACK DIRT ON HIS FATHER'S LAND OUTSIDE OF OPELOUSAS, LOUISIANA. HE CAME TO THE END OF A ROW, STUCK HIS HOE IN THE GROUND AND SAID:

I AM **NEVER** GOING TO PUT ANOTHER PLOW OR HOE OR MULE IN THIS HAND.

STORY by HARVEY PEKAR ART by GARY DUMM

CHENIER, WHO LATER BECAME KNOWN AS "THE KING OF ZYDECO," MOVED TO TEXAS AND BY THE EARLY 1950'S HE WAS WORKING FOR GULF OIL AND SINGING AND PLAYING HIS ACCORDION AT CLUBS AT NIGHT AND ON WEEKENDS.

HE DID WELL AND CONTINUED TO PURSUE HIS MUSIC-AL CAREER, IN SOME WAYS A CHANGED MAN.

HE HAD ALL KINDS OF COLORED CLOTHES, AND HE HAD CONKED HAIR, GOLD TEETH, TALKED NICE, TALKED PROPER. BUT ONE THING ABOUT CLIFTON THAT NEVER CHANGED, CLIFTON WAS A MAN YOU COULD ALWAYS REACH.

IN 1954 A RECORD PRODUCER HEARD CHENIER IN PORT ARTHUR, TEXAS AND, IMPRESSED. ("YOU PLAY TOO MUCH AC-CORDION TO BE IN THESE WOODS") BROUGHT HIM BACK TO LAKE CHARLES, LA. FOR A RECORDING SESSION. CHENIER CUT SEVEN SIDES, WHICH WERE SOLD ON THE *IMPERIAL* LABEL.

IN 1955 *CHENIER* TRAVELED TO L.A. TO CUT MORE RE-CORDS FOR THE SPECIALTY LABEL. AMONG THEM WAS A HIT SINGLE "AY-TETE FEE," A FRENCH COVER OF PROFESSOR LONGHAIR'S "HEY, LITTLE GIRL."

THEN CHENIER SETTLED BACK IN *LOUISIANA* AND STARTED TOUR-ING WITH R&B ARTISTS INCLUDING *CHUCK BERRY* AND *LITTLE RICHARD.* THINGS WERE MOVING ALONG NICELY.

In 1956 and 1957 CLIFTON did a couple of sessions for CHESS, cutting "MY SOUL," an R&B classic on which ETTA JAMES appeared.

SOON AFTER THAT SHE WAS TOURING WITH CHENIER.

NOW CHENIER'S FIRST COUSIN WAS MARRIED TO BLUES GREAT LIGHTNIN' HOPKINS. HOPKINS TALKED UP CHENIER, AND RECORD PRODUCER CHRIS STRACHWITZ OF ARHOOLIE RECORDS WENT TO SEE HIM.

STRACHWITZ WANTED CHENIER TO EMPHASIZE HIS FRENCH ROOTS FOR THE COLLEGE CROWD, CHENIER WANTED TO PUSH HIS R&B STYLE. THEY COMPROMISED, SOME COMMERCIALLY SUCCESSFUL L.P.'S WERE CUT AND CHENIER'S CAREER REACHED NEW HEIGHTS.

FOR YEARS AFTER THAT CHENIER TOURED THROUGH THE U.S., CANADA AND EUROPE, POPULARIZING ZYDECO MUSIC LIKE NO ONE BEFORE HAD. SOMETIMES HE'D WEAR A CAPE AND A CROWN TO EMPHASIZE HIS "KING" STATUS.

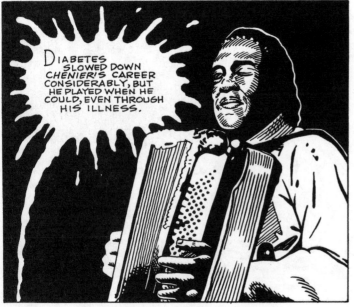

DIABETES SLOWED DOWN CHENIER'S CAREER CONSIDERABLY, BUT HE PLAYED WHEN HE COULD, EVEN THROUGH HIS ILLNESS.

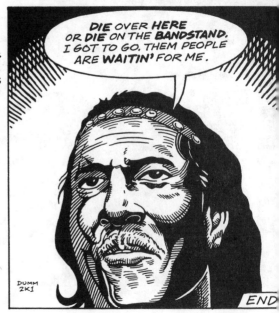

ONE OF CHENIER'S SIDEMEN RECALLED CLIFTON'S WIFE TELLING HIM ONCE THAT HE WAS TOO SICK TO PLAY. HE REPLIED:

DIE OVER HERE OR DIE ON THE BANDSTAND. I GOT TO GO. THEM PEOPLE ARE WAITIN' FOR ME.

DUMM 2K1

END

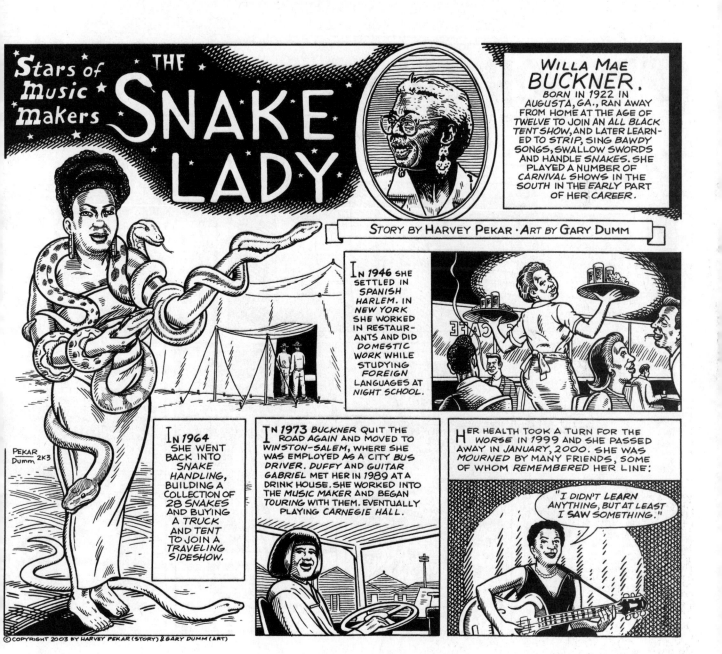

PRESTON FULP

STORY BY HARVEY PEKAR · ART BY GARY DUMM

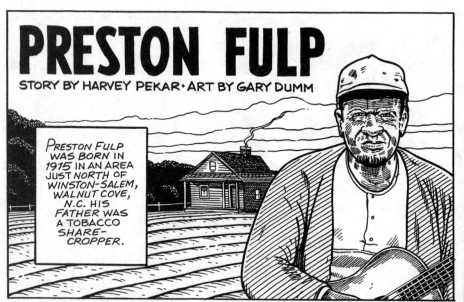

PRESTON FULP WAS BORN IN 1915 IN AN AREA JUST NORTH OF WINSTON-SALEM, WALNUT COVE, N.C. HIS FATHER WAS A TOBACCO SHARE-CROPPER.

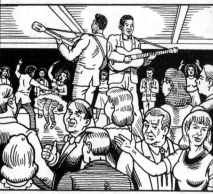

PRESTON STARTED PLAYING GUITAR WHEN HE WAS SIX, AND LATER LEARNED BANJO AND VIOLIN. HE SANG BOTH HILLBILLY & BLUES TUNES, PERFORMING IN BOTH STYLES ON SATURDAY NIGHTS, WHEN HE PLAYED DANCES AT SEGREGATED MOUNTAIRY. HE'D GO TO ONE SIDE OF THE HALL FOR THE BLACKS, AND THE OTHER SIDE FOR THE WHITES.

HE GOT GOOD MONEY PLAYING AT TOBACCO AUCTIONS IN WINSTON-SALEM, OFTEN MAKING ONE HUNDRED DOLLARS FOR WORKING FRIDAY & SATURDAY NIGHTS.

DURING THE DEPRESSION PRESTON HOBOED IN THE MIDWEST AND CANADA, DOING FARMWORK AND MAKING GOOD SELLING MOONSHINE.

Pekar
DUMM
2K3

AFTER ABOUT FIVE YEARS HE MOVED BACK TO WALNUT COVE, MARRIED AND WORKED AT GROWING TOBACCO AND AT A SAWMILL.

HE PLAYED INTO OLD AGE, SITTING IN HIS YARD AND PERFORMING WHEN IT WAS WARM ENOUGH. A NEIGHBORING FARMER WOULD GET PRESTON'S GUITAR OUT OF THE PAWNSHOP IN TOBACCO CURING TIME SO THAT HE COULD SING AND PLAY HOUR AFTER HOUR.

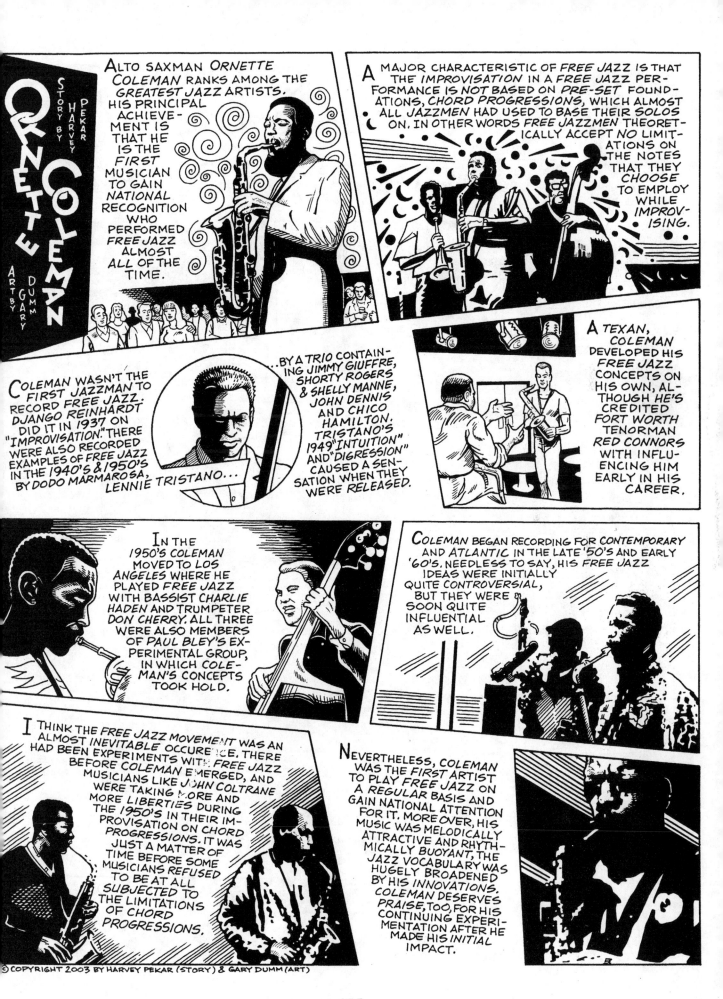

ORNETTE COLEMAN

STORY BY HARVEY PEKAR

ART BY GARY DUMM

ALTO SAXMAN *ORNETTE COLEMAN* RANKS AMONG THE *GREATEST JAZZ ARTISTS.* HIS PRINCIPAL ACHIEVEMENT IS THAT HE IS THE *FIRST MUSICIAN* TO GAIN *NATIONAL RECOGNITION* WHO PERFORMED *FREE JAZZ* ALMOST ALL OF THE TIME.

A MAJOR CHARACTERISTIC OF *FREE JAZZ* IS THAT THE *IMPROVISATION* IN A FREE JAZZ PERFORMANCE IS *NOT* BASED ON *PRE-SET* FOUNDATIONS, *CHORD PROGRESSIONS,* WHICH ALMOST ALL JAZZMEN HAD USED TO BASE THEIR SOLOS ON. IN OTHER WORDS *FREE JAZZMEN* THEORETICALLY ACCEPT *NO* LIMITATIONS ON THE NOTES THAT THEY *CHOOSE* TO EMPLOY WHILE *IMPROVISING.*

COLEMAN WASN'T THE *FIRST JAZZMAN* TO RECORD *FREE JAZZ. DJANGO REINHARDT* DID IT IN *1937* ON "IMPROVISATION." THERE WERE ALSO RECORDED EXAMPLES OF *FREE JAZZ* IN THE *1940'S & 1950'S* BY *DODO MARMAROSA, LENNIE TRISTANO...* ...BY A TRIO CONTAINING *JIMMY GIUFFRE, SHORTY ROGERS & SHELLY MANNE, JOHN DENNIS* AND *CHICO HAMILTON. TRISTANO'S* 1949 "*INTUITION*" AND "*DIGRESSION*" CAUSED A SENSATION WHEN THEY WERE *RELEASED.*

A *TEXAN,* COLEMAN DEVELOPED HIS *FREE JAZZ* CONCEPTS ON HIS OWN, ALTHOUGH *HE'S* CREDITED *FORT WORTH* TENORMAN *RED CONNORS* WITH INFLUENCING HIM EARLY IN HIS CAREER.

IN THE *1950'S* COLEMAN MOVED TO *LOS ANGELES* WHERE HE PLAYED *FREE JAZZ* WITH BASSIST *CHARLIE HADEN* AND TRUMPETER *DON CHERRY.* ALL THREE WERE ALSO MEMBERS OF *PAUL BLEY'S* EXPERIMENTAL GROUP, IN WHICH COLEMAN'S CONCEPTS TOOK HOLD.

COLEMAN BEGAN RECORDING FOR *CONTEMPORARY* AND *ATLANTIC* IN THE LATE '50'S AND EARLY '60'S. NEEDLESS TO SAY, HIS *FREE JAZZ* IDEAS WERE INITIALLY QUITE *CONTROVERSIAL,* BUT THEY WERE SOON QUITE *INFLUENTIAL* AS WELL.

I THINK THE *FREE JAZZ MOVEMENT* WAS AN ALMOST INEVITABLE OCCURRENCE. THERE HAD BEEN EXPERIMENTS WITH *FREE JAZZ* BEFORE COLEMAN EMERGED, AND MUSICIANS LIKE *JOHN COLTRANE* WERE TAKING MORE AND MORE *LIBERTIES* DURING THE *1950'S* IN THEIR IMPROVISATION ON CHORD PROGRESSIONS. IT WAS JUST A MATTER OF TIME BEFORE SOME *MUSICIANS REFUSED* TO BE AT ALL SUBJECTED TO THE LIMITATIONS OF CHORD PROGRESSIONS.

NEVERTHELESS, COLEMAN WAS THE *FIRST ARTIST* TO PLAY *FREE JAZZ* ON A *REGULAR BASIS* AND GAIN NATIONAL ATTENTION FOR IT. MORE OVER, HIS MUSIC WAS MELODICALLY ATTRACTIVE AND RHYTHMICALLY *BUOYANT,* THE JAZZ VOCABULARY WAS HUGELY BROADENED BY HIS *INNOVATIONS.* COLEMAN DESERVES *PRAISE,* TOO, FOR HIS CONTINUING EXPERIMENTATION AFTER HE MADE HIS *INITIAL* IMPACT.

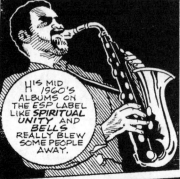

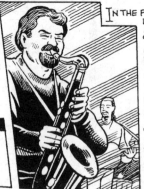

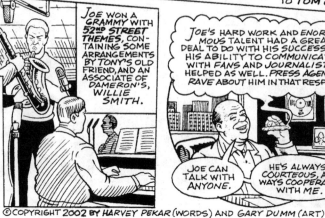

KING OLIVER

STORY BY HARVEY PEKAR • ART BY GARY DUMM

CORNETIST/ TRUMPETER JOSEPH "KING" OLIVER RANKS AMONG THE MAJOR FIGURES IN EARLY JAZZ HISTORY. HE WAS BORN IN NEW ORLEANS OR ITS VICINITY IN 1885. AS A KID HE BEGAN PLAYING IN A BRASS BAND IN HIS NEIGHBORHOOD AND CONTINUED TO PLAY WITH THEM WHEN HE BECAME AN ADULT IN THE MELROSE, OLYMPIA, EAGLE AND MAGNOLIA BANDS.

FOR AWHILE OLIVER WORKED DAY JOBS e.g. AS A BUTLER, UNTIL HIS REPUTATION WAS SUCH THAT HE WAS ABLE TO SUPPORT HIMSELF AS A MUSICIAN. AT THIS POINT JAZZ WAS IN A FORMATIVE STAGE AND ITS FIRST STARS WERE EMERGING.

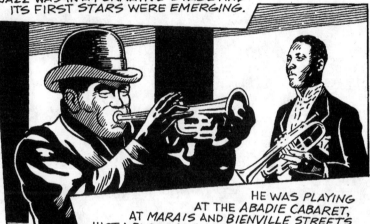

HE WAS PLAYING AT THE ABADIE CABARET, AT MARAIS AND BIENVILLE STREETS JUST A BLOCK AWAY FROM WHERE THE HIGHLY REGARDED CORNETIST FREDDIE "KING" KEPPARD WAS PERFORMING AND REPORTEDLY OUTPLAYED KEPPARD, SO THAT SOME OF HIS FOLLOWERS CALLED OLIVER "KING."

FROM 1911-1918 OLIVER WAS PROBABLY THE MOST PROMINENT NEW ORLEANS JAZZMAN. HE NOT ONLY PLAYED IN THE CITY BUT DID SOME TOURING IN LOUISIANA,

IN NOVEMBER 1917, THE U.S. NAVY CLOSED DOWN THE WIDE-OPEN STORYVILLE DISTRICT, CUTTING DOWN THE NUMBER OF JOBS FOR MUSICIANS.

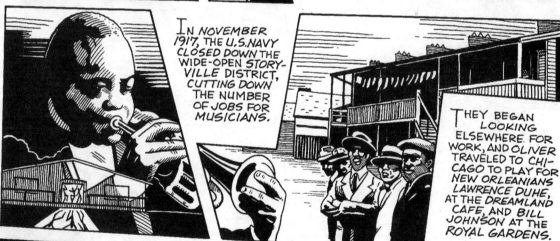

THEY BEGAN LOOKING ELSEWHERE FOR WORK, AND OLIVER TRAVELED TO CHICAGO TO PLAY FOR NEW ORLEANIANS LAWRENCE DUHE, AT THE DREAMLAND CAFE, AND BILL JOHNSON AT THE ROYAL GARDENS.

BY JANUARY, 1920, OLIVER WAS POPULAR ENOUGH TO FORM HIS OWN BAND IN CHICAGO. THIS INCLUDED OTHER JAZZ PIONEERS, CLARINETIST JOHNNY DODDS, TROMBONIST HONORE DUTREY AND PIANIST LIL HARDIN WHO LATER MARRIED LOUIS ARMSTRONG.

MEANWHILE NEW ORLEANS TROMBONIST KID ORY HAD BEEN PLAYING IN CALIFORNIA WITH CONSIDERABLE SUCCESS. OLIVER FOLLOWED HIM THERE IN 1921-22, WORKING IN THE BAY AREA AND LOS ANGELES.

OLIVER RETURNED TO CHICAGO IN 1922... HE WORKED AT THE *LINCOLN GARDENS* WITH HIS GREAT "CREOLE JAZZ BAND", INCLUDING *JOHNNY* AND DRUMMER *BABY DODDS, DUTREY, HARDIN* AND BASSIST *BILL JOHNSON.* THEY WERE JOINED BY *LOUIS ARMSTRONG,* WHOM OLIVER HAD SENT FOR TO PLAY SECOND CORNET, IN *JUNE,* 1922.

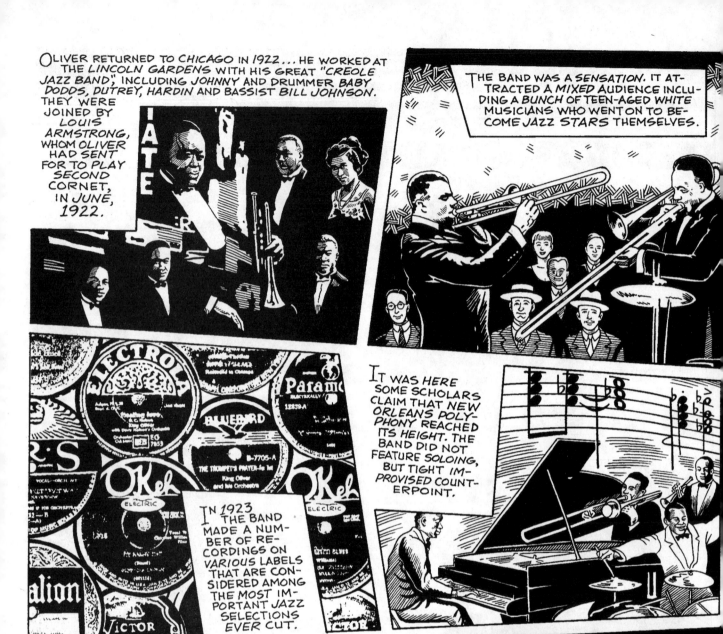

THE BAND WAS A SENSATION. IT ATTRACTED A *MIXED* AUDIENCE INCLUDING A *BUNCH* OF TEEN-AGED WHITE MUSICIANS WHO WENT ON TO BECOME JAZZ STARS THEMSELVES.

IN 1923 THE BAND MADE A NUMBER OF RECORDINGS ON *VARIOUS* LABELS THAT ARE CONSIDERED AMONG THE MOST IMPORTANT *JAZZ* SELECTIONS EVER CUT.

IT WAS *HERE* SOME SCHOLARS CLAIM THAT *NEW ORLEANS* POLYPHONY REACHED ITS *HEIGHT.* THE BAND DID NOT FEATURE *SOLOING,* BUT TIGHT *IMPROVISED* COUNTERPOINT.

1923 WAS OLIVER'S PEAK YEAR. AFTER THE *CREOLE JAZZ BAND* BROKE UP HE CONTINUED TO PLAY, RECORD AND TOUR, MOVING BETWEEN *CHICAGO* AND *NEW YORK,* STAYING IN *NASHVILLE* BRIEFLY. BUT CHANGING MUSICAL STYLES & ILL-HEALTH TOOK THEIR TOLL ON HIM. HIS DENTAL PROBLEMS GREW SO SEVERE THAT HE COULD NO LONGER PLAY *TRUMPET.*

WHEN HE DIED IN 1938 HE WAS WORKING AS A JANITOR IN A POOL HALL IN SAVANNAH. BUT HE ACCEPTED HIS FATE STOICALLY, WRITING IN ONE OF HIS LAST LETTERS.

My heart don't bother me just a little at times. But my breath is still short... Don't think I will ever raise enough money to buy a ticket to New York. I am not one to give up quick... I always feel like I've got a chance. I still feel I'm going to snap out of the rut I've been in for several years ... I open the pool rooms at 9 a.m. and close at 12 midnight. If the money was only a quarter as much as the hours I'd be all set. But at that I can thank God for what I am getting.

END

138

RIDE, RED, RIDE

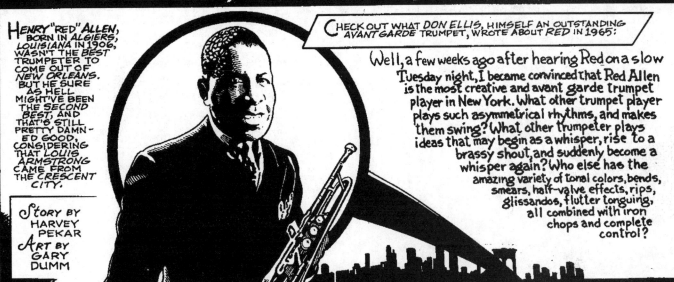

HENRY "RED" ALLEN, BORN IN ALGIERS, LOUISIANA IN 1906, WASN'T THE BEST TRUMPETER TO COME OUT OF NEW ORLEANS. BUT HE SURE AS HELL MIGHT'VE BEEN THE SECOND BEST, AND THAT'S STILL PRETTY DAMNED GOOD, CONSIDERING THAT LOUIS ARMSTRONG CAME FROM THE CRESCENT CITY.

STORY BY HARVEY PEKAR
ART BY GARY DUMM

CHECK OUT WHAT DON ELLIS, HIMSELF AN OUTSTANDING AVANT GARDE TRUMPET, WROTE ABOUT RED IN 1965:

Well, a few weeks ago after hearing Red on a slow Tuesday night, I became convinced that Red Allen is the most creative and avant garde trumpet player in New York. What other trumpet player plays such asymmetrical rhythms, and makes them swing? What other trumpeter plays ideas that may begin as a whisper, rise to a brassy shout, and suddenly become a whisper again? Who else has the amazing variety of tonal colors, bends, smears, half-valve effects, rips, glissandos, flutter tonguing, all combined with iron chops and complete control?

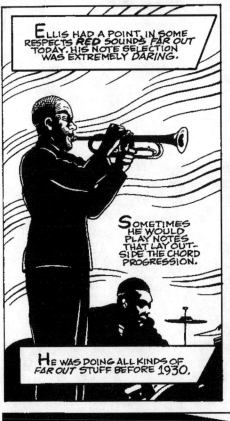

ELLIS HAD A POINT. IN SOME RESPECTS RED SOUNDS FAR OUT TODAY. HIS NOTE SELECTION WAS EXTREMELY DARING.

SOMETIMES HE WOULD PLAY NOTES THAT LAY OUTSIDE THE CHORD PROGRESSION.

HE WAS DOING ALL KINDS OF FAR OUT STUFF BEFORE 1930.

RED'S FATHER WAS A LONGSHOREMAN, BUT HE WAS BEST KNOWN LOCALLY AS A TRUMPETER AND LEADER OF A BRASS BAND WHICH CONTAINED SOME OF NEW ORLEANS'S FINEST MUSICIANS.

RED WAS PLAYING IN HIS FATHER'S OUTFIT AS A KID. HE ATTRIBUTED SOME OF HIS STAMINA AND POWER TO HIS MARCHING BAND EXPERIENCE, BUT IN THE EARLY 1920'S HE WAS PLAYING IN JAZZ BANDS AS WELL, SUCH AS ONE LED BY THE RESPECTED CLARINETIST GEORGE LEWIS.

SOON HE WAS LEADING HIS OWN BAND IN NEW ORLEANS, AND DID QUITE WELL. THEN HE PLAYED ON A MISSISSIPPI RIVER EXCURSION BOAT. HE IMPRESSED EVERYWHERE HE PLAYED.

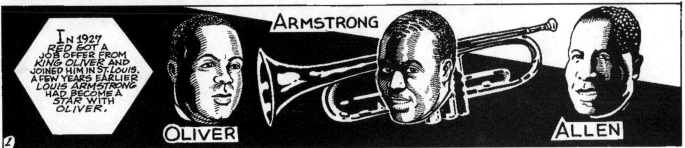

IN 1927 RED GOT A JOB OFFER FROM KING OLIVER AND JOINED HIM IN ST. LOUIS. A FEW YEARS EARLIER LOUIS ARMSTRONG HAD BECOME A STAR WITH OLIVER.

ARMSTRONG

OLIVER

ALLEN

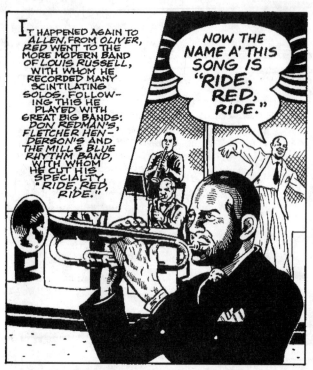

IT HAPPENED AGAIN TO ALLEN, FROM OLIVER. RED WENT TO THE MORE MODERN BAND OF LOUIS RUSSELL, WITH WHOM HE RECORDED MANY SCINTILATING SOLOS. FOLLOWING THIS HE PLAYED WITH GREAT BIG BANDS: DON REDMAN'S, FLETCHER HENDERSON'S AND THE MILLS BLUE RHYTHM BAND, WITH WHOM HE CUT HIS SPECIALTY, "RIDE, RED, RIDE."

NOW THE NAME A' THIS SONG IS "RIDE, RED, RIDE."

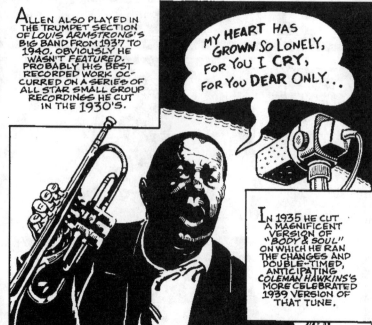

ALLEN ALSO PLAYED IN THE TRUMPET SECTION OF LOUIS ARMSTRONG'S BIG BAND FROM 1937 TO 1940. OBVIOUSLY HE WASN'T FEATURED. PROBABLY HIS BEST RECORDED WORK OCCURRED ON A SERIES OF ALL STAR SMALL GROUP RECORDINGS HE CUT IN THE 1930'S.

MY HEART HAS GROWN SO LONELY, FOR YOU I CRY, FOR YOU DEAR ONLY...

IN 1935 HE CUT A MAGNIFICENT VERSION OF "BODY & SOUL" ON WHICH HE RAN THE CHANGES AND DOUBLE-TIMED, ANTICIPATING COLEMAN HAWKINS'S MORE CELEBRATED 1939 VERSION OF THAT TUNE.

IN THE 1940'S RED CONTINUED TO PLAY BRILLIANTLY, EVEN INCORPORATING BOP IDEAS IN HIS WORK. EVEN DIZZY GILLESPIE NOTICED RED'S OPENNESS.

THE SQUABBLE BETWEEN THE BOPPERS AND MOLDY FIGS... ...AROSE BECAUSE THE OLDER MUSICIANS INSISTED ON ATTACKING OUR MUSIC...

...BUT THEN YOU NOTICED SOME OF THE OLDER GUYS STARTING PLAYING OUR RIFFS. A FEW OF THEM LIKE HENRY "RED" ALLEN. THE OTHERS REMAINED HOSTILE TO IT.

EUROPE, 1959

FROM 1954 TO 1965, ALLEN FRONTED THE HOUSE BAND AT NEW YORK'S METROPOLE CAFE. HE ALSO TOURED FROM 1959-1967 THE FIRST TIME AS A MEMBER OF NEW ORLEANS JAZZ FOUNDING FATHER KID ORY'S BAND.

IN THE LAST FEW YEARS OF HIS LIFE RED GOT QUITE A BIT OF ATTENTION, CONSIDERING THAT THE MUSIC HE WAS GENERALLY IDENTIFIED WITH WAS TRADITIONAL JAZZ AND EARLY SWING. HOWEVER, THERE WAS A GROWING REALIZATION THAT HIS WORK TRANSCENDED GENRE. THE ELLIS ARTICLE HELPED. RED DIED IN 1967.

BY JAZZ MUSICIAN'S STANDARDS RED LIVED A REMARKABLY STEADY LIFE. HE DIDN'T GET DEPORTED FROM TWO COUNTRIES OR GO AROUND SHOOTING PEOPLE LIKE THAT OTHER GREAT NEW ORLEANS JAZZ MUSICIAN SIDNEY BECHET.

GARY DUMM 2X1

HE LED A QUIET LIFE, HAD A LONG, STABLE MARRIAGE, WASN'T A SUBSTANCE ABUSER. BUT HE WAS ONE OF THE GREATEST AND MOST INNOVATIVE TRUMPETERS OF ALL TIME. THAT'S PLENTY, RIGHT?

-END

JIMMY SCOTT

STORY BY HARVEY PEKAR

ART BY GARY DUMM

ONE OF THE GREATEST JAZZ ARTISTS TO EMERGE FROM THE *CLEVELAND* AREA, VOCALIST *LITTLE JIMMY SCOTT* COMES BACK HOME ON *NOV. 2ND & 3RD* WHEN HE'LL BE PERFORMING AT *NIGHT TOWN*.
JIMMY WAS BORN HERE IN *1925*. HE SUFFERED FROM A RARE DISEASE, *KALLMAN'S SYNDROME*, WHICH KEPT HIM FROM FULLY MATURING PHYSICALLY. HE REMAINED SMALL OF STATURE (4'11") UNTIL HE *MYSTERIOUSLY* GREW TO 5'7" IN HIS MID-THIRTIES. HIS VOICE *NEVER* CHANGED, HE HAD THE VOCAL RANGE OF A WOMAN.

JIMMY GREW UP IN THE *CEDAR-CENTRAL* AREA AND WAS HEAVILY INFLUENCED BY HIS WARM, PROTECTIVE MOTHER, WHO PLAYED GOSPEL PIANO. GOSPEL MUSIC WAS WHAT HE ORIGINALLY SANG. ONE OF THE GREAT *TRAGEDIES* OF SCOTT'S LIFE WAS THE UNTIMELY DEATH OF HIS MOTHER IN AN AUTOMOBILE ACCIDENT WHEN HE WAS THIRTEEN. AFTER THAT HE LIVED IN FOSTER HOMES.

AT SIXTEEN SCOTT GOT A WORK PERMIT AND A *JOB* AT A FACTORY. HE WAS *SUPPORTING* HIMSELF.

BUT HE LOVED *SINGING* AND, INSPIRED BY *PAUL ROBESON* AND *JUDY GARLAND*, BEGAN TO PERFORM. HE HOOKED UP WITH A COUPLE OF TAP DANCERS AS A VALET BUT STARTED SINGING WITH THEM TOO.

THROUGHOUT THE LATTER PART OF THE *1940s* SCOTT TOOK JUST ABOUT ANY SINGING JOB HE COULD GET. HE BECAME A MORE ASSURED, DISTINCTIVE STYLIST, A POIGNANT INTERPRETER OF BALLADS. FINALLY IN *1948* HE JOINED *LIONEL HAMPTON'S* BAND AND SANG ON HAMPTON'S HIT RECORDING OF *"EVERYBODY'S, SOMEBODY'S FOOL."*

IN THE *1950s* JIMMY WENT OUT ON HIS OWN, SINGING IN CLUBS AND RECORDING FOR VARIOUS LABELS. HE WAS A *SINGER'S* SINGER, RESPECTED IN *JAZZ* AND *R&B* CIRCLES. AT THAT TIME SCOTT WAS ADMIRED BY, AND/OR INFLUENCED A LARGE NUMBER AND VARIETY OF VOCALISTS *INCLUDING:*

RUTH BROWN

RAY CHARLES

NANCY WILSON

FRANKIE VALLI

MARVIN GAYE

DURING THE *1970s* AND '80s JIMMY, DOGGED BY PERSONAL PROBLEMS, LEFT THE MUSIC BUSINESS FOR A LONG TIME, WORKING AMONG OTHER PLACES AT THE *CLEVELAND SHERATON* HOTEL AS A SHIPPING CLERK.

SHIPPING DEPARTME

MARCH

10/03

TOWARD THE END OF THE *EIGHTIES JIMMY*, ENCOURAGED BY *DOC POMUS* AND *RUTH BROWN*, STARTED SINGING AGAIN AND EVENTUALLY RECORDING. THIS TIME HE WAS COMMERCIALLY SUCCESSFUL. HE'S BEEN THE ADMIRED SUBJECT OF MANY ARTICLES AND A BIOGRAPHY BY *DAVID RITZ*.

SUDDENLY PEOPLE WERE ADMIRING SCOTT AGAIN FOR HIS SWEET TIMBRE AND RHYTHMIC DARING. HE FINALLY HAS GOTTEN A LOT OF THE ATTENTION HE DESERVES AS AN OUTSTANDING AND ORIGINAL JAZZ VOCALIST. GET DOWN TO *NIGHT TOWN* EARLY WHEN HE COMES, THERE MAY NOT BE MANY SEATS AVAILABLE.

EARLY ELVIS

STORY BY HARVEY PEKAR · ART BY GARY DUMM

I REMEMBER WHEN ELVIS PRESLEY MADE HIS FIRST APPEARANCE IN THE NORTH, HERE IN CLEVELAND. HE PERFORMED AT THE HILLBILLY JAMBOREE AT THE CIVIC THEATRE ON 105TH AND EUCLID IN FEBRUARY, 1955 AND, IN OCTOBER, 1955, AT BROOKLYN HIGH SCHOOL AND ST. MICHAEL'S HALL ON 100TH AND UNION.

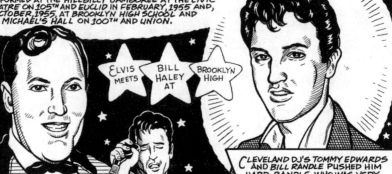

ELVIS MEETS BILL HALEY AT BROOKLYN HIGH

MAN, I WAS JUST LISTENING TO THE RECORDS ELVIS MADE FOR SUN IN 1954 AND 1955. I THINK THEY'RE HIS BEST. THERE WAS A LOT OF CREATIVITY INVOLVED IN THEIR MAKING. ROCKABILLY WAS A NEW GENRE. SAM PHILLIPS OF SUN RECORDS SAW ELVIS'S POTENTIAL AND HE DID SOMETHING ABOUT IT.

I'M WALKING ALONG ON A TYPICALLY BLEAK CLEVELAND DECEMBER IN MY DECLINING YEARS, THINKING OF ANOTHER TIME, A TIME WHEN I HAD MORE HAIR, A TIME WHEN THE BROWNS COULD BE COUNTED ON TO WIN MORE THAN FIVE GAMES IN ONE SEASON, A TIME WHEN ROCK'N'ROLL MADE ITS INITIAL IMPACT ON THE NATION. YEAH, I WAS AROUND THEN. I USED TO LISTEN TO DJ ALAN FREED.

CLEVELAND DJ'S TOMMY EDWARDS AND BILL RANDLE PUSHED HIM HARD. RANDLE, WHO WAS VERY INFLUENTIAL NATIONALLY, INTRODUCED HIM ON HIS INITIAL TV APPEARANCE ON "STAGE SHOW" HOSTED BY TOMMY & JIMMY DORSEY IN JANUARY, 1956.

PHILLIPS GOT ELVIS TOGETHER WITH GUITARIST SCOTTY MOORE AND BASSIST BILL BLACK...

...AND THROUGH A TRIAL AND ERROR METHOD THEY DEVELOPED A STYLE TOGETHER, WITH BLACK PLAYING SIMPLY BUT PROPULSIVELY, ELVIS ON RHYTHM GUITAR AND MOORE SUPPLYING THE LEAD WORK. MOORE WAS A SELF-TAUGHT BUT RELATIVELY SOPHISTICATED MUSICIAN, A TASTY SOLOIST AND PROVIDED NICE FILLS & HELD EVERYTHING TOGETHER. LATER D.C. FONTANA WAS ADDED ON DRUMS.

WHAT WAS SO GREAT ABOUT THIS PROCESS WAS THAT CREATIVE SPARKS WERE FLYING...

...ELVIS AND MOORE DIDN'T KNOW WHAT COULDN'T BE DONE, SO THEY TRIED EVERYTHING.

THERE WERE COUNTRY AND BLUES AND R&B INFLUENCES MIXED IN THEIR MUSIC, BUT THEY DREW ON OTHER AREAS AS WELL. ON TOP OF BEING AN EXCITING PERFORMER, ELVIS WAS A FINE BALLAD SINGER, WHOSE WORK WAS INFLUENCED BY DEAN MARTIN, AS HIS HEAVY VIBRATO INDICATES, BILLY ECKSTINE, THE INK SPOTS AND BLACK AND WHITE GOSPEL MUSIC.

HE MAY'VE BEEN BORN IN A SMALL TOWN, BUT HE GREW UP IN MEMPHIS, WHERE HE HEARD ALL SORTS OF MUSIC.

LISTEN TO THE VARIETY OF STUFF HE RECORDED FOR SUN: "THAT'S ALL RIGHT," "MILKCOW BLUES BOOGIE," "BLUE MOON," "JUST BECAUSE"—HE, PHILLIPS, WHO WAS EXPERIMENTING WITH ECHO EFFECTS, AND MOORE WERE ON TO SOMETHING NEW, THEY WERE EXCITED ABOUT IT AND IT SHOWED IN THEIR MUSIC.

HEY, I THINK SOME OF THE EARLY STUFF LIKE "HEARTBREAK HOTEL" AND "JAILHOUSE ROCK" THAT ELVIS DID FOR VICTOR IS GREAT, BUT THERE'S NO DOUBT THAT THE LABEL SUPPLIED HIM WITH CORNY ARRANGEMENTS AND COMMERCIAL SONGS THAT WATERED DOWN THE IMPACT OF HIS MUSIC.

WITH JUDY TYLER IN "JAILHOUSE ROCK".

IF YOU WANT TO HEAR ELVIS AT HIS MOST EXCITING CHECK OUT "THAT'S ALL RIGHT," "GOOD ROCKIN' TONIGHT," "MILKCOW BLUES BOOGIE," "MYSTERY TRAIN," YOU CAN HEAR THE THRILL OF DISCOVERY IN TH' SINGLE ALBUM'S WORTH OF SUN MATERIAL MORE STRONGLY THAN IN ANYTHING HE DID LATER.

SUN

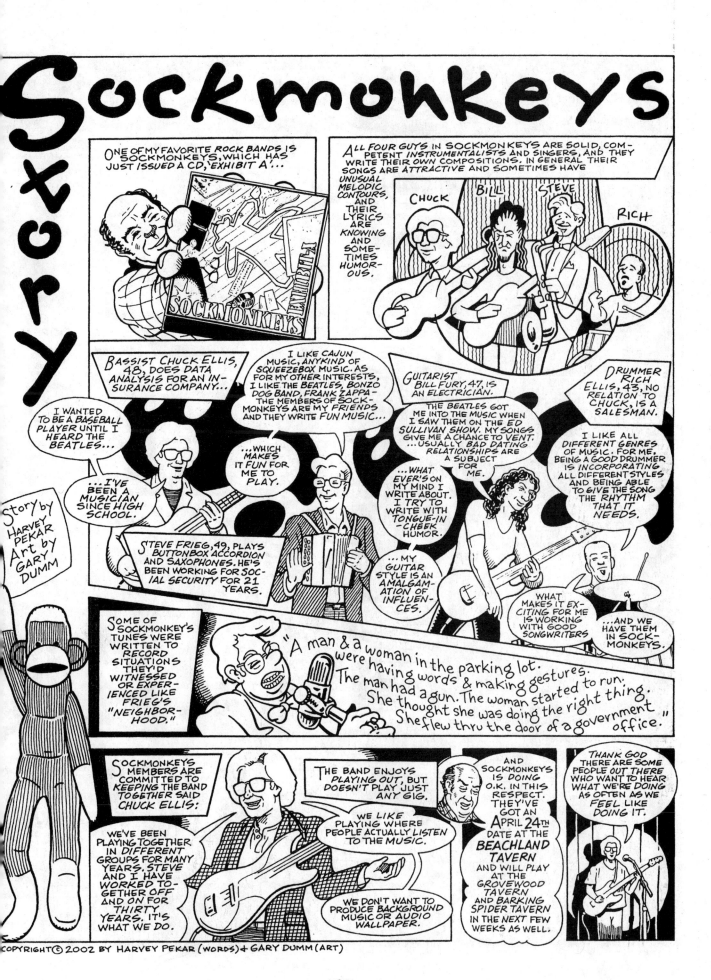

Sockmonkeys Story

Story by Harvey Pekar Art by Gary Dumm

One of my favorite *rock* bands is Sockmonkeys, which has just issued a CD, 'Exhibit A'...

All four guys in Sockmonkeys are solid, competent *instrumentalists* and *singers*, and they write their own compositions. In general their songs are attractive and sometimes have unusual melodic contours, and their lyrics are knowing and sometimes humorous.

CHUCK · BILL · STEVE · RICH

Bassist Chuck Ellis, 48, does data analysis for an insurance company...

"I wanted to be a baseball player until I heard the Beatles..."

"...I've been a musician since high school."

"I like cajun music, anykind of squeezebox music. As for my other interests, I like the Beatles, Bonzo Dog Band, Frank Zappa—the members of Sockmonkeys are my friends and they write fun music..."

"...which makes it fun for me to play."

Steve Frieg, 49, plays buttonbox accordion and saxophones. He's been working for Social Security for 21 years.

Guitarist Bill Fury, 47, is an electrician.

"The Beatles got me into the music when I saw them on the Ed Sullivan show. My songs give me a chance to vent. ...usually bad dating relationships are a subject for me."

"...whatever's on my mind I write about. I try to write with tongue-in-cheek humor."

"...my guitar style is an amalgamation of influences."

Drummer Rich Ellis, 43, no relation to Chuck, is a salesman.

"I like all different genres of music. For me, being a good drummer is incorporating all different styles and being able to give the song the rhythm that it needs."

"What makes it exciting for me is working with good songwriters"

"...and we have them in Sockmonkeys."

Some of Sockmonkey's tunes were written to record situations they'd witnessed or experienced like Frieg's "Neighborhood."

"A man & a woman in the parking lot were having words & making gestures. The man had a gun. The woman started to run. She thought she was doing the right thing. She flew thru the door of a government office."

Sockmonkeys members are committed to keeping the band together said Chuck Ellis:

"We've been playing together in different groups for many years. Steve and I have worked together off and on for thirty years. It's what we do."

The band enjoys *playing out*, but doesn't play just any gig.

"We like playing where people actually *listen* to the music."

"We don't want to produce background music or audio wallpaper."

And Sockmonkeys is doing O.K. in this respect. They've got an April 24th date at the Beachland Tavern and will play at the Grovewood Tavern and Barking Spider Tavern in the next few weeks as well.

"Thank god there are some people out there who want to hear what we're doing as often as we feel like doing it."

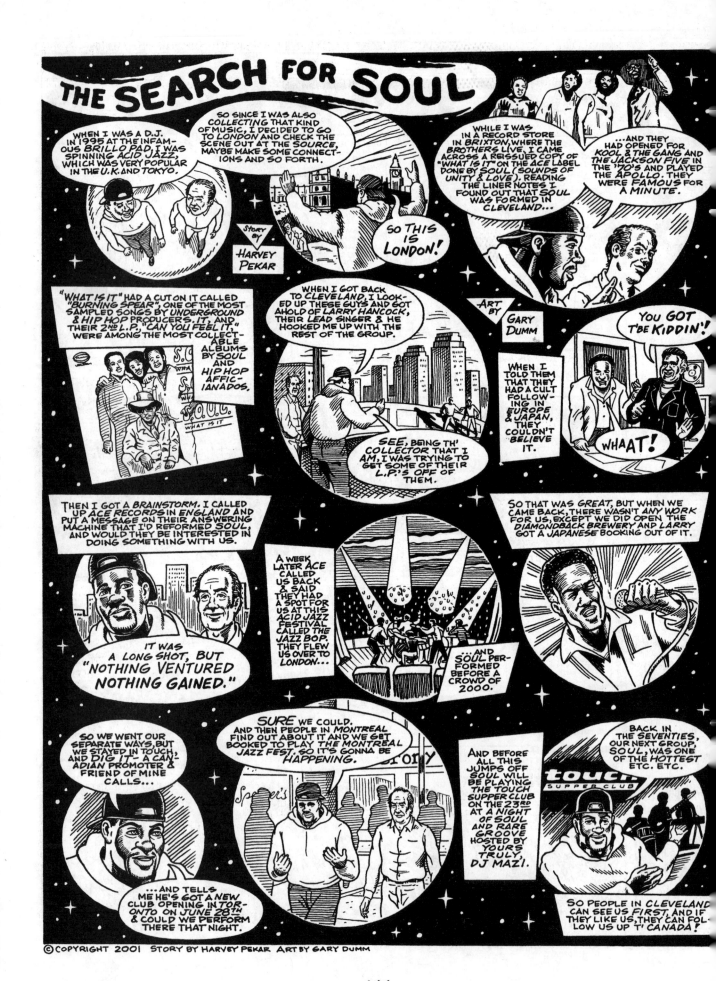

JUBILEE

Story by HARVEY PEKAR
Art by G. DUMM

ON SATURDAY, THE WORKMEN'S CIRCLE WILL BE CELEBRATING ITS 100th ANNIVERSARY WITH A JUBILEE AT THE MANDEL JEWISH COMMUNITY CENTER ON SOUTH WOODLAND.

IN RECENT DECADES THE ORGANIZATION'S HAD AN UPHILL STRUGGLE, WHAT WITH THE CUTTING OFF OF YIDDISH CULTURE AT ITS ROOTS DURING THE HOLOCAUST, AND THE DECLINE OF INTEREST IN LIBERAL CAUSES IN THE JEWISH COMMUNITY.

BUT DURING THE PAST THREE YEARS, UNDER THE LEADERSHIP OF DOCTOR MEL ARNOFF, THE OHIO DISTRICT, HEADQUARTED ON GREEN ROAD, HAS BEEN MAKING A COMEBACK.

WELCOME WORKMEN'S CIRCLE
BENEFITS FAIR

THE ORGANIZATION WAS FOUNDED NATIONALLY BY EASTERN EUROPEAN JEWISH WORKING CLASS IMMIGRANTS, THEIR GOALS WERE TO IMPROVE THE CONDITIONS OF WORKERS, TO FOSTER YIDDISH CULTURE AND TO PROVIDE MEMBER BENEFITS, E.G. HEALTH INSURANCE, CEMETARY BENEFITS.

FROM THE BEGINNING WORKMEN'S CIRCLE HAD A LIBERAL ORIENTATION. WHILE NOT PRIMARILY AN ACTIVIST-GROUP, IT ENCOURAGED ACTIVISM, E.G. INVOLVEMENT IN LABOR UNIONS, SUPPORT FOR WORKERS RIGHTS, ANTI-CHILD LABOR LEGISLATION.

BOOKKEEPER'S STENOGRAPHER'S AND COUNTANT'S UNION ·12646·

DOWN WITH SWEAT SHOPS
NO HOUR WORK
WORKER'S RIGH
NO 12 HOUR WORK DAY

MORE DIRECTLY, WORKMEN'S CIRCLE SPONSORED THE DISCUSSION OF POLITICAL ISSUES AND PARTICIPATED IN MARCHES FOR THE FURTHERANCE OF RACIAL & GENDER EQUALITY, INCREASED HEALTH CARE BENEFITS, A PEACE IN THE MIDDLE EAST BASED ON THE OSLO ACCORDS, GAY RIGHTS.

THE GROUP'S MEMBERSHIP PEAKED AT 85,000 IN 1925 AND IT REMAINED A MAJOR INFLUENCE IN THE JEWISH COMMUNITY UNTIL ABOUT 1980, WHEN, ACCORDING TO ARNOFF, "THE "ME GENERATION" INCLUDING SOME YOUNGER JEWS, "CHOSE NOT TO AFFILIATE." '

JOIN THE WORKMEN'S CIRCLE?

...I NEVER HEARD OF IT.

ALSO AT THAT TIME THERE WAS A LOT LESS INTEREST IN YIDDISH AND, MORE SPECIFICALLY YIDDISH CULTURE.

THE DECLINE IN YOUNGER MEMBERS LEFT A VACCUUM IN THE AREA OF DEVELOPMENT OF NEW LEADERSHIP. AT ONE TIME THE AVERAGE AGE OF WORKMEN'S CIRCLE BOARD MEMBERS WAS ABOUT EIGHTY, OF THE SCHOOL BOARD EIGHTY-FIVE.

MANY OF THE NEW MEMBERS WERE NON-ACTIVE, PEOPLE WHO JOINED MAINLY TO TAKE ADVANTAGE OF THE ORGANIZATION'S HMO PROGRAMS.

SORRY, I'M TOO BUSY TO ATTEND THE MEETING THIS SUNDAY.

FORTUNATELY THERE'S BEEN A REVIVAL OF INTEREST, IN JEWISH, PARTICULARLY YIDDISH, CULTURE DURING THE '90'S, WHICH HELPED ARNOFF RECRUIT YOUNG, DEDICATED ACTIVISTS AND BEGIN NEW PROGRAMS.

SO I CAN COUNT ON YOU TO PLAN THE PURIM CARNIVAL?

MEL, I DON'T SEE HOW I CAN REFUSE YOU.

FOR YEARS WORKMEN'S CIRCLE HAD SPONSORED A ONCE A YEAR KLEZMER CONCERT IN CAIN PARK. (ONE'S COMING UP ON SUNDAY).

IT'S SUCH A PLEASURE FOR ME TO BE INVOLVED WITH THIS GROUP...

WORKMEN'S CIRCLE

UNDER ARNOFF, HIMSELF A PIANIST, THE GROUP FORMED ITS OWN ORCHESTRA NOW LED BY CLEVELAND AREA R&B SAXOPHONIST NORMAN TISCHLER.

...INCLUDING PEOPLE FROM NINE TO EIGHTY-SIX YEARS OLD, FROM GENTILES TO ORTHODOX JEWS. THE THING THAT BINDS THEM TOGETHER IS THE LOVE OF YIDDISH CULTURE.

IN FACT, THE CIRCLE PLANS TO ASSIST IN PRODUCING A CD OF YIDDISH CHILDREN'S SONGS BY MEMBER LORI SIMON.

THE CIRCLE HAS ESTABLISHED A SUNDAY SCHOOL IN WHICH THE KIDS LEARN JEWISH AND YIDDISH HISTORY, JEWISH COOKING, ARTS & CRAFTS, ISRAELI DANCING, THE PARENTS DANCE WITH THEM, AND CELEBRATE HOLIDAYS. THE AVERAGE AGE OF BOARD MEMBERS IS DOWN TO ROUGHLY FIFTY-FIVE, OF SCHOOL BOARD MEMBERS TO THIRTY-EIGHT.

THE SCHMOOZ CAFE IS ANOTHER OF ARNOFF'S INNOVATIONS, AN INFORMAL DISCUSSION GROUP IN WHICH VARIOUS TOPICS OF MUTUAL INTEREST CAN BE DEALT WITH. RECENTLY THE SUBJECT WAS "HOW TO FIND THE JEWISH RELATIONSHIP I WANT."

SOME PEOPLE HAVE FOUND THE INTERNET TO BE A RESOURCE. HERE ARE SOME WEB ADDRESSES:

WWW. MAZELTOV.COM

WWW. JEWISHLA.ORG

WWW. JDATE.COM AND WWW. YID.COM

ARNOFF'S PLEASED ABOUT THE WAY THINGS HAVE IMPROVED, BUT AT THE SAME TIME DOESN'T HAVE ILLUSIONS ABOUT THE FUTURE.

THE EXCITEMENT THAT I GET FROM THE WORKMEN'S CIRCLE NOW IS GENERATED BY THE VITALITY OF ITS NEW, YOUNG MEMBERS WHO ARE TAKING POSITIONS OF LEADERSHIP ...WHILE YIDDISH IS NOT AS CENTRAL TO THEM AS IT WAS TO MEMBERS IN THE TWENTIES, YIDDISHKEIT, THE VALUES, THE CULTURE, IS.

A Cautionary Baseball Tale
Story by Harvey Pekar • Art by Gary Dumm

ANOTHER BASEBALL SEASON IS UPON US, AND ONCE AGAIN *INDIANS* FANS ARE HOPING FOR THE BEST, I.E. A *WORLD SERIES* VICTORY. BUT *FORGET IT*; THE TEAM HAS *LOST FAVOR* WITH THE FORCES THAT *RULE THE UNIVERSE*. (ON TOP OF THAT IT DOESN'T HAVE *ENOUGH PITCHING*.)

I'M HERE TO TELL YOU TO *WISE UP* AND NOT BE *LIKE ME*. DON'T EXPECT TOO MUCH; LIKE I DID.

I STARTED FOLLOWING THE *INDIANS* IN 1947. I WAS JUST A KID. WHAT DID I KNOW? AT THAT TIME CLEVELAND HAD ONLY WON ONE A.L. PENNANT AND WORLD SERIES IN IT'S ENTIRE EXISTENCE (IN 1920). IT HAD PRETTY MUCH ALWAYS BEEN A LACKLUSTER FRANCHISE, BUT IN '47 THE TEAM'S FORTUNES WERE ON THE RISE.

STILL NO ONE FIGURED THEY COULD OVERTAKE THE 1947 WORLD CHAMPION NEW YORK YANKEES WITH JOE DIMAGGIO OR THE BOSTON RED SOX LED BY TED WILLIAMS.

The Yankee Clipper

The Splendid Splinter

THE 1948 INDIANS WERE A *CINDERELLA* TEAM, THOUGH. THEY HAD A DASHING PLAYER-MANAGER IN *LOU BOUDREAU*, THE BEST SHORTSTOP IN BASEBALL.

THE ACE OF THE PITCHING STAFF WAS THE GREAT *BOB FELLER*, BUT IN '48 *BOB LEMON*, A CONVERTED INFIELDER-OUTFIELDER, HAD AN EVEN BETTER RECORD THAN *RAPID ROBERT*.

19-15

LEMON

FELLER

20-14

BOUDREAU

INDIANS LEFT FIELDER *DALE MITCHELL*, A PERENNIAL .300 HITTER, HIT .336 THAT YEAR.

BUT THE GUY THAT PUT 'EM *OVER THE TOP* WAS *GENE BEARDEN*, A ROOKIE KNUCKLEBALL PITCHER WHO'D BEEN *BADLY WOUNDED* IN THE SECOND WORLD WAR BUT CAME BACK TO WIN TWENTY GAMES IN '48. WHEN THE *INDIANS* AND RED SOX TIED AT THE END OF THE REGULAR SEASON, BEARDEN WON THE PLAYOFF GAME & BOUDREAU WENT 4 FOR 4 INCLUDING TWO HOME RUNS. THEN THE INDIANS WON THE SERIES AGAINST THE BOSTON BRAVES. BEARDEN SAVED THE FINAL GAME.

MITCHELL

VEECK

PAIGE

GORDON

DOBY

BILL VEECK SIGNED TWO BLACK PLAYERS WHO QUICKLY BECAME IMPORTANT CONTRIBUTORS, YOUNG *LARRY DOBY* AND THE AGELESS PITCHING GREAT *SATCHELL PAIGE*.

SECOND BASEMAN *JOE GORDON*, WHOSE DEFENSE WITH BOUDREAU'S GAVE THE *INDIANS* A TOP NOTCH *DOUBLE PLAY* COMBINATION, ALSO HAD A *FINE YEAR* WITH THE BAT...

KELTNER

AS DID THIRD SACKER *KENNY KELTNER*, THE MAN WHO'D *SINGLE-HANDEDLY* STOPPED *JOE DIMAGGIO'S* HITTING STREAK AT 56 GAMES IN 1941 WITH HIS DEFENSIVE *BRILLIANCE*.

THE BROWNS WERE WINNING CHAMPIONSHIPS. THE BARONS, OUR MINOR LEAGUE HOCKEY TEAM WERE WINNING. I THOUGHT IT'D GO ON *FOREVER*.

BUT IT DIDN'T. BEARDEN NEVER HAD ANOTHER GOOD YEAR. FOR THE NEXT FEW SEASONS THE INDIANS PLAYED WELL, BUT THE YANKEES WON. THEN, IN 1954, CLEVELAND HAD A FANTASTIC REGULAR SEASON. THEY WON AN AMERICAN LEAGUE RECORD 111 GAMES, BREAKING THE PREVIOUS RECORD OF 110, HELD BY THE 1927 YANKEES.

SO, HOW DID THE *INDIANS*, WHO *BROKE* THE RECORD OF A TEAM THAT INCLUDED *BABE RUTH* AND *LOU GEHRIG*, DO IN THE SERIES? THEY *FOLDED*, LOST FOUR STRAIGHT TO THE NEW YORK GIANTS. THEY NEVER SEEMED TO GET OVER THE FANTASTIC CATCH THAT *WILLIE MAYS* MADE IN THE FIRST GAME TO *SPIKE* AN *INDIANS* RALLY.

SINCE THEN THE *INDIANS* HAVE HAD SOME PRETTY *BAD* TEAMS. BUT IT'S EASIER TO LIVE WITH A CELLAR DWELLER THAN A TEAM THAT COMES CLOSE BUT *BLOWS IT* IN THE END, WHICH IS WHAT THEY'VE BEEN *DOING* LATELY.

1997, WHEN THEY GAVE UP THE LEAD TO THE MARLINS IN THE NINTH INNING OF THE LAST SERIES GAME WAS AS CLOSE AS THEY'LL GET. THEY LOST TO A WILD CARD TEAM FOR CRYING OUT LOUD! WHEN ARE THEY GONNA GET A *BETTER SHOT* THAN THAT?

JOSE MESA LEAVES THE MOUND IN *DISGRACE*

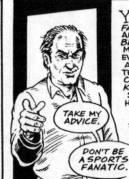

TAKE MY ADVICE.

DON'T BE A SPORTS FANATIC.

RATHER, GO OUT INTO THE WORLD AND MAKE SOMETHING OF YOURSELVES.

YOU YOUNG PEOPLE NEED TO FACE FACTS. THE INDIANS ARE *CURSED*. THE BROWNS AND CAVS MAY BE TOO. AND EVEN IF THE *INDIANS* AREN'T CURSED, THEY MAY BE IN DECLINE. JIM THOME, KENNY LOFTON & SANDY ALOMAR HAVE BEEN GOING *DOWNHILL*. THE PITCHING STAFF LEAVES PLENTY TO BE DESIRED.

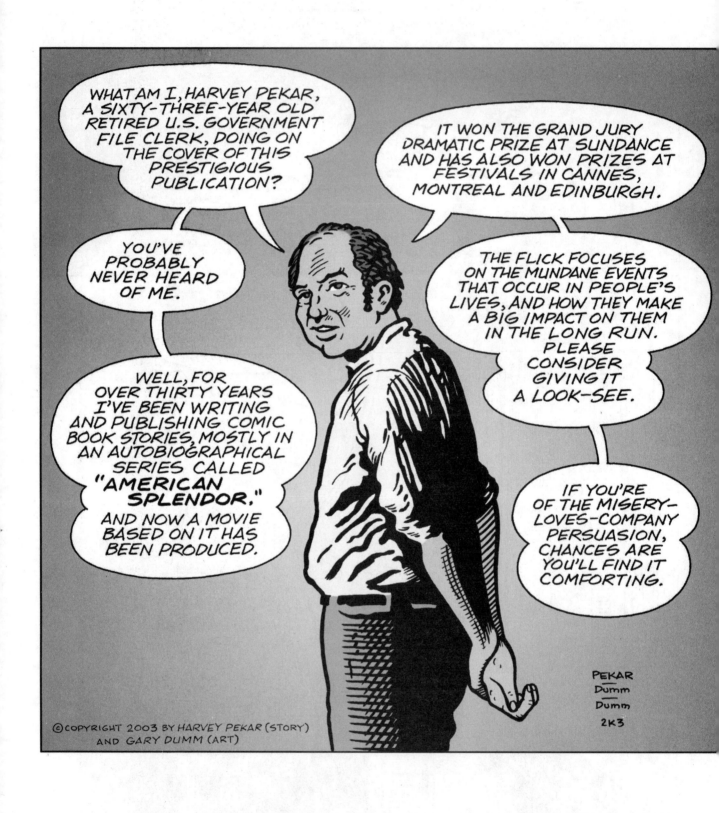

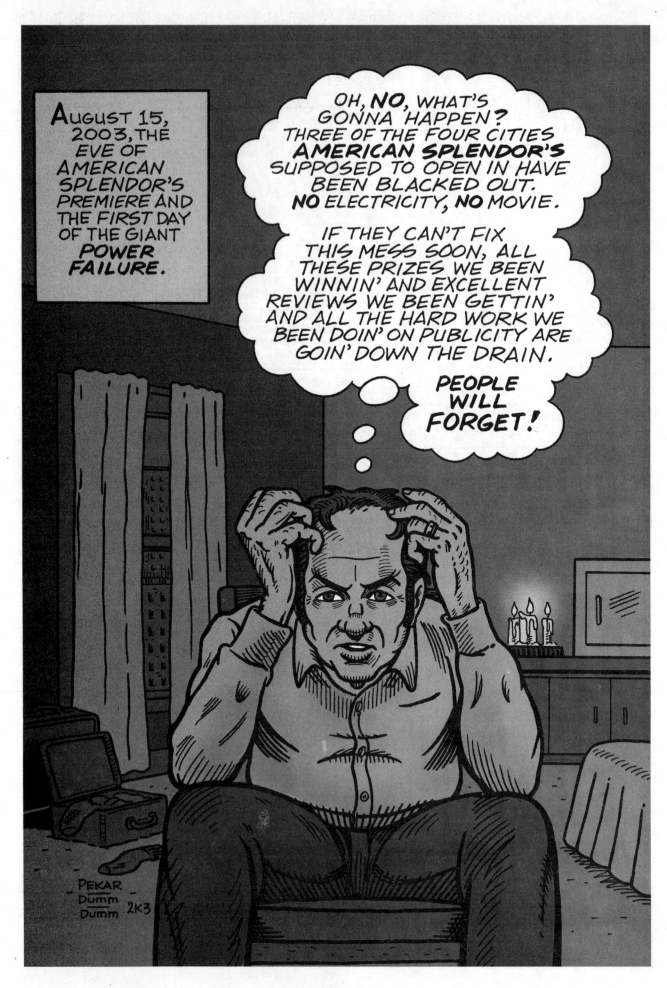

AROUND THE WORLD AND BACK TO EARTH

STORY BY HARVEY PEKAR · ART BY ED PISKOR

COPYRIGHT © 2004 BY HARVEY PEKAR

IT'S LATE JULY 2004, AND I'M COMING DOWN TO EARTH WITH ALL OF THAT MOVIE STUFF.

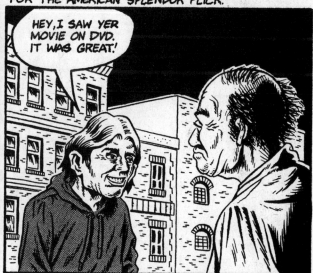

"O DON'T MIND THAT PEOPLE I DON'T KNOW DON'T STOP ME ON THE STREET AND CONGRATULATE ME FOR THE AMERICAN SPLENDOR FLICK."

HEY, I SAW YER MOVIE ON DVD. IT WAS GREAT!

"BUT THE JOBS AND CONSEQUENT MONEY THAT THE FLICK GENERATED ARE FADING FAST, JUST LIKE THEY ALMOST INEVITABLY WOULD."

NOTHIN' IN THE MAIL T'DAY AGAIN.

"AND INSTITUTIONS AND BUSINESSES THAT OWE ME MONEY HAVEN'T BEEN PAYING ME, SOME FOR MONTHS."

I GOTTA CALL T'DAY ABOUT THE TWO GRAND THAT COLLEGE OWES ME. OH WAIT, I CALLED 'EM YESTERDAY... I'LL COOL IT AN' GIVE 'EM A RING T'MORRA!

I KNEW THINGS WOULD BE DIFFERENT AFTER I TOOK THAT SIX WEEK TRIP AROUND THE WORLD. THEY WERE SLOWING DOWN A LOT BEFORE I LEFT. AND NOW THERE'S NO MONEY COMIN' IN AN' I'M SCRAMBLIN' T'WRITE THOSE SCRIPTS I SAID I'D DO FOR THOSE TWO COMPANIES. WILL THEY EVER PAY ME, I WONDER?

"IT WAS WEIRD HOW IT CAME ABOUT. FIRST MY WIFE GOT A CALL FROM A WOMAN IN SYDNEY, AUSTRALIA IN THE WINTER OF 2003-2004 ASKING IF I'D BE THEIR GUEST AT A BOOK FESTIVAL THERE."

IT'LL ACTUALLY HAPPEN IN MAY, 2004.

"I DON'T LIKE TRAVELING AND WASN'T KEEN TO GO, BUT I KNEW MY WIFE, JOYCE, AND KID, DANIELLE WOULD WANT TO SO I PUT JOYCE ON THE TELE-PHONE WITH THE LADY.

WELL, WOULD YOU BE ABLE TO FLY MY DAUGHTER AND ME ALONG WITH HARVEY?

I'M NOT SURE. WE MIGHT BE ABLE TO.

"A FEW DAYS LATER WE GOT A CALL FROM HER."

JOYCE, I JUST GOT THE O.K. IF HARVEY COMES ALONG WE'LL BRING YOU AND DANIELLE IN FREE AS WELL.

WE CAN ALL GO TO AUSTRALIA TO THE SYDNEY BOOK FESTIVAL. ISN'T THAT GREAT?

PLUS SHE THINKS SHE CAN BOOK US IN MELBOURNE.

YEAH, WELL, IT'S NOT TILL MAY SO I'LL HAVE PLENTY OF TIME ADJUSTING TO THE IDEA OF THE TRIP.

2

"THEN A FEW WEEKS LATER, I GOT ANOTHER CALL FROM A WOMAN IN KILKENNY, IRELAND, WHO WANTED TO KNOW IF I COULD BE A GUEST AT A COMEDY FESTIVAL THEY WERE HAVING THERE IN EARLY JUNE."

OH, YOU'RE GOING TO A BOOK FESTIVAL IN AUSTRALIA A COUPLE OF WEEKS BEFORE! WHAT A COINCIDENCE.

I'LL PUT MY WIFE ON THE LINE. I THINK SHE'D LIKE TO TALK TO YOU.

I'M NOT SURE I CAN BOOK YOU AND YOUR DAUGHTER ALONG WITH YOUR HUSBAND. I'LL HAVE TO CHECK.

YES, BECAUSE THAT WOULD HAVE A GREAT DEAL OF BEARING ON WHETHER WE COULD COME.

"BELIEVE IT OR NOT, WE, MY WIFE AND KID AS WELL AS MYSELF, GOT AN OFFER OF FREE TRANSPORTATION AND A FREE HOTEL STAY, IF WE WOULD ATTEND A COMICS CONVENTION IN SAN FRANCISCO ON THE FIRST SEVERAL DAYS OF MAY. MAY WAS THE MONTH THIS YEAR."

"YOU THINK I'M THROUGH? NOPE, ONE MORE INVITATION, TO TOKYO IN MAY TO PUBLICIZE **AMERICAN SPLENDOR**, WHICH THEY NEEDED TO GET STUFF IN THE CAN FOR (ARTICLES, VIDEO INTERVIEWS) FOR THE JULY OPENING OF THE MOVIE IN JAPAN."

I TOLD HER WE'D PROBABLY DO IT. I COULD SEE MY SISTER IN SANTA CLARA THEN.

OK, O.K.

NOW THAT SCARED ME, GOING TO JAPAN. I DIDN'T HAVE ANY IDEA OF WHAT TO EXPECT THERE. THEY DIDN'T TALK ENGLISH LIKE IN THE OTHER PLACES. AND I DIDN'T LIKE JAPANESE OR ANY OTHER KIND OF ORIENTAL COOKING, BUT I COULDN'T ADMIT IT OR I'D OFFEND SOMEBODY. SO THE THING TO DO WAS TO HOPE THEY HAD A LOT OF PIE AND CAKE AND ICE CREAM FOR DESSERT

"MEANTIME MY KID HAD BEEN CORRESPONDING WITH SOME BOY IN HAWAII ON THE INTERNET AND SHE WANTED TO GO THERE TO MEET HIM. SHE'D MET SOME REAL JERKS ON THE INTERNET, BUT THIS GUY WAS SUPPOSED TO BE OK."

YAHOO!!

"AND ANOTHER THING DANIELLE WANTED TO DO WAS GET HOLD OF THE PEOPLE AT THE SPECIAL EFFECTS COMPANY IN NEW ZEALAND, WETA, WHICH HAD DONE SO MUCH WORK FOR "LORD OF THE RINGS." SHE'D MET PEOPLE FROM THE COMPANY IN L.A. DURING A PREVIOUS PROMOTION TOUR AND WAS FASCINATED WITH WHAT THEY DID. AT THIS TIME IT LOOKS LIKE DANIELLE WANTS TO MAKE A PROFESSION OUT OF ART, AND SHE'S ESPECIALLY INTERESTED IN MOVIE SPECIAL EFFECTS."

"MY WIFE WAS GOING FOR BROKE ON THIS TRIP. SHE WANTED TO TAKE IN EVERYTHING. SO DIG HOW SHE MANAGED TO HOOK EVERYTHING UP. SHE CALLED TOKYO AND GOT THEM TO PAY FOR OUR STOP IN HONOLULU."

HELLO, I HAD AN IDEA THAT MAYBE YOU COULD HELP US OUT REGARDING...

"THEN SHE GOT AUSTRALIA AND IRELAND TO AGREE THAT IT WOULD BE BEST FOR THEM TO BUY US 'ROUND THE WORLD' AIRPLANE TICKETS THAT WOULD ALLOW US TO STOP OFF IN NEW ZEALAND AND ALSO IN ENGLAND, WHERE JOYCE HAS A FRIEND IN CAMBRIDGE.

I FIXED IT ALL UP. OUR ENTIRE AIR-FARE FOR THE TRIP IS BEING PAID FOR.

WHAT A WOMAN!!

"SO THEN TIME WENT ALONG AND I WASN'T THINKING ABOUT THIS TRIP COMING UP, BUT IT EVENTUALLY GOT TO BE APRIL 28, TIME TO GO."

ONE PIECE

"MY WIFE AND DANIELLE LIKE TO GO SHOPPING ON THEIR TRIPS, SO MY WIFE DECIDED TO PACK SUIT-CASES WITHIN SUITCASES SO SHE COULD ACCOM-ODATE THE NEW STUFF WE BOUGHT."

"SO THEN MY FRIEND AND ALSO AUTHOR OF A COUPLE OF BOOKS AND OWNER OF A LIMO SERVICE," HOLLY-WOOD BOB," DROVE US DOWN TO THE AIRPORT TO START OUR GREAT ADVENTURE."

"WE GET ON THE PLANE AND HEAD FOR SAN FRANCISCO, WHERE THEY HAD US BOOKED AT A VERY NICE HOTEL, THE ARGENT.

5

"THE CITY LOOKED NICE, THEY TREATED ME WELL AT THE COMIC CONVENTION, BUT WHEN I WAS BY MYSELF I GOT THIS QUEASY FEELING IN THE PIT OF MY STOMACH."

THINGS AREN'T GOING TO BE THE SAME AFTER THIS TRIP. THEY'LL BE GETTING BACK TO NORMAL AND I'LL BE MORE AND MORE WORRIED ABOUT HOW I MAKE A LIVING FROM HERE ON IN.

"WELL, BUT SAN FRANCISCO'S A BIG DEAL, SO IT WASN'T ALL DRUDGERY. I MET SOME OLD FRIENDS I HADN'T SEEN FOR A WHILE."

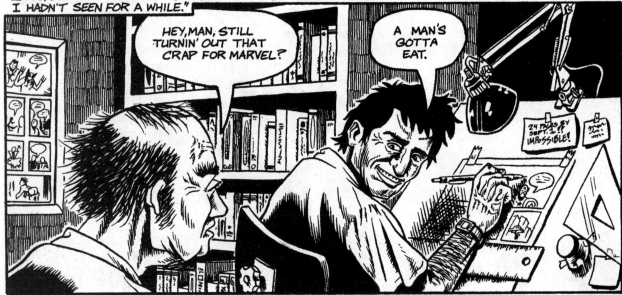

HEY, MAN, STILL TURNIN' OUT THAT CRAP FOR MARVEL?

A MAN'S GOTTA EAT.

24 PAGES BY SEPT. 1!! IMPOSSIBLE!

"AND I HAD A NICE PANEL APPEARANCE REGARDING COMICS BEING MADE INTO MOVIES."

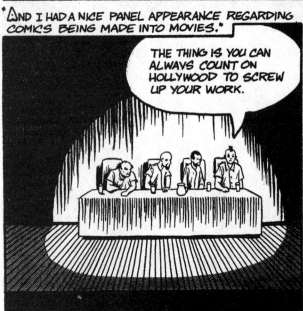

THE THING IS YOU CAN ALWAYS COUNT ON HOLLYWOOD TO SCREW UP YOUR WORK.

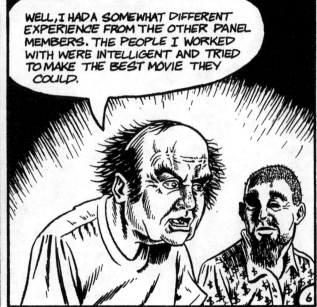

WELL, I HAD A SOMEWHAT DIFFERENT EXPERIENCE FROM THE OTHER PANEL MEMBERS. THE PEOPLE I WORKED WITH WERE INTELLIGENT AND TRIED TO MAKE THE BEST MOVIE THEY COULD.

I HAD CONFIDENCE THEY'D DO A GOOD JOB ON THE FILM, AND THE PEOPLE THAT PAID FOR IT, HBO, NEVER INTERFERED.

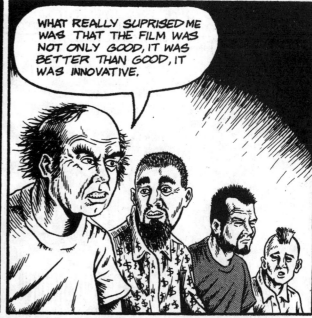

WHAT REALLY SUPRISED ME WAS THAT THE FILM WAS NOT ONLY GOOD, IT WAS BETTER THAN GOOD, IT WAS INNOVATIVE.

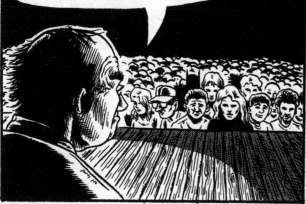

DIG IT, I'M NOT A HOLLYWOOD FAN, BUT THE PEOPLE WHO DID MY FILM TRIED TO MAKE THE BEST ONE THEY COULD. THEY DIDN'T WORRY ABOUT COMMERCIAL CONSIDERATIONS TOO MUCH, AND THEY GOT AWAY WITH IT, IT DIDN'T DO BAD AT THE BOX OFFICE.

"SAN FRANCISCO'S SUCH A PRETTY TOWN TOO. YOU CAN GET OFF JUST BY LOOKIN' AT IT."

"WE GOT TOGETHER WITH JOYCE'S SISTER AND THEY SWAPPED MEDICAL INFORMATION."

HOW ARE THOSE PILLS MY DOCTOR PRESCRIBED FOR YA DOING? ARE THEY CHANGING ANYTHING.

WELL, A LITTLE BIT, BUT NOT TOO MUCH YET.

"THE NEXT WAS HONOLULU. THIS HAD NOTHING TO DO WITH COMICS, SO I REALLY TOOK A BACK SEAT HERE. NO, THIS WAS ABOUT DANIELLE AND HER YOUNG MAN, JOHN."

"HONOLULU WAS A NICE TOWN. WARM BUT WITH PLENTY OF BREEZES BLOWING THROUGH. SO IT DIDN'T GET TOO HOT. AND THIS VAST ARRAY OF ETHNIC TYPES TOO. HONOLULU PEOPLE WERE INTERESTING TO LOOK UPON."

"OUR HOTEL WAS KIND OF OLD FASHIONED, NOT LIKE SOME OF THE HIGH TECH PLACES WE STAYED AT, BUT STILL COMFORTABLE. THE PEOPLE WORKING THERE WERE NICE, MOSTLY FROM THE OLD SCHOOL."

OHIO.

OHIO.

"WE HAD A NICE VIEW OF THE OCEAN AND THE MOUNTAINS FROM OUR WINDOWS AND BALCONY."

"I DUG THE HOTEL HAD A COIN LAUNDRY. WE HAD TO DO SOME CLOTHES AND NORMALLY HOTELS DON'T HAVE COIN LAUNDRIES AND CHARGE YOU AN ARM AND A LEG FOR CLEANING CLOTHES."

"SO WE MET JOHN AND HIS MOTHER FOR LUNCH THAT DAY. TURNED OUT HE WAS INTO ACTING AND SINGING ON STAGE. HE SEEMED LIKE A NICE ENOUGH GUY. HE WAS FILIPINO, AND ASKED DANIELLE RIGHT OFF THE BAT..."

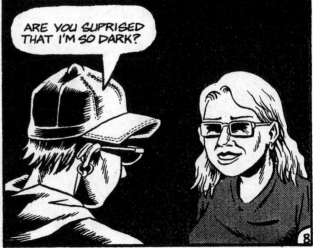

ARE YOU SUPRISED THAT I'M SO DARK?

"AFTER LUNCH DANIELLE AND JOHN WENT OFF TO SEE A MOVIE. SHE CAME BACK ABOUT SIX O'CLOCK AND JOYCE SENT HER AND ME OFF TO GET SOME FOOD, SO WE HAD A LOOK AT DOWNTOWN HONOLULU."

"ON THE NEXT DAY DANIELLE GOT UP EARLY AND WENT TO SCHOOL WITH JOHN, WHERE SHE HUNG OUT WITH HIM. SHE CAME BACK FROM THERE SEEMING IN GOOD SPIRITS, BUT ABOUT AN HOUR LATER CAME TO JOYCE CRYING."

I JUST HAD A PHONE CONVERSATION WITH JOHN AND HE TOLD ME HIS PRIMARY INTEREST WAS GETTING AHEAD IN THEATRE AND THAT HE DIDN'T THINK OUR RELATIONSHIP HAD MUCH OF A FUTURE, ESPECIALLY SINCE CLEVELAND AND HAWAII ARE SO FAR AWAY.

"I WAS KIND OF SURPRISED THAT DANIELLE TOOK IT SO HARD, BECAUSE THEY DID LIVE PRETTY FAR AWAY FROM EACH OTHER AND IT'S HARD TO SEE A RELATIONSHIP LIKE THAT FLOURISHING. BUT WHAT DO I KNOW?"

"A COUPLE OF DAYS LATER WE TOOK OFF FOR TOKYO. DANIELLE WAS STILL PRETTY UPSET, BUT SHE'D GET OVER IT BECAUSE SHE WAS RESILIENT. THAT I KNEW."

"WE GOT INTO TOKYO, WHERE WE WERE MET BY TOHKO NISHIMURO OF TOSHIBA, THE FILM'S DISTRIBUTOR WHO PROVED TO BE ONE OF THE FINEST, MOST MEMORABLE PEOPLE I MET ON THE TRIP."

"TOHKO KIND OF CO-ORDINATED STUFF, INTERVIEWS, APPEARANCES, DINNERS. I DON'T REALLY KNOW IF THERE WAS A HIERARCHY OF JOBS, OR, IF THERE WAS, HOW IT WAS SET UP, BUT TOHKO, SEEMED TO BE THE LEADER. SHE AND THE OTHER TOSHIBA EMPLOY-EES WERE WATCHING US AT ALL TIMES TO SEE WE DIDN'T (SOMETIMES LITERALLY) MIS-STEP."

THE BATHROOM IS TO THE LEFT, HARVEY.

HUH? OH THANKS TOHKO.

"ANOTHER FINE PERSON I MET WAS MAKI HAKUI, MY INTERPRETER. SHE HAD LIVED IN THE STATES AND SPOKE ENGLISH WITH AN AMERICAN ACCENT. SHE WAS INFORMAL, EASY-TO-BE-AROUND AND VERY HELPFUL. MAKI WAS INTO PRODUCING ALTERNATIVE COMICS, SHE HAD DONE SOME STUFF BY DAN CLOWES AND JIM WOODRING, AND GAVE ME VALUABLE INFORMATION ABOUT JAPANESE COMICS."

I WORK WITH A PUBLISHER OF COMICS HERE IN TOKYO.

"I WAS UNDER THE IMPRESSION THAT JAPANESE COMICS, OR MANGA, WERE ABOUT A VAST RANGE OF SUBJECTS AND THAT A LOT OF THEM WERE AIMED AT ADULTS, BUT WHEN WE WERE IN A COMIC STORE I SAID..."

JUST ABOUT ALL OF THESE BOOKS LOOK LIKE THEY'RE AIMED AT KIDS, WHERE IS THE ALTERNATIVE OR ADULT STUFF?

THERE'S PRACTICALLY NONE OF IT. IN FACT THERE'S ONLY ONE BOOK IN THIS ENTIRE STORE I'D RECOMMEND YOU GET. IT'S ABOUT THE ONLY UNDERGROUND COMIC IN THE PLACE.

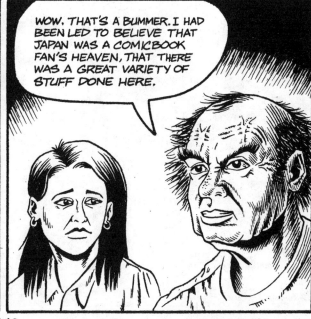

WOW, THAT'S A BUMMER. I HAD BEEN LED TO BELIEVE THAT JAPAN WAS A COMIC BOOK FAN'S HEAVEN, THAT THERE WAS A GREAT VARIETY OF STUFF DONE HERE.

NO, JUST ABOUT ALL OF THIS STUFF IS MEANT FOR KIDS.

"LATER SHE INTRODUCED ME TO ONE OF THE RELATIVELY FEW ALTERNATIVE COMIC BOOK ARTISTS IN JAPAN AND HE CORROBORATED WHAT SHE'D TOLD ME."

I HAVE A HARD TIME GETTING PUBLISHED HERE.

"THAT WAS PRETTY DISCOURAGING NEWS AS I THOUGHT THAT MY ADULT ORIENTED COMICS WOULD MAYBE BE MORE POPULAR IN JAPAN THAN THE U.S., BUT HERE I WAS FINDING OUT THERE WAS PRACTICALLY NO JAPANESE ALTERNATIVE MOVEMENT."

THAT MAKES ME WONDER HOW THE AMERICAN SPLENDOR MOVIE WILL DO HERE.

TOWARD THE END OF OUR STAY IN JAPAN WE WENT TO A SMALL TOWN WHICH HAD A HOTEL NOTED FOR ITS HOT SPRINGS.

11

"I'M NOT BIG ON HOT SPRINGS AND MINERAL SPRINGS ETC., BUT EVERYONE APPARENTLY ASSUMED THEY WERE UNIVERSALLY ENJOYED AND SO I WENT AND TRIED TO MAKE THE BEST OF IT."

"INTERESTINGLY THE GUY I WENT TO THE SPRINGS WITH WAS PRETTY LUKEWARM ABOUT THEM TOO, SO WE DIDN'T STAY VERY LONG."

YOU WANNA GO NOW.

YEAH.

"I DID HAVE A SUPRISINGLY GOOD TIME WHEN THEY TOOK ME TO A KARAOKE ROOM IN THE HOTEL, AND WOUND UP SINGING, DESPITE MY RUINED VOCAL CORDS."

♪ I HEARD IT THROUGH THE GRAPEVINE. ♪♪♭

"AND THEN IT WAS TIME TO GO TO AUSTRALIA. I HAD ENJOYED MYSELF IN JAPAN FAR MORE THAN I REALIZED, BECAUSE OUR COLLEAGUES THERE WERE SO THOUGHTFUL."

"AS A MATTER OF FACT, TOHKO NOT ONLY TOOK US TO THE AIRPORT, SHE WAITED IN THE LOBBY FOR ABOUT AN HOUR AND A HALF UNTIL OUR PLANE ACTUALLY TOOK OFF."

12

"NEXT STOP SYDNEY AND THE BOOK FESTIVAL. SYDNEY WAS A PRETTY MODERN LOOKING CITY THAT WAS A BIT REMINISCENT OF LOS ANGELES. WE STAYED IN A HOTEL THAT WAS NEAR THE BAY WHERE THE FAMOUS OPERA HOUSE WAS LOCATED."

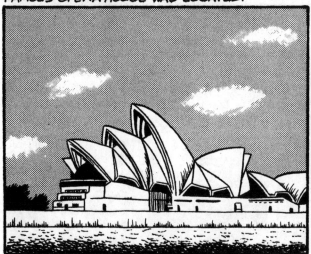

I GOT DRAGGED AROUND TO DO A LOT OF PRESS IN SYDNEY, WHICH I COULDN'T RESENT TOO MUCH AS THE BOOK FESTIVAL OFFICIALS AND PRESS PEOPLE WERE NOT ONLY ACCOMODATIVE, BUT HAD SOME DOING IN GETTING OUR FAMOUS ROUND-THE-WORLD PLANE TICKETS.

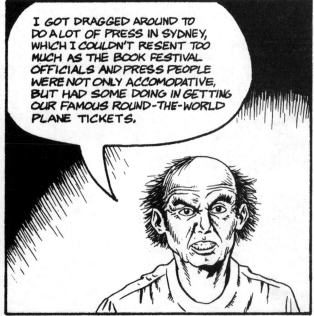

"I SHARED A COUPLE OF APPEARANCES IN SYDNEY WITH TWO INTERESTING GUYS. AUSTRALIAN CARTOONIST, MICHAEL LEUNIG AND SALAM PAX, THE BAGHDAD BLOGGER."

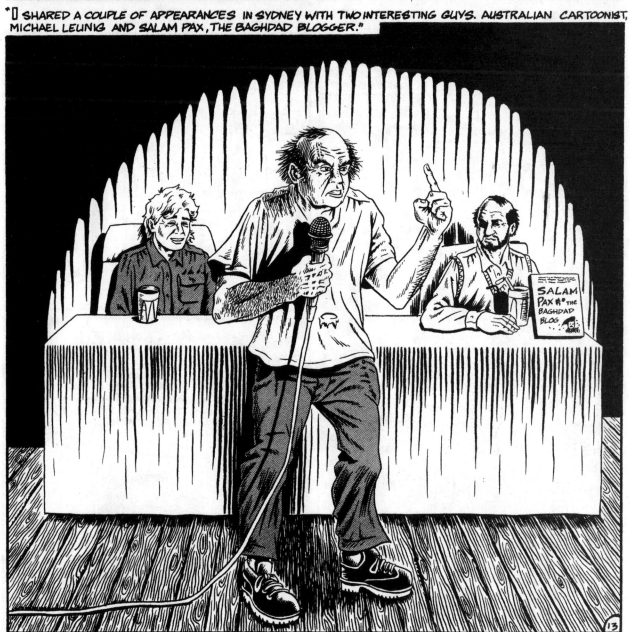

"NEXT STOP SYDNEY AND THE BOOK FESTIVAL. SYDNEY WAS A PRETTY MODERN LOOKING CITY THAT WAS

13

"LEUNIG IS HIGHLY RESPECTED IN AUSTRALIA, BUT NOT WELL KNOWN OUTSIDE OF IT. HE'S A VERY LYRICAL, PHILOSOPHICALLY INTERESTING ARTIST WHOSE WORK SEEMS TO HAVE BEEN INFLUENCED BY JULES FEIFFER AND JAMES THURBER."

AM I RIGHT IN ASSUMING JULES FEIFFER WAS ONE OF YOUR INFLUENCES.

WHY, YES, YOU ARE.

"OF COURSE, ONE REASON I LIKED HIM SO MUCH WAS THAT HIS POLITICS WERE SIMILAR TO MINE."

IT'S GREAT TO SEE YOU EXPRESSING YOUR OPPOSITION TO THE U.S INVASION OF IRAQ. THANK YOU.

"SALAM PAX, THE BAGHDAD BLOGGER, IS A WEST-ERN-EDUCATED, LIBERAL, GAY ARCHITECT, LIVES IN BAGHDAD. IN SEPTEMBER 2002 HE BEGAN PUB-LISHING HIS DIARY ON THE INTERNET, IN WHICH HE WAS OFTEN CRITICAL OF THE SADDAM HUSSEIN ADMINISTRATION. NEEDLESS TO SAY, THE GUY HAS A LOT OF COURAGE TO GO WITH HIS IMPRESSIVE INTELLECT."

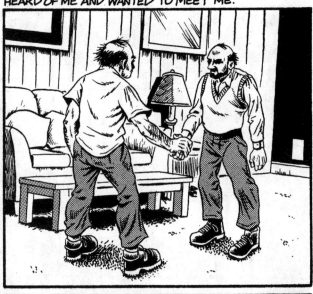

"I WAS VERY PLEASED TO FIND OUT THAT HE'D HEARD OF ME AND WANTED TO MEET ME."

A FUNNY THING ABOUT SALAM PAX IS THAT I DON'T THINK HE DISAPPROVES AS MUCH OF THE U.S. INVASION AS MOST PEOPLE AROUND THE WORLD. IF I'M RIGHT, I DON'T EXACTLY BLAME HIM, THOUGH I OPPOSED THE INVASION.

SEE, LIFE IN IRAQ WITH SADDAM IN CHARGE MUST'VE BEEN SO HORRIBLE TO HIM. NOT ONLY WOULD HE HAVE BEEN APPALLED BY THE MAN'S BRUTALITY, HE WOULD'VE FOUND HIS REGIME INTELLEC-TUALLY STULTIFYING, AND SALAM IS A BRIGHT GUY WITH A GREAT SENSE OF HUMOR, WHO LIKES ROCK MUSIC AND HAVING FUN.

14

WITH SADDAM GONE, THINGS MAY GET EVEN WORSE, BUT WITH HIM STILL IN PLACE THERE WAS NO HOPE OF PROGRESS.

"THERE WAS ONE DAY WHEN WE HAD NOTHING TO DO, SO JOYCE, DANIELLE, AND I TOOK A BUS TOUR OF THE BLUE MOUNTAINS, OUTSIDE SYDNEY. WE STOPPED A COUPLE OF TIMES TO CHECK OUT THE LOCAL FAUNA, E.G. KANGAROOS, AND THEY WERE IMPRESSED BY THE RUGGED, HEAVILY WOODED, IF NOT PARTI- CULARLY HIGH, MOUNTAINS."

"ON 5-24 WE WENT TO MELBOURNE, WHICH WAS SOUTH OF SYDNEY. IT WAS AUTUMN THERE, AND KIND OF COLD, BUT I DUG IT MORE THAN SYDNEY. PHYSICALLY IT REMINDED ME A BIT OF CHICAGO."

"IT'S PROBABLY THE INTELLECTUAL CAPITOL OF AUS- TRALIA, AND HAS MORE OF A BOHEMIAN CULTURE THAN SYDNEY."

"THE PEOPLE THAT PICKED US UP AT AIRPORT WERE INTO UNDERGROUND COMICS. SOME PRODUCED THEM AND THEY WERE PRETTY GOOD."

HOW YA DOIN' HARVEY.

"THE FESTIVAL WAS CALLED THE NEXT WAVE CON- VENTION. IT WAS KIND OF AN ALTERNATIVE FESTIVAL. IT WAS HELD IN A KIND OF FUNKY HALL AND I WAS INVITED TO CONTRIBUTE SOME GRAFFITI TO THE BATHROOM WALL."

165

"THERE WAS A FULL HOUSE TO SEE ME THAT NIGHT, MAYBE AS PACKED AS I'VE EVER DRAWN."

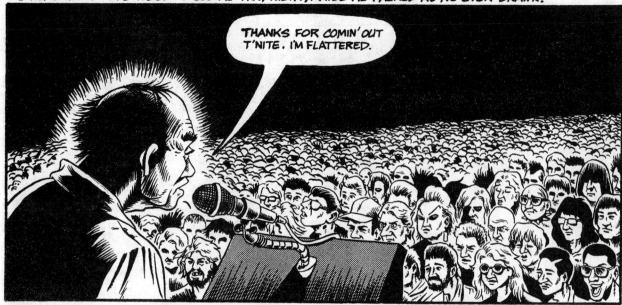

THANKS FOR COMIN' OUT T'NITE. I'M FLATTERED.

"IT WAS REALLY FUN, TO BE RECEIVED SO ENTHUSIASTIC- ALLY, AND THE FESTIVAL DIRECTOR GAVE ME A SUR- PRISE."

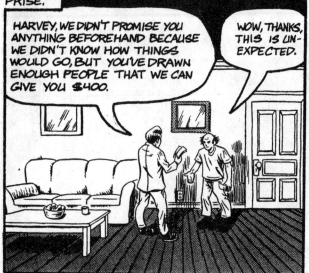

HARVEY, WE DIDN'T PROMISE YOU ANYTHING BEFOREHAND BECAUSE WE DIDN'T KNOW HOW THINGS WOULD GO, BUT YOU'VE DRAWN ENOUGH PEOPLE THAT WE CAN GIVE YOU $400.

WOW, THANKS, THIS IS UN- EXPECTED.

"SO THE NEXT DAY WE WENT TO SEE THIS DUMB MOVIE 'TROY,' TO PLEASE DANIELLE. THAT NIGHT AT THE FESTIVAL THE SPEAKER WAS SALAM PAX SO I WENT TO SEE HIM AGAIN."

HEY, MAN, WE'RE FOLLOWING EACH OTHER AROUND HERE. GOOD T'SEE YA.

"THE NEXT DAY WE PACKED. MAN, I WAS SO SICK OF PACKING AND UNPACKING. OUR LOAD WAS GETTING LARGER AND LARGER. I WAS WORRIED ABOUT THE AMOUNT OF MONEY WE WERE SPENDING, BECAUSE I WANTED THIS TRIP TO BE PROFITABLE AND THERE WERE SIGNS THAT IT WOULD NOT BE. BUT ONWARD TO NEW ZEALAND."

"IN WELLINGTON, NEW ZEALAND WE STAYED AT THE AIR- PORT MOTEL, WHICH WAS CLOSE TO WETA HEAD- QUARTERS. IT WAS A PRETTY ORDINARY PLACE, BUT THE OWNERS WERE HELPFUL."

HERE, LET ME GIVE YOU A HAND.

"AS SOON AS WE COULD WE WENT OVER TO WETA, AND IT WAS A FASCINATING PLACE. THERE WAS ALL THIS STUFF AROUND FROM THE "LORD OF THE RINGS" MOVIES AND ALSO WORK WAS BEGINNING ON THE NEW PROJECT, A REMAKE OF KING KONG."

OOH, LOOK AT THAT ARMOR. IT LOOKS SO REAL AND YET IT'S SO LIGHT.

"MORALE AT WETA WAS REALLY HIGH. THE EMPLOYEES TOOK GREAT PRIDE IN WORKING THERE. THEY WERE PROUD OF THEIR INNOVATIVE SOLUTIONS TO DIFFICULT SITUATIONS."

WE TRIED A LOT OF DIFFERENT MATERIALS ON THIS PROJECT BUT WE FINALLY CAME UP WITH THE RIGHT ONES.

"A LOT OF THIS WAS DUE TO THE INSPIRED LEADERSHIP OF RICHARD TAYLOR. DANIELLE HAD MET RICHARD IN L.A. A COUPLE OF TIMES AND WAS EXTREMELY IMPRESSED BY HIM. HE'D HAD A ROUGH TIME AS A KID, AS SHE HAD, AND HAD OVERCOME SEVERE OBSTACLES."

167

"AFTER JOYCE AND I LEFT THAT DAY DANIELLE STAYED AT WETA AND WORKED ON A PROJECT THEY HAD GOING—KING KONG. THEY WERE SCULPTING OUT A MODEL OF A TYRANNOSAURUS REX AND SHE STAYED AND WORKED ON THE SKIN."

"SHE CAME BACK ALL HAPPY. EVERYBODY WAS NICE TO HER AND I GUESS SHE DID AN O.K. JOB, SHE DIDN'T GET SENT HOME EARLY."

OH, MAN, IT WAS SO GREAT!

"SEE, 'AMERICAN SPLENDOR' AND 'LORD OF THE RINGS' WERE HANDLED BY THE SAME DISTRIBUTOR, SO THEY KNEW ABOUT US AT WETA AND EVIDENTLY APPROVED OF US. ONE THING I'M HAPPY WITH, DANIELLE HAS TRUE ARTISTIC TALENT. AND SHE'S GENUINELY INTERESTED IN WHAT SHE'S DOING, SO THERE'S A CHANCE SHE'LL GET THE KIND OF WORK SHE WANTS."

"ANYWAY, THE WETA PEOPLE TOOK US UNDER THEIR WINGS. THEY TOOK US SHOPPING AND TO A MUSEUM AND NATURE RESERVE."

"WE ALSO WENT TO A BIRTHDAY PARTY, AND DINNER, AND A MOVIE WITH THEM."

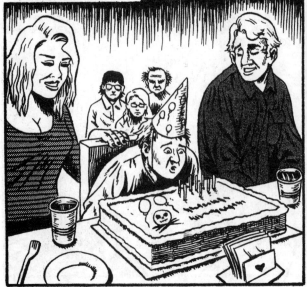

"AND THEY LET DANIELLE WORK WITH THEM ANOTHER DAY ON THE T-REX."

18

"I'LL TELL YA, I'M NOT CRAZY ABOUT TRAVELING, BUT PEOPLE LIKE THE ONES AT WETA MAKE THINGS EASIER. AS LONG AS JOYCE AND DANIELLE GOT SOMETHING OUT OF IT."

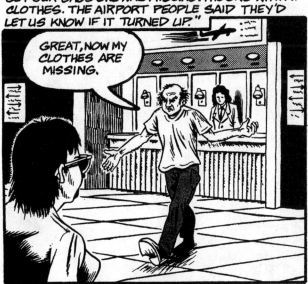

"WE WENT TO IRELAND FROM NEW ZEALAND. MAN, THAT WAS A HASSLE. IT TOOK SO LONG. WE HAD TO CHANGE PLANES AT HONG KONG. MAN, I GOT SO TIRED OF WALKING AROUND AIRPORTS WITH ALL THIS CARRY ON LUGGAGE HANGING OFF ME."

"WE FINALLY GOT TO DUBLIN, BUT WHEN WE WENT TO GET OUR BAGS ONE WAS MISSING. THE ONE WITH MY CLOTHES. THE AIRPORT PEOPLE SAID THEY'D LET US KNOW IF IT TURNED UP."

GREAT, NOW MY CLOTHES ARE MISSING.

"WE GOT DRIVEN FROM THERE TO KILKENNY AND GOT SETTLED INTO OUR HOTEL. KILKENNY IS AN ATTRACTIVE TOWN, BUT OLD-LOOKING. NARROW WINDING STREETS."

"I DIDN'T HAVE MUCH TO DO IN KILKENNY, JUST ONE Q & A AFTER THE MOVIE, AND JOYCE AND DANIELLE WERE HANGING OUT TOGETHER SHOPPING AND STUFF, SO THAT LEFT ME ALONE FOR A LOT OF THE TIME. I JUST WALKED AROUND THE TOWN. IT WASN'T THE HIGHPOINT OF THE JOURNEY."

"THE HIGH POINT CAME WHEN THEY FOUND MY BAG AT THE DUBLIN AIRPORT AND DELIVERED IT TO THE HOTEL."

IT'S HERE.

"OH YEAH, WE TOOK DANIELLE TO SEE THE NEW 'HARRY POTTER' MOVIE. SHE LIKES THAT SERIES, 'THE LORD OF THE RINGS' AND 'PIRATES OF THE CARRIBEAN.'"

HOW'D YOU LIKE IT?

IT WAS THE BEST IN THE SERIES SO FAR.

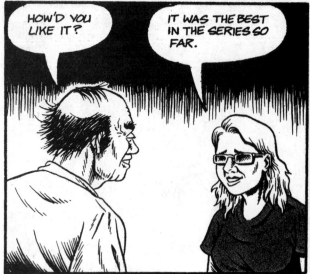

"SO FINALLY SATURDAY CAME AND THEY SHOWED AMERICAN SPLENDOR AND I DID THE Q & A AFTERWARDS."

HOW DOES IT FEEL TO SEE MY FACE ON THE SILVER SCREEN? WELL...

"ONE STOP LEFT— CAMBRIDGE, ENGLAND WHERE JOYCE MET OUR FRIEND DANA, AN ISRAELI GIRL LIVING IN ENGLAND PARTLY BECAUSE SHE COULD NOT STAND THE RIGHT-WING POLITICS PRACTICED IN ISRAEL."

"WHEN WE GOT TO DANA'S APARTMENT IT WAS GOOD TO SEE HER AND HER DAUGHTER, ELLIE AND THEIR CATS. IT WAS A COMFORTABLE PLACE FOR ME."

"AT DANA'S I READ 'THE TIMES' AND CAME ACROSS ARTICLES ON THE POLYNESIAN EXPLORATION AND SETTLING OF THE PACIFIC AND THE MORE-EXTENSIVE THAN GENERALLY REALIZED VOCABULARIES OF BORDER COLLIES AND OTHER DOGS WHICH I CLIPPED AND TOOK HOME WITH ME."

"WE WENT TO LONDON ONE DAY TO SEE ARI, ANOTHER ISRAELI FRIEND OF OURS WHO WAS LIVING IN ENGLAND AGAIN PARTLY BECAUSE HE COULDN'T STAND THE STATE OF POLITICS IN HIS NATIVE COUNTRY. HE TREATED US BEAUTIFULLY, ESCORTED US TO THE BRITISH MUSEUM OF WAR SO THAT JOYCE COULD LEARN MORE ABOUT WHAT BRITISH WOMEN DID DURING THE BLITZ, AND TOOK DANIELLE AND ME ON A TOUR OF THE OLD DOCK AREA, NOW BEING RENOVATED. HE TOOK THE SUBWAY WITH US TO THE TRAIN STATION AND KINDLY WAITED UNTIL WE GOT THE TRAIN BACK TO CAMBRIDGE."

"TWO DAYS BEFORE WE WENT BACK TO THE STATES WE VISITED COMIC BOOK WRITER ALAN MOORE AND HIS FRIEND MELINDA GEBBIE AT MOORE'S HOME IN NORTHAMPTON."

"I KNEW ALAN THROUGH JOYCE. HE WROTE A STORY FOR A COMIC BOOK SHE EDITED. THEN HE KINDLY ILLUSTRATED A STORY OF MINE FOR AMERICAN SPLENDOR AND WE ONCE MET IN WASHINGTON D.C. TO SEE A PLAY THAT WAS BASED ON MY COMIC."

"ALAN IS A VERY GOOD AND VERY TALENTED GUY. YOU COULDN'T HAVE A BETTER FRIEND. MELINDA IS VERY NICE TOO, AND ALSO A FINE COMIC BOOK ARTIST."

LOST GIRLS PAGE 31

"I TALKED TO ALAN ABOUT WHY HE STILL LIVED IN HIS HOMETOWN, NORTHAMPTON, AND WHY HE PLANS TO CONTINUE TO LIVE THERE FOR THE FORSEE-ABLE FUTURE."

IT CENTERS ME.

IT HAS A LARGE WORKING CLASS POPULATION THAT I FEEL COMFORTABLE WITH.

21

IT'S BEEN INHABITED CONTINUOUSLY FOR 8,000 YEARS.

LOOK AT THIS ONE, IT'S A MORGAN LE FAYE DOLL.

"WE STAYED IN NORTHAMPTON SEVERAL HOURS LATER THAN WE HAD PLANNED, HAVING A PLEASANT CONVERSATION."

IT'S ALWAYS A PLEASURE TO VISIT ALAN MOORE.

"TWO DAYS LATER JOYCE, DANIELLE AND I WENT BACK TO CLEVELAND."

"WHEN WE GOT BACK HOME THERE WAS A HUGE AMOUNT OF MAIL FOR US TO PROCESS. BOY, WE HAD GOTTEN BEHIND."

22

"THANK GOD THE CHECKS I EXPECTED TO BE THERE, WERE THERE."

THESE MIGHT HAVE TO LAST ME FOR A LONG TIME.

"MY WIFE TOOK OVER PAYING THE BILLS IN HER USUAL EFFICIENT FASHION."

I PAID IN ADVANCE FOR SOME OF THESE SO IT WON'T BE SO BAD.

"THEN IN TWO DAYS WE HAD TO DROP EVERYTHING AND GO TO JOYCE'S FAMILY REUNION IN CONNECTICUT FOR A WEEK."

WHEN ARE WE EVER GONNA CATCH UP?

IT WASN'T A BAD OUTING EXCEPT IT WAS KEEPING ME FROM MY WORK, WRITING STORIES AND DUNNING THOSE WHO OWED ME MONEY.

"FINALLY WE GOT BACK TO CLEVELAND AGAIN. TO ADD INSULT TO INJURY, I GOT A SPEEDING TICKET IN PENNSYLVANIA."

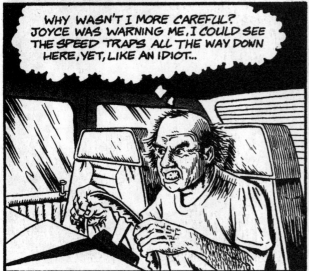

WHY WASN'T I MORE CAREFUL? JOYCE WAS WARNING ME, I COULD SEE THE SPEED TRAPS ALL THE WAY DOWN HERE, YET, LIKE AN IDIOT...

"SO NOW I'M HERE AND WORKING MY BUTT OFF. I JUST FINISHED A GRAPHIC NOVEL, AND EVERYBODY I'VE READ IT TO HAS BEEN REALLY ENTHUSIASTIC."

NO KIDDIN'!? YOU REALLY LIKED IT? YOU'RE NOT JUST SAYIN' THAT?

OF COURSE, I'VE WRITTEN A LOT OF GOOD THINGS OVER THE YEARS THAT DIDN'T SELL, ALTHOUGH THAT TIE IN BOOK BALLANTINE PUBLISHED ALONG WITH THE MOVIE SOLD REALLY WELL.

AND MY OTHER PUBLISHERS SOLD OUT OF ALL MY STUFF...

I WONDER WHAT PUBLIC REACTION TO MY WRITING WILL BE NOW THAT I DON'T HAVE A CURRENT MOVIE OUT.

I GET SO SICK A' WORRYIN', I WISH I COULD BE AN OPTIMIST. MY PERPETUAL PESSIMISM IS REALLY HARD FOR PEOPLE TO TAKE.

WELL, BETTER STOP GOIN' OVER AND OVER AGAIN EVERYTHING I ALREADY KNOW. BETTER STOP RUMINATIN'.

JUST WORK, WORK, WORK AND HOPE SOMETHIN'LL COME OF IT.